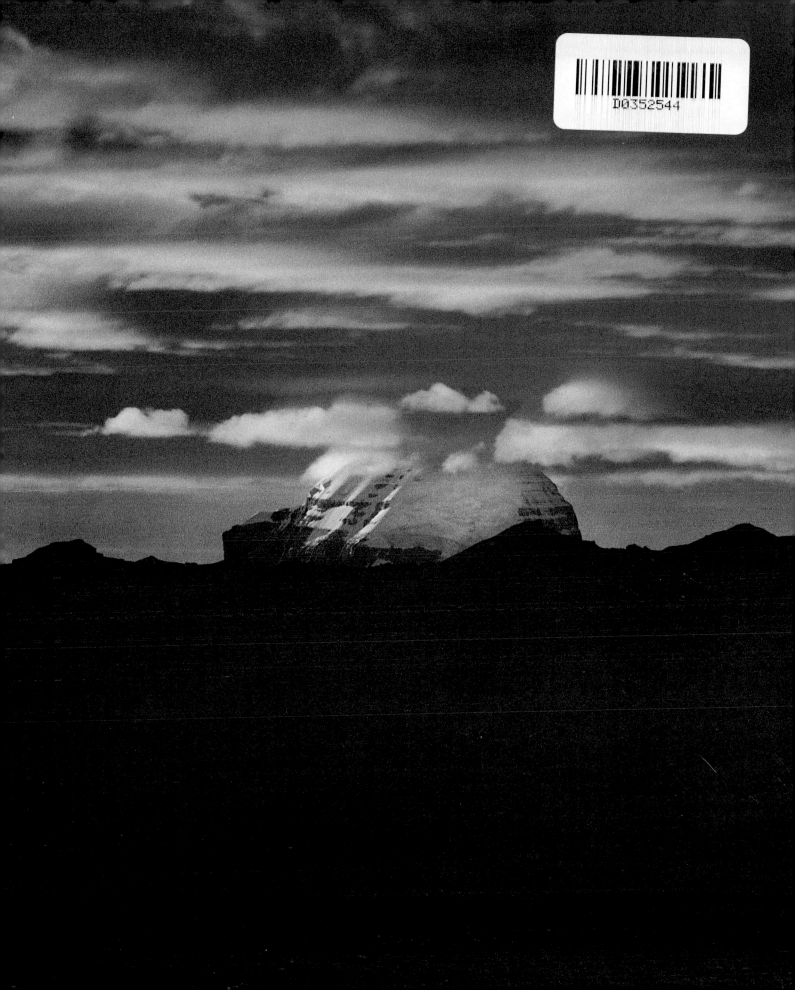

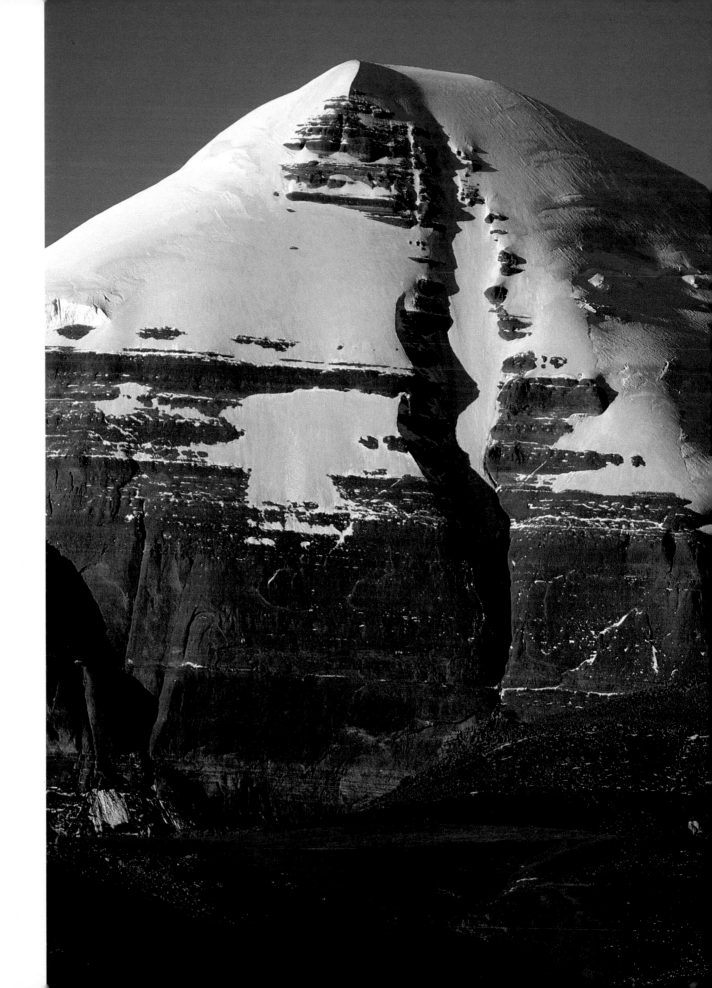

KAILAS
ON PILGRIMAGE TO
THE SACRED MOUNTAIN
OF TIBET

Photographs by
RUSSELL JOHNSON
Text by
KERRY MORAN

116 colour illustrations

THAMES AND HUDSON

Halftitle: Mount Kailas rises above the dark waters of Lake Manasarovar. *Titlepage*: To pilgrims, the great fissure marking the southern face of the mountain appears as the vertical axis of a gigantic swastika, an ancient symbol of power; inset is a painted rock on the pilgrim path which reduplicates the mountain's shape in miniature form. *Contents page*: *left*, Monks from a Central Tibetan monastery blow conch shells in the call to morning prayer; *right*, this wall painting in Trugo Gompa is a diagram of Tibet's holy land: the magic mountain and sacred lake encircled by monasteries and the four great rivers said to flow from the region. *Overleaf*: Kailas looms behind the hilltop monastery of Chiu Gompa on the western shore of Lake Manasarovar.

Illustrations © 1989 Russell Johnson
Text © 1989 Kerry Moran

Maps drawn by Barbara Ierulli

Printed and bound in Singapore by C.S. Graphics

Contents

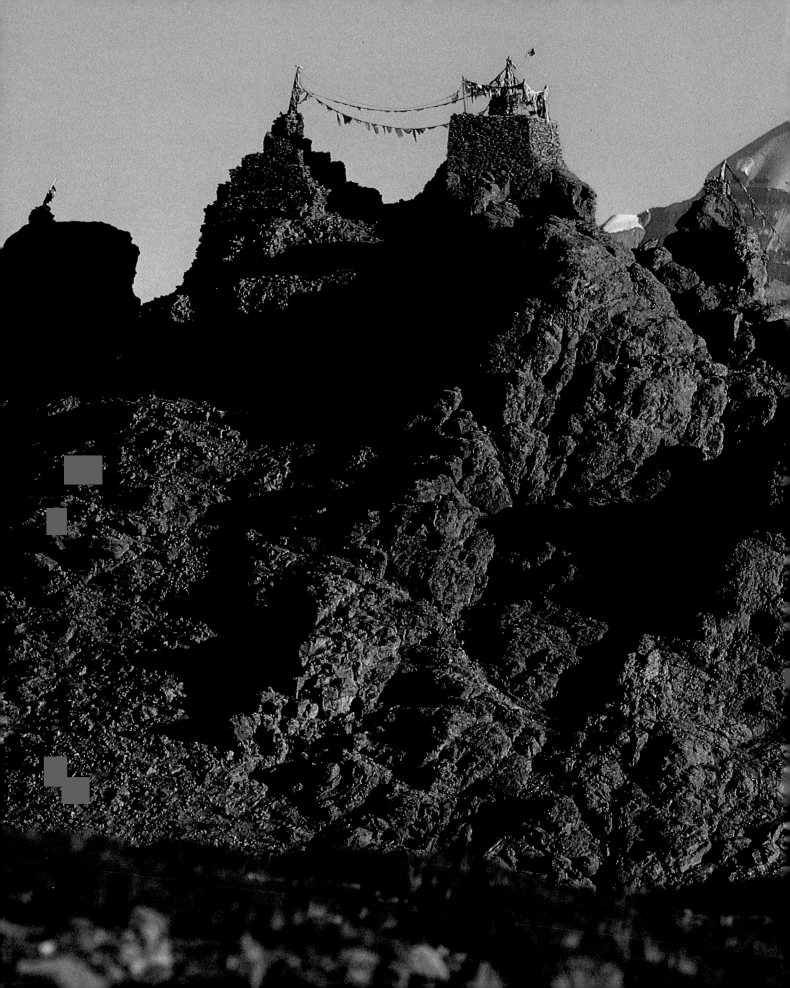

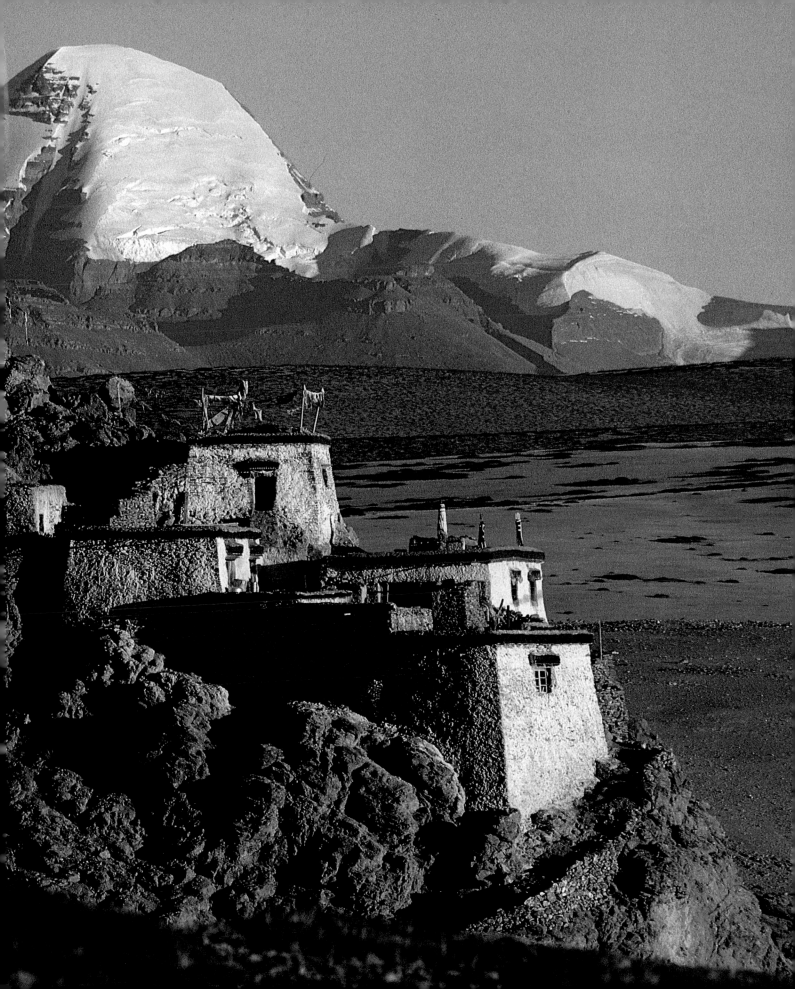

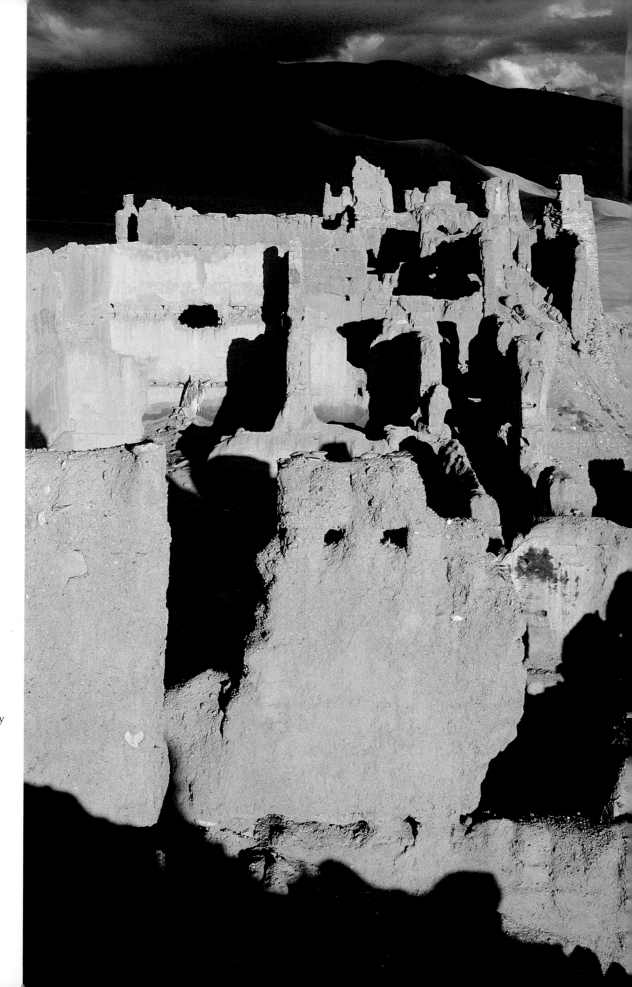

The crumbling walls of Purang's Simbiling Gompa, shelled by artillery during the Cultural Revolution, bear silent witness to the destruction Tibet suffered during the first two decades of Chinese rule. Although many of the region's monasteries have been rebuilt since 1980, Simbiling, seventy miles south of Kailas, remains shattered.

1 To The Navel of the Earth

'Away from the road there stands an enormously high mountain, very wide in circumference, its summit hidden among the clouds, covered with perpetual snow and ice, and most terrible on account of the icy cold . . . [Tibetans] with very great inconvenience to themselves make the round of the whole mountain, an occupation of some days, by which they gain what I might call great indulgences.' (Father Ippolito Desideri, 1715)

Asia's most sacred mountain stands in a remote corner of Western Tibet, isolated by rugged terrain from all but a handful of outsiders. Its name is Mount Kailas, its reputation near-legendary. To pilgrims of four religions this 22,028-foot rock pyramid is the throne of the gods and the 'Navel of the Earth', a place where the divine takes earthly form. For well over a thousand years, pilgrims have journeyed here to pay homage to the mountain's mystery, circumambulating it in an ancient ritual of devotion that continues to this day.

Here at Kailas the mythic image of Meru, the great mountain at the centre of the universe, has come to rest. Rooted in the seventh hell, piercing through to the highest heaven, Mount Meru appears at the heart of Asian religious cosmography. It is the central pivot around which the whole of creation revolves, the 'World Pillar' and the 'First of Mountains'.

As an archetype of the divine Centre, Meru rises in a realm invisible to mortal eyes. Man's urge to fix his ideals in solid form drew Meru to Earth, imposing its divinity on the snow-peak of Kailas. To the pilgrims who walk the thirty-two-mile path about it, Kailas *is* Meru embodied in ice and stone, and a single circuit erases the sins of a lifetime. Their faith proclaims that not just the mountain's ice-capped summit but the entire region is the abode of the gods: a holy land made doubly sacrosanct by the presence of nearby Lake Manasarovar, a fifteen-mile-wide circle of deepest blue which is among man's most ancient holy sites.

The lake and mountain are the crowning jewels of a magical land of pure light and intense colour born in the rarefied atmosphere of 15,000 feet. The stark windswept plains, the luminous intensity of the sky and the ranks of immense snowcovered giants guarding the region are a fitting backdrop for the dazzling purity of Kailas. Upon this sublime natural landscape are placed the rock cairns and fluttering prayer flags delineating the geography of faith. Every step of the sacred routes encircling Kailas and Manasarovar has its own legend, every rock, hill and spring its own god: an outpouring of myth and belief which confirms by its very abundance the presence of the sacred.

To each pilgrim Kailas speaks differently. Hindus cross the frozen mountain passes of India to circle the peak that is Shiva's throne and bathe in the lake created from the mind – *Manas* – of Brahma. Buddhists journey from Ladakh, Bhutan, Nepal, Mongolia and every corner of Tibet to this holiest of mountains they call Kang Rinpoche, the 'Precious Snow Mountain'. The Jain religion knows Kailas as Mount Ashtapada; atop the summit, its founder, Rishabanatha, gained spiritual liberation. And to the Bonpo, followers of Tibet's old pre-Buddhist beliefs, it is the 'Nine-Storey Swastika Mountain', the mystic 'soul' of the entire region.

Hindu, Buddhist, Jain and Bonpo: each holds different beliefs, each sees different gods, but the underlying reality is the same. At this site of natural power the temporal and the eternal unite; the divine takes physical form. Skeptics will see only the barest reality of a 22,028-foot peak of stratified conglomerate, but to the faithful Kailas is the supreme mountain, and a journey to it is made in the spiritual as well as the earthly realm.

Kailas rises in the Ngari region of Western Tibet, one of the highest, loneliest and most desolate places on the planet. Except for a few small bands of nomadic herders the empty

plains are crossed only by the wind. Ordinary standards would judge it a bleak, barren wasteland, but, like much of Tibet, the region seems to rise above common judgement. What is barren elsewhere becomes luminous here.

Every inessential has been stripped away to reveal the beauty of the earth itself in its raw colour and elemental form. Naked hills of rose, violet and flaming orange ripple off into the distance, a vast frozen ocean of land whose curves and folds seemed moulded by deliberate intent. Over this immensity arches Earth's companion, Sky, in the primordial partnership of the most ancient myth. Just as the landscape is unearthly, the Tibetan sky is from a fairytale, a dream. The word 'blue' cannot approach its luminous intensity: it is a hue so deep and clear all else would pale in contrast, were it not for the light that outlines every form with exquisite clarity. Each blade of grass and fragment of rock stands apart from the rest, suffused, so it seems, with a significance beyond reason. Here, if anywhere on earth, the gods exist as an immediate experience, a tangible presence in the pure thin cold air.

Confronted with such space and silence man feels superfluous, out of place. The land dominates him, he does not control it, and in its immensity he senses the presence of larger, unseen forces. Ancient Tibetans knew their country was inhabited by invisible legions of gods, demons and spirits. They ruled earth, air and water, guarded mountain passes and river fords, dwelt in the hearth of every home and the ridgepole of every tent.

Towering above all these were the mountain gods, the centres of Tibet's ancient folk religion. A holy peak was a mighty lord: it embodied a region's 'soul' and protected those dwelling in its shadow. Tibet's first king was said to have descended from heaven onto a mountaintop in response to the prayers of the people; and when their reign was over it was from a mountaintop that the early kings returned into the sky, following a silver cord linking earth and heaven.

From these beliefs a shamanistic religion known as Bon developed in the remote Shang-Shung kingdom of Western Tibet. The soul-mountain of Shang-Shung was an ice-capped pyramid called Kang Tise – later known in the West by its Hindi name, Kailas. Another title was Yungdruk Gu Tseg, the 'Nine-Storey Swastika Mountain'. To Bonpo, as to Hindus, the swastika was an ancient symbol of power. On the southern face of the sacred mountain a vertical gully intersecting with horizontal striations in the rock emblazoned the sign for the faithful to see.

Bon's influence dwindled after Buddhism was brought to Tibet from India in the seventh century AD. It became little more than a mirror-image imitation of Tibetan Buddhism, which in its turn was shaped by the older religion's influences. The legend of the magical battle between the Buddhist saint Milarepa and the Bonpo shaman Naro Bon Chun (described in Chapter 5) mythologizes the Kailas region's transition from Bonpo to Buddhist holy land. With Milarepa's victory the mountain came under the influence of the Kargyu sect. Beginning in the twelfth century, the Kargyu developed first the mountain, then Lake Manasarovar, as a centre for meditation and retreat. The first of the Kailas-Manasarovar monasteries were built, and Buddhist pilgrims began to journey to the mountain, adding their vision to the Bon concept of Kailas. Atop the mountain they placed Demchog, a powerful tutelary deity of terrifying appearance. In the style of Tantrik deities, he is depicted locked in union with his consort, Dorje Pangmo, whose throne is the small peak of Tijung on the west side of Kailas. Together the pair symbolizes the mystic duality of compassion and wisdom which results in spiritual Enlightenment.

By this time Hindu pilgrims were also tracing the holy path around the mountain. Their connection with Manasarovar is even more ancient, said to stretch back two millennia.

Hindus revere the entire Himalaya as an embodiment of the divine, but the presence of the sacred mountain and lake are the ultimate seal of sanctity upon the range. The *Ramayana* says: 'There is no mountain like Himalchal [Himalaya], for in it are Kailas and Manasarovar. As the dew is dried up by the morning sun, so are the sins of mankind by the sight of Himalchal.'

It is easy to understand how the Himalaya was elevated to such spiritual heights: the great ice-wall curving on the northern flank of India is truly on a superhuman scale, at once beautiful and dangerous. Its snows feed the rivers which give life to the subcontinent; its inaccessible, cloud-wrapped summits are the abodes of the gods. Shiva, the Destroyer and Transformer of the Hindu triad, is especially connected with the Himalaya, and his particular home is Kailas. There he sits in the lotus position, a naked ash-smeared ascetic absorbed in meditation. Or he may be shown atop his mountain throne in a less austere form, whiling away eternity with his beautiful wife Parvati on his knee.

Kailas and Manasarovar remained unknown to the Western world until the eighteenth century, hidden behind some of the greatest natural barriers on earth. The first European to pass through the region was an Italian Jesuit missionary, Father Ippolito Desideri. In the winter of 1715 he crossed Western Tibet, a 'vast, sterile and terrible desert', following the course of the Tsangpo river all the way to Lhasa. On the way he passed Lake Manasarovar and a cloud-hidden mountain that he reported was sacred to the powerful Tantrik wizard 'Urghien', or Padmasambhava.

The mountain was Kailas. A century later it became the key piece in a geographic puzzle which was to intrigue European explorers for nearly another hundred years: the riddle of the sources of India's four great rivers, which Hindu tradition placed at Lake Manasarovar. Beginning in 1812 a parade of explorers journeyed to remote Western Tibet, intent on filling in one of the last remaining blank spots of the nineteenth century's world map. In 1812 William Moorcroft made the British discovery of Manasarovar. Subsequent visitors had mixed motivations; there were Victorian-era adventurers, explorers of the Raj, and sportsmen sneaking across the Tibet border for a good hunt. One Englishman launched a rubber boat on the sacred waters of Manasarovar, an indignity for which the local Tibetan official reportedly lost his head.

The boldest and most persevering of the lot was the Swede Sven Hedin, whose explorations took in a previously unknown 65,000 square miles of Western Tibet. On his 1907 expedition to the Kailas region, Hedin discovered the source of the Indus river and clarified the sources of the Brahmaputra and the Sutlej. (He also became the first Westerner to follow the pilgrim path around Kailas.) Hedin's victory was tarnished by accusations of exaggeration when he returned to Europe in 1909. Regardless of this, he had succeeded in solving the mystery of the four rivers. The Indus, the Sutlej, the Brahmaputra and the Karnali all had their sources in the small corner of Western Tibet dominated by Kailas – a geographic improbability with uncanny parallels to Mount Meru, from whose summit are said to flow four great rivers which water Asia.

As befits a cosmic mountain, Meru is given a spectacular description in the Hindu *Vishnu Purana* of 200 BC. It rises 84,000 leagues high at the centre of the universe, encircled by the concentric rings of the seven continents and seven oceans. The mountain's four faces are oriented to the four directions: the eastern is of crystal, the western of ruby, the southern of lapis lazuli and the northern of gold. The sun, moon and stars take their course about this dazzling central pivot and the multiple tiered realms of heaven, earth and underworld are spread out around it. Atop its summit the sacred River Ganges falls from heaven, and divides

into four great rivers which water the four quarters of the earth. Tibetan scriptures also speak of the four rivers issuing from the world mountain: they are the Senge Khambab, the north-flowing 'River from the Mouth of a Lion'; the Mapchu Khambab, the south-flowing 'River from the Mouth of a Peacock', the Tamchok Khambab or 'Horse-Mouth River' to the east and the Langchen Khambab or 'Elephant-Mouth River' to the west. These are the names of the four actual rivers of the Kailas region, and at this juncture myth begins to take on overtones of reality; the legendary Meru merges with the actual Kailas. By a quirk of geology the Himalayan watershed occurs almost one hundred miles north of the range's highest peaks. It is one of nature's classic improbabilities that four rivers ending 1500 miles apart in the Bay of Bengal and the Arabian Sea should begin their wildly diverging courses in the same unlikely region of Tibet.

This juxtaposition of myth and fact is too startling to be dismissed as coincidence. The Himalaya has been revered for millennia by Hindu pilgrims following transverse river gorges that lead deep into the heart of the sacred mountains. Possibly, thousands of years ago, these rivers were traced to the Kailas plateau. The pilgrim-explorers would have returned with tales of a great mountain at the fountainhead of the world – a concept which lived on in the Meru legend even after the actual facts were forgotten. Centuries later, as Hindus again began to venerate Kailas, myth and fact were unwittingly reunited.

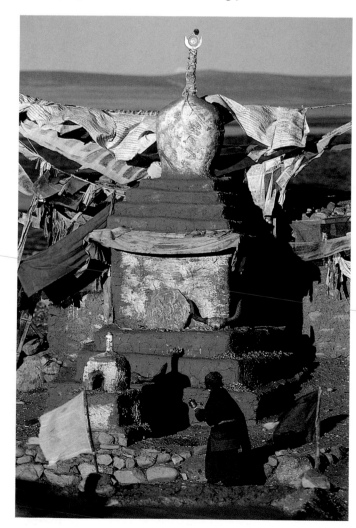

Buddhism permeates Tibetan life, infusing the landscape with a sense of the sacred. *Right*: A local woman performs her daily circumambulations around the *chorten* at Tarchen, the small settlement south of Kailas. *Centre*: Pilgrims walk beneath the richly coloured cliffs at Tirthapari, a pilgrimage site twenty-eight miles southwest of Kailas. The place is sacred to the consort of the Lord of Kailas: for Hindus, this means Parvati; Buddhists worship Dorje Pangmo.

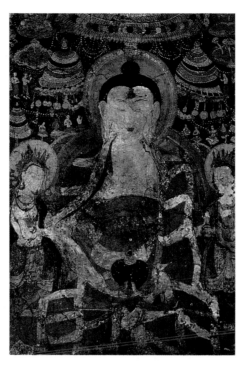

Despite several decades of attempted repression, Buddhism remains a living tradition in Tibet. *Left*: This ancient fresco of O Pa Me, the Buddha of Boundless Light, adorns the wall of a temple in Gugong Gompa, Purang. *Below*: A shrine in the kitchen of Seralung Gompa at Lake Manasarovar displays photocopied pictures of the exiled Dalai Lama, still revered as the spiritual leader of Tibet. *Bottom*: A young novice and an older monk perform their daily prayer ritual in Gugong Gompa.

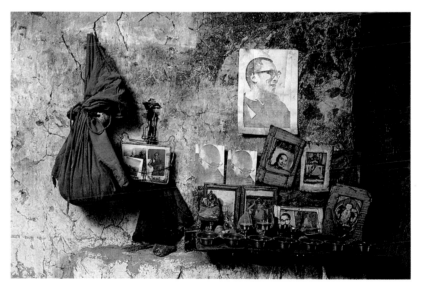

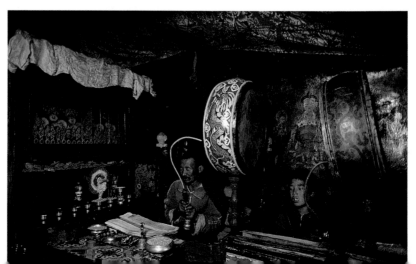

The image of Meru originated in the Mesopotamian cities of Sumeria, which flourished between 3500 and 2000 BC. The cosmic mountain was embodied in the ziggurat, a stepped pyramid built as a man-made mountain to link the forces of heaven and earth. From Sumeria the concept of a sacred central peak moved both west and east, inspiring the medieval European vision of the tiered realms of heaven and hell and the Oriental concept of Meru. The etymological link between Sumeria and Meru is apparent; a common variant is Mount Sumeru.

The vision of the universal mountain spread across Asia, inspiring centuries of art, architecture and literature. Meru appears in Jain cosmograms and Javanese temples, Japanese mythology and Tibetan paintings. The spire of the Indian *shikara* and the hemispheric mound of the Buddhist stupa were both influenced by the image of the cosmic mountain; the great stupa of Borobodur in Java is a precise interpretation of Meru in stone.

The concept of Meru filtered inward also, expressed in the form of a mandala, those geometric projections of the universe used by Tantrik cults as meditative tools. The central mountain is symbolized in yoga by the central subtle channel of psychic energy running up the spinal column (which itself is known as *meru danda*). Ultimately, Meru appears within man himself. 'In your body is Mount Meru, encircled by the seven continents . . . He alone who knows this is held to be a true yogi', the *Shiva Samhita* says. Certain other passages in Indian texts support the concept of Meru as a spiritual rather than a geographic centre. The *Mahabharata* describes Meru as 'a kingdom of the mind', 'a heap of effulgence . . . immeasurable and unapproachable by men of manifold sins'.

At this point it is clear that Meru's meaning goes beyond an archaic attempt at cosmology. Like the cosmic tree that stands at the centre of other cultures' visions of the universe, the mountain is an inner image of a divine pattern that infuses and orders creation. Carl Jung saw in the mandala a diagram of the self's journey to completeness; likewise Meru can be interpreted not as an actual mountain, but a symbolic axis: T. S. Eliot's 'still point of the turning world'.

Religious pilgrims approach Kailas in this way, as a spiritual rather than cosmological centre. The great number of them are anonymous; a pilgrim's journey is intensely personal, and only a very few have left records of their thoughts. One who did was a Japanese Buddhist monk, Ekai Kawaguchi, who studied Tibetan and passed himself off as Chinese in order to make the pilgrimage to Kailas and Manasarovar in 1900. Nearly a half-century later came Lama Anagarika Govinda, a Bolivian-German Buddhist monk whose *Way of the White Clouds* is an esoteric account of his 1948 sojourn in the Kailas region. The unquestioned expert on Kailas and Manasarovar was the energetic Indian Swami Pranavananda, who between 1928 and 1949 made 25 circuits of the mountain and 23 of the lake and wrote a pilgrim guidebook crammed with a mixture of scientific and spiritual observations.

The accounts of these three men differ from the records of the Victorian explorers. They came to the mountain as pilgrims – more reflective, perhaps, than ordinary pilgrims, who rarely contemplate the metaphysic subtleties implied in the image of Meru/Kailas. To most pilgrims it is enough to know the mountain is holy; they do not ask why, but take its presence as a blessing and go through tremendous hardships to be touched by its power.

The pilgrim tradition continued unbroken for over a thousand years, impelled by a faith so strong only a catastrophe could halt it. That came in 1950, as the Chinese army entered Tibet. In 1959 Sino-Indian border clashes closed the Hindu pilgrimage route across the Himalaya. A few years later, the Cultural Revolution exploded in China, and nowhere was it expressed with greater fury than in occupied Tibet. The violence took form as a concerted

attack on Tibetan culture, with Buddhism as its main target. Monuments and monasteries were pulled down, their frescoes mutilated, statues smashed, libraries burned, monks sent to labour camps. Every manifestation of religion and the old 'feudal' society came under attack. In the process the Red Guard struck at the very roots of Tibetan identity, for in this culture life, art and religion are inextricably entwined.

The Kailas region suffered comparatively little violence, but with religious expression forbidden, the few pilgrims circumambulating the mountain were forced to walk about secretly in a single night. China's Tibet policy began to relax in 1980. In 1981, under a special agreement between India and China, the first group of Hindu pilgrims in twenty-two years visited Kailas and Manasarovar. Despite hasty reconstruction efforts, the devastation was apparent. Of the thirteen monasteries and innumerable monuments that once lined the pilgrim circuits, not a single one remained. The only reminders were a few crumbling walls, and heaps of rock Tibetans had piled to mark the sites of their former places of worship.

Now the situation has again changed. Tibetans are allowed a degree of religious freedom, and pilgrims are returning to Kailas and Manasarovar in increasing numbers. In 1987 over five thousand circled Kailas, joined by more than two hundred Hindu pilgrims allowed every year under the 1981 agreement. Ten of the thirteen monasteries have been rebuilt with government funding, and prayer flags and monuments once again line the circumambulatory paths.

The fortitude and faith displayed by pilgrims is strong enough to make the tragedy of the recent past seem a bad dream. Despite years of suppression the holiness of the site has remained intact in the minds of believers. The Cultural Revolution could pull down only the monuments man had made: it was unable to touch the true source of the region's sanctity, which springs from a place beyond human control. As Tibetologist Giuseppe Tucci wrote of Muktinath, another Himalayan pilgrimage site:

Holy places never had any beginning. They have been holy from the time they were discovered, strongly alive because of the invisible presences breathing through them. Man is amazed or fearful as he feels the vibrations of invisible power in the air, and religions, feebly falling behind like all human institutions, gradually assign various names and different symbols to delineate the mystery.

Man's response to Kailas and Mansarovar is varied and fascinating, emotionally moving in itself. But underlying the different cultural and religious expressions is a more fundamental reality, a realm approached not by reason, but by intuition and faith. Faith *does* move mountains. In the case of Kailas it has lifted an earthly peak into the realm of the divine, transforming it into a symbol of the single unifying centre lying at the heart of all creation.

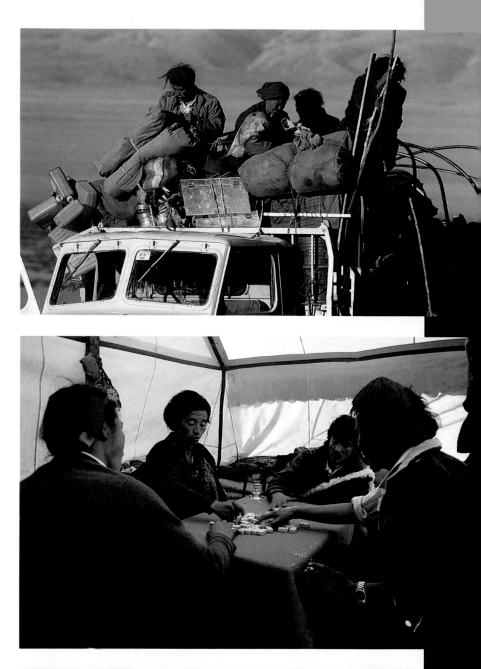

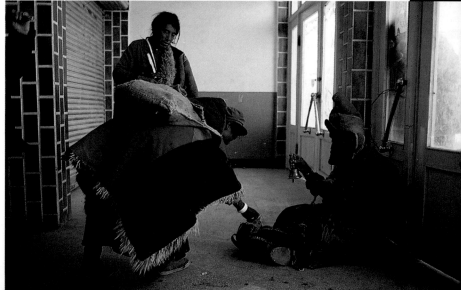

On the pilgrim road. *Top*: Passengers make a last-minute check of their baggage before their truck departs. *Middle*: Khampa traders pass a long afternoon with a gambling session inside their tent. *Bottom*: A Rutok woman pauses at the exit of the Ali Department Store to make an offering to a *lama* performing a prayer ritual.

2 Pilgrims' Path

'In order to understand the full significance of Mount Kailas and its extraordinary surroundings one has to see it not only geographically, culturally or historically, but first and foremost through the eyes of a pilgrim. In order to do this, we have to divest ourselves of the narrow confines of our personality . . . the experiences with which we are dealing here are too great and timeless to fit the stage of a purely personal occurrence or a description or accidental happenings.' (Lama Anagarika Govinda, *The Way of the White Clouds*)

Not counting the eight-month-old baby cradled on her mother's lap, there were twenty Tibetans crammed on the back of the truck waiting for the ferry over the Tsangpo river. They were bound for our destination, Kailas, but the chances of catching a ride on that truck seemed low: luggage and sheepskins and people were heaped so high only a few well-placed side ropes kept the load from spilling over the sides. Still, we asked the driver, a tough middle-aged Tibetan named Tashi. He narrowed his eyes, calculating a complex equation of space versus two more fares, then looked at us and grinned. 'Okay', he said, using up his entire English vocabulary. We passed our luggage up to willing hands and climbed up onto the back.

Our new companions were all bound for Western Tibet, but their motives for going were as mixed as their background. A half-dozen big-boned Khampas, men from the Kham region of Eastern Tibet, took up the front half of the truck. They were heading out for a summer of business, selling their bundles of trinkets along the way and returning with bales of sheepskin to trade in Lhasa.

In the rear was a group of Kailas-bound pilgrims, farm families from a small village in Central Tibet. We sat between the two groups, and their boisterous, sometimes ribald exchange of jokes flew back and forth over our heads in all senses of the phrase. Two old Buddhist nuns sitting in a corner were unperturbed at the turn the conversation had taken. They joined in the general laughter at the saltiest comments, then serenely resumed their murmured prayers.

The exhilaration of finding a ride had time to wear off as we waited for the ferryman. Deep into a tea-drinking session with friends, he ignored the shouts of impatient drivers stranded across the river. A leisurely two hours later we arrived on the opposite bank. One of the Khampas crank-started the engine with such enthusiasm that the red tassel wound about his head loosened and tumbled down to his feet, and he had to pause, laughing, to rewrap it. After vigorous persuasion the engine caught, coughed and spluttered and evened out into a purr. And at last we were off, down the dirt road leading straight into the middle of nowhere: the road which, nine hundred miles later, would bring us to Kailas.

In the old days Tibetans journeyed on foot for months or years to reach Kailas. Now their routes are replaced by Chinese-built roads, and most arrive atop cargo trucks – the only remotely public form of transport in Western Tibet. In pilgrim season, May through September, the roads leading to Kailas are filled with Chinese-made trucks as rickety as the one we climbed aboard, decked with prayer flags and crammed with human cargo.

The necessities of road life surrounded us, competing for space: legs of dried mutton, thick bedrolls, plastic water jugs and enormous cookpots. A foxskin tied onto the top rail fluttered in the breeze in a barbaric banner, counterbalanced by a domestic clutter of teakettles lashed on below. Amid this gear our travelling companions were packed knee-to-knee in a remarkable assembly. The women wore long wrap-around dresses over brightly-patterned blouses and sweaters; striped woollen aprons topped their layers of clothing and coloured tassels lengthened their black braids.

In comparison the men were a relatively drab lot. Most had abandoned their traditional coat-like *chuba* for Western-style shirts and trousers, ill-fitting polyester garments layered

over luridly coloured long underwear. Their individuality reasserted itself in fantastic headgear, hats of foxskin or lambswool or fur-trimmed caps of gold brocade. It was easy to identify the Khampas from the thick tassels of red or black yarn they braided into their long hair and wrapped about their heads with a flourish. Long daggers, heavy leather money belts and bootsoles studded with metal taps completed the effect of dashing barbarity. Central Tibetans say Khampas are uncouth and wild, not to be trusted; the Easterners glory in their bad-boy reputation and do their best to live up to the legend. Once I asked a Khampa why he needed such a long knife. 'It's for killing people', he replied with a wicked gold-toothed grin.

Underneath the wild hats, the faces around me were more uniform: resourceful, shrewd, lined by sun, wind and laughter. Every bit of ingenuity and good humour was needed to deal with life on the Tibetan road. The cargo truck jolted down the corrugated dirt track at an excruciatingly slow pace. 150 miles was good progress for a single day, and that was at least twelve hours of riding.

Not a single minute of it could be called comfortable. With each pothole we were flung into the air to crash down with a bone-rattling thud. The Tibetans simply laughed at the worst jolts as if it were a carnival ride and settled back to brace themselves against the next series. A more subtle torment was the dust that billowed up on certain stretches, coating everything, even our teeth, with a thick grey pall. Within minutes we would be transformed into a load of doddering greyheads, the beautiful black-haired girl across from me replaced by an old crone.

To them this was life on the road, accepted with an equanimity born of toughness and faith. Endurance is expected in Tibetan society, and complaints are rarely heard. At our roadside rest stops there was no need to assign tasks: some gathered dried yak dung for fuel while others fetched water and unloaded cooking gear, and soon kettles were heating over fires, speeded up at times by the blast of a blowtorch.

At mealtimes we sat cross-legged on the ground about the fire and shared tea and *tsampa*, the twin staples of Tibetan life. Early explorers deplored the unpleasant aroma of butter tea; although I didn't find it as rancid as they had described, it helped to think of the brew of black tea, salt, butter and a little soda as soup rather than tea. Tibetans live on the stuff, some drinking 40 or 50 cups a day. 'We have one stomach for tea and another for food', they say.

Tsampa – barley which is roasted, then ground into flour – is the companion to butter tea; it is the ideal food in high-altitude, fuel-scarce Tibet as it requires no cooking. The diner pours a mound of flour into his wooden bowl, adds tea and with his right hand kneads the mixture into a doughy mass, sticky or dry according to his taste. *Tsampa* was the backbone of our road diet, but meat is plentiful in Western Tibet, so we usually had boiled mutton, or at least a strip of semi-dry meat if there was no time to cook.

More often than not it was dried mutton: roadside stops were few and far between. Tashi drove like a demon for fourteen-hour stretches, trying to make up time lost in breakdowns. Usually we would not halt until well past sunset – in a government truck stop if we managed to reach one of Ngari's few roadside settlements; more often by the side of the road. The amenities of travel in Western Tibet had not progressed far since the time of Desideri, the Jesuit who journeyed across the region in 1715:

For three whole months the traveller finds no village nor any living creature; he must therefore take with him all provisions . . . now wood is not to be found in the desert, save

here and there a few prickly bushes, and to make a fire one has to search for the dry dung of horses and cattle. Your bed at night is the earth, off of which you have to scrape the snow, and your roof is the sky, from which falls snow and sleet.

Our companions knew how to coax comfort out of the bleakest situations, proving the Tibetan proverb that 'He who knows how to go about it can live comfortably even in Hell.' Within twenty minutes of a halt tents would be up and tea brewing; we were always invited inside to join the circle seated on carpets about the fire. In contrast to the freezing blackness outside, it was a haven of warmth and companionship. Firelight played on the faces in the circle, some cooking, some talking, some softly murmuring mantras, swinging prayer wheels.

The conversation those nights was low-key and companionable. We were accepted with surprisingly little comment as the *Inchi nekorpa*, the 'foreign pilgrims' we had introduced ourselves as. The questions our fellow pilgrims posed us were limited by their mental map of the world. *Aa-merika*, like all Western countries, was vaguely located somewhere 'out there', and all we *Inchi*, round-eyed and big-nosed as we were, were more or less the same to them. Conversation alternated with rounds of murmured prayers. In the darkness the different voices blended into a single soothing hum, and I drifted to sleep with the low tones ringing in my ears.

Like all of Tibetan life, pilgrimage blends the worldly and the divine in near-equal proportions. The journey's spiritual potential does not diminish the delight of a new adventure. Pilgrimage is a time for merriment and feasting, a break from everyday routine, and a chance to satisfy the nomadic wanderlust that seems to possess so many Tibetans. Religion is an essential part, but a pilgrim's practices are often not much different from the prayers and prostrations he performs at home, although they may be more frequent and perhaps more fervent.

The long hours of riding passed with talk and song, but as the monotony of the journey took hold thoughts turned inward. Eyes gazed off into the vast distances while hands automatically picked up prayer beads or a prayer wheel; lips began to murmur the beneficient syllables of a mantra. There are dozens of these sacred formulas, each dedicated to a particular deity. The most-recited and most frequently seen is OM MANI PADME HUM, invoking the mercy of Tibet's compassionate protector Chenrezig. 'Hail, the Jewel in the Lotus', it has been translated, but it is futile to seek a literal meaning in the phrase, for the power of mantra is not semantic, but mystic. Certain syllables are believed to concentrate subtle energies, channelling them into a potent form of sound.

Most Tibetans do not give much thought to these esoteric subtleties. They simply murmur the syllables over and over, with the certainty that each repetition adds to their stock of religious merit and brings them one small step closer to liberation. Merit comes with each revolution of a prayer wheel, releasing the power of the thousands of written mantra encased within. Every circumambulation of a *mani* wall equals a recitation of the mantra carved upon its flat rocks, just as each flutter of a prayer flag sends forth the charms printed upon it. Prayer, circumambulation, prostration, offerings – religious merit comes from all these rituals, for they are tangible links to a spiritual state, and they bring the worshipper into contact with the divine.

For days on end we rode through golden plains bordered with rolling hills, their bare sides patterned with variegated swirls of colour, salmon and sienna and purple. From my perch atop the load I watched distant trucks race across the land, tossing up great clouds of dust

that streamed out behind like banners. Nomads shooed their frantic herds out of our way, then turned to watch us roll by, tiny figures standing alone in a vast landscape. These *drogpa*, 'people of the high pastures', were among the few tough enough to wrest a living from the desolate terrain of Western Tibet, and we met them often on our roadside stops. Invariably we would think ourselves alone on the empty plains. Then a near-invisible flock of sheep would appear on a distant horizon, a thin line growing steadily larger as it approached. The nomads would always see us first, and come to investigate the strangers on their territory.

I grew familiar with their manner, at once shy and proud, elusive and aggressive. They stood and stared at me solemn-faced, in the dress of another century. Their baggy *chuba* were tied up at the waist, sleeves dangling down past the knees; from their sashes hung tinder pouches and needle cases of inlaid leather and bone-handled knives. Most striking were the faces: flawlessly smooth rose-brown skin, triple-plaited black braids, and eyes with a stare that might have been from another planet, so removed was it from what I knew.

Their gaze was nearly unfathomable. It came from a world of open spaces and frosty stars and tents pitched in the shadows of great mountains. For these people there were no divisions. Life and work were one, just as the day was not chopped up into hours but traced across the sky by the sun. Life and time both moved in a seamless flow, and this showed in the eyes that bored into me, impassive and incisive. They were weighing me, it was clear, and I sometimes had the uncomfortable feeling they might find me lacking in comparison to them, so direct, as clear as the space they lived in. 'They are the only people I envy', Giuseppe Tucci wrote. 'They are unfettered, serene in their essential inborn simplicity . . . As they wander through those immense open spaces they seem to be suspended between heaven and earth.'

Trucks break down frequently on the road to Kailas (*below*): drivers must rely on their own skills to make repairs. *Right*: A passenger crank-starts the engine of a Chinese-made *Jie Fang* ('Liberation') truck, the standard model on Tibetan roads.

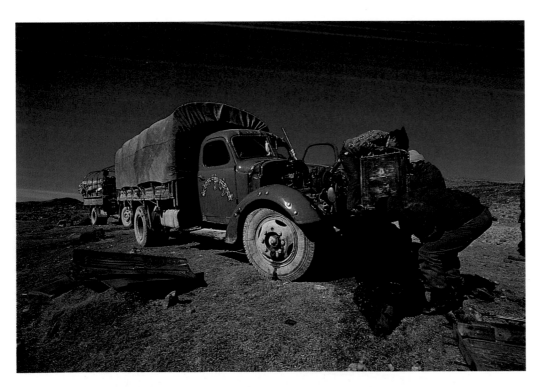

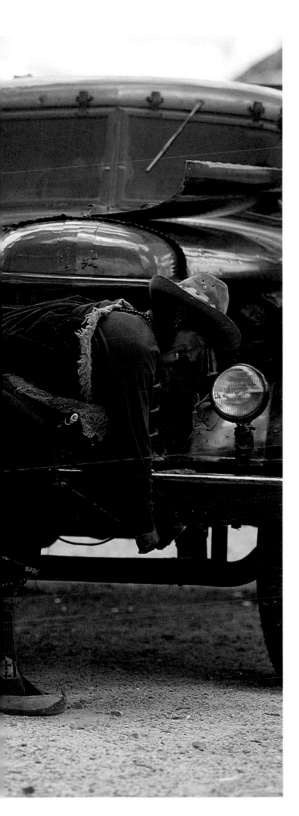

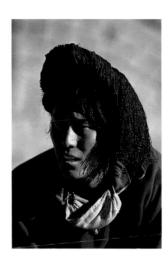

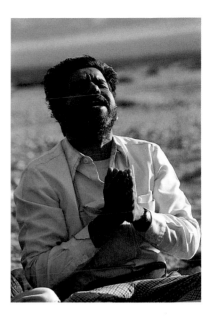

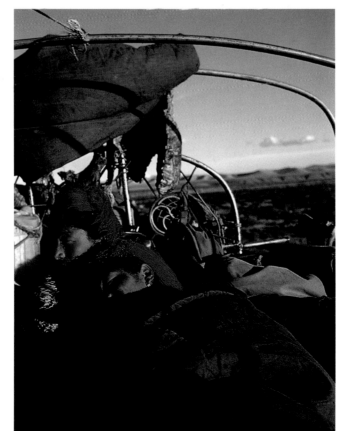

Faces on the journey: *top left*, a Khampa from Eastern Tibet; *top right*, a Jain pilgrim at prayer in Tarchen; *right*, two Khampas share a joke during the long ride out to Kailas.

Endless hours of riding across flat plains; and then a crumpled ridge of mountains rose up to block the way. A subtle sense of anticipation grew as the truck crept up the ascent to the pass. The climb continued for hours, until I wondered how the road could go any higher. Through half-closed eyes we kept a watch for the rock cairns and wind-shredded prayer flags that would signal the top of the pass. At last they appeared silhouetted up high. Excitement built as we slowly drew near. For a moment it was as if everyone on the truck was holding their breath, then as we crested the top all broke loose with jubilant cries: 'La, so so so so!', 'Lha gyalo!' – 'Victory to the Gods!' A Khampa cut loose with a ringing war cry, 'Ki-ki-ki-so!', and for a few minutes we all shared smiles, the tension of the approach magically dispelled. Freed of the burden of gravity, the truck swooped downhill into the newly revealed land below.

Sometimes we would halt atop a pass and climb out to walk clockwise around the cairns, tie on new prayer flags and add more stones to the growing heaps. Like the great circuit of Kailas we were bound for, this too was *kora*, a ritual so central to Tibetan practice that the very word for pilgrimage, *nekorwa*, means 'making circles about holy places'.

The dust, the sun, the vastness of the landscape and the monotonous whine of the engine kept us all hypnotized. As days passed, it grew easy to slide into a sort of trance in which the mind cut loose from the body's ordeal and lived entirely in its own reverie. Down a gully, over a ridge – and suddenly the man beside me was up and leaning over the side. 'Kang Rinpoche!' he shouted. On the horizon an unmistakable ice-capped pyramid rose from a range of peaks: Kang Rinpoche, the 'Precious Snow Mountain', Mount Kailas. Everyone on the truck was silent, transfixed at the sight of our goal at last within reach and drawing slowly closer. Mantras began anew; a few folded their hands before their faces and bowed in reverence. For me, everything suddenly slid into place. Far from diminishing its worth as I had feared, the hardships of the journey made the sight of our goal that much more powerful.

The truck creaked to a halt at the small settlement of Tarchen, the pilgrim's traditional starting point under the mountain's southern face. Until forty years ago it was a major centre of the region's wool trade with India, and in the summer the surrounding plains were dotted with nomads' tents and herds. Restrictions following 1959 Sino-Indian border conflicts brought the business to a halt. Today Tarchen is a handful of low stone buildings, a government-run guesthouse for Indian pilgrims, and an ochre-washed monastery that shelters Tibetan pilgrims.

In summer Tarchen is the scene of much excitement: trucks come and go in an endless round of loading and unloading passengers and goods; tents are set up and regularly blow down in the fierce afternoon winds, and a constant curious procession wanders between tents, houses and rooms. Our truck's Khampas set up their tents and spread their goods outside for sale; the pilgrims settled into a routine of walking around Kailas. Most Tibetans try to do more than one *kora*; three is a popular number, while thirteen is the goal of the more serious, and every year there are a few working on their goal of 108 *kora*, which a determined walker can accomplish in two seasons. A single circuit of the mountain is said to erase the sins of a lifetime; ten the sins of an age, while 108, a holy number, ensures Nirvana.

These numbers are not to be taken literally, however. To gain Enlightenment, after one *kora* or one thousand, 'your mind must be in touch with the gods and holy things', a Tibetan man told us. Without this sense of reverence, nothing is gained by mere circling. In practice, this qualification is sometimes ignored; substitutes can be hired in Tarchen to perform the arduous journey for the indolent or ill. The religious merit earned is shared between the

sponsor and he who actually walks the path. To earn full merit, there can be no substitution, nor acceptance of payment. Unless the pilgrim is very young or very ill, even going about on horseback reduces the amount of merit – to the advantage of the animal.

Most Tibetans prefer to walk about Kailas in a single day, an ordeal of twelve to seventeen hours which they insist is easier than walking two or three days burdened with luggage. Once I tried this *nying-kor*, this 'afternoon circuit', I had to agree. Early explorers recorded a more derogatory term for the one-day kora: *kyi-kor*, 'dog *kora*', for the unseemly haste with which it is performed. Modern pilgrims, however, do not use this term. One-day *kora* are simply efficient means of earning merit; a man in good condition can walk one day, rest the next and be off on another round the day after, and the same is true for women; the old women of Tarchen outstripped us all in the one-day circuit.

There were many Bonpo pilgrims at Tarchen, come from the remote southeastern border regions where Bon still flourishes to walk their counter-clockwise path about the mountain. And there were Hindu pilgrims – but they were not the same as the barefoot travellers of the past, who struggled alone through an unfamiliar, high and hostile land. Modern Indian pilgrims are organized under the joint auspices of the Indian and Chinese governments. After a week-long trek through roadless mountains across the Indian border to the Tibetan village of Purang, they are whisked by bus to their ancient holy land. There they are split into two groups and make the circuits around Kailas and Manasarovar on foot, yak and horseback. The scheduling allows a dozen 'batches' of pilgrims to visit in a single season.

In the past the ranks of Hindus who came to Shiva's throne were selected by the strength of their devotion and limited by the difficulty of the journey. Today the process is conducted through the Indian Foreign Ministry, which from a flood of applications chooses two hundred pilgrims by lottery. Most are middle-aged businessmen from Calcutta, Delhi, Bangalore, Bombay – men of the world, they readily admit, not overly religious, but all express their gratitude and joy at being here. 'I never thought I would be able to come here in my lifetime', said one. 'I am so happy to be here . . . the dream of a lifetime', they all agreed. Kailas and Manasarovar are so deeply rooted in the Hindu soul that even the self-professed unbelievers in the group are moved by the sight.

Watching the ebb and flow of the pilgrim tide at Tarchen I had time to compare the pilgrims of the present to those of the past. On the surface it seems much is different: with distances shortened by modern transportation, the commitment of pilgrims could be said to be correspondingly diminished.

The pilgrims of the past approached slowly, travelling on foot or pony a year or more, from the farthest reaches of Tibet and India. Some prostrated every inch of the way in a supreme act of devotion, measuring the holy path with the length of their bodies. The power of the mountain was inexplicable; its worship sprang not from organized religion but from an individual urge to experience the divine in a personal way. With pilgrim staffs in their hands and mantras on their lips they walked from dawn to dusk, drawn to their goal as if by a magnet. They carried no weapons, no protection against the danger of the journey except an amulet box or a turquoise ring for good luck. Their faith was in their own karma, and in the mercy of benevolent deities like Chenrezig and Tara who they were confident would lead them through – and if not, even death held little terror; to die on pilgrimage afforded the highest merit.

Hindu, Buddhist, Bonpo, they shared in common the hardships of the journey: hunger and thirst, bitter cold and blazing sun, dangerous passages over high ranges and across

turbulent rivers. In summer marauding robber bands patrolled the Kailas region, sweeping down to attack trade caravans and pilgrim groups. The nomadic bandits were 'pitiless if offered the slightest resistance', noted one traveller, but in their own way they were devout, donating a share of their spoils to monasteries. Seldom would they kill an unresisting victim, or completely rob him of his possessions, for to do so would be a death sentence in those empty wastes. In his 1900 visit to Kailas, the Japanese monk Ekai Kawaguchi observed a young Khampa brigand fervently prostrating before the mountain in atonement for his past sins, as well as for any crimes he might happen to commit in the future – 'a convenient mode of repentance', Kawaguchi dryly commented.

The pilgrims accepted these hardships uncomplainingly; not as austerities, but as a means to an end, a tool with which to chisel a new being. This is where the link to the pilgrims of today remains, for their faith is equally strong, and it allows them to overcome all the trials placed in their way. Their eyes are fixed on something greater, and as long as they keep this goal in mind nothing is truly difficult.

Anyone with enough determination can reach Kailas. For the journey to become a pilgrimage he must be open to the transformative power not just of the goal, but of the journey itself: deprivation and danger and most importantly, the breaking of all patterns of habit, the constant necessity to be alert to new situations. The pilgrims' path purifies the heart, leaving the traveller able to experience something far greater than his limited self. This transformative power is visible on the faces of those who submit themselves wholeheartedly to the process. Francis Younghusband wrote of meeting Hindu pilgrims returning from Kailas: 'They have attained to such a degree of sanctity that holiness positively radiates from them.' A true pilgrimage lifts the traveller out of his everyday self into a realm beyond ego. When it returns his self back to him, all of life has become a single, endless pilgrimage.

Prayer beads are used to count silent or spoken repetitions of mantra; the daily total of prayers may run into the thousands.

His pilgrimage around Kailas completed, a nomad boy holds his pony in a quiet interlude as his family prepares to leave Tarchen. *Overleaf*: Two dozen passengers crowd onto the back of a truck bound for Kailas. *Inset*: Boredom shows on the face of a Ladakhi monk waiting for his truck to depart. Although motor vehicles speed a journey which once took months or years, life on the road brings its own set of hardships.

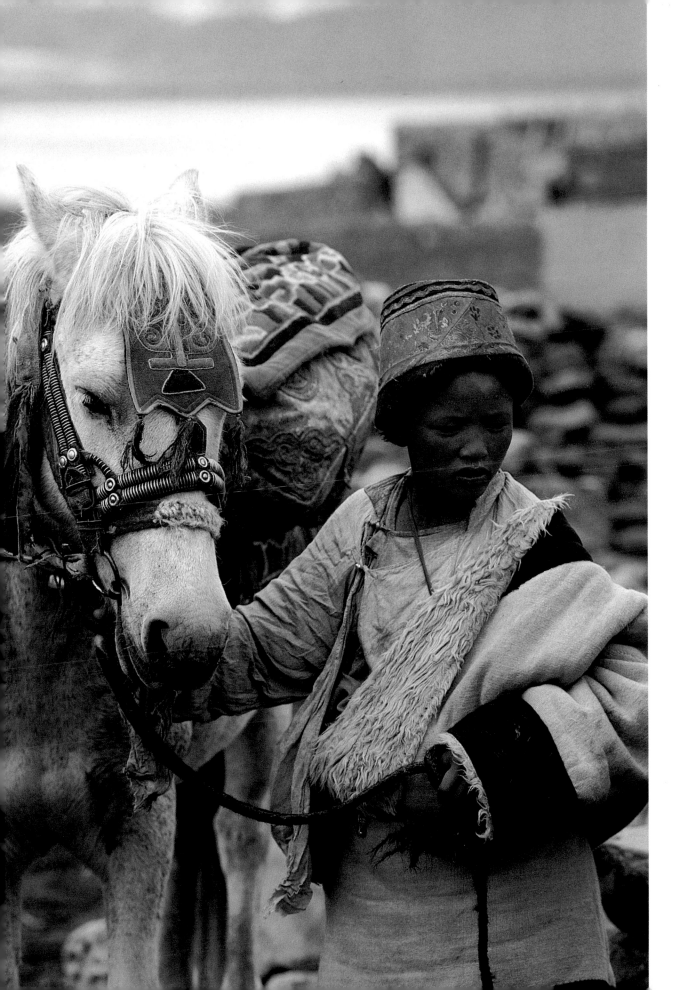

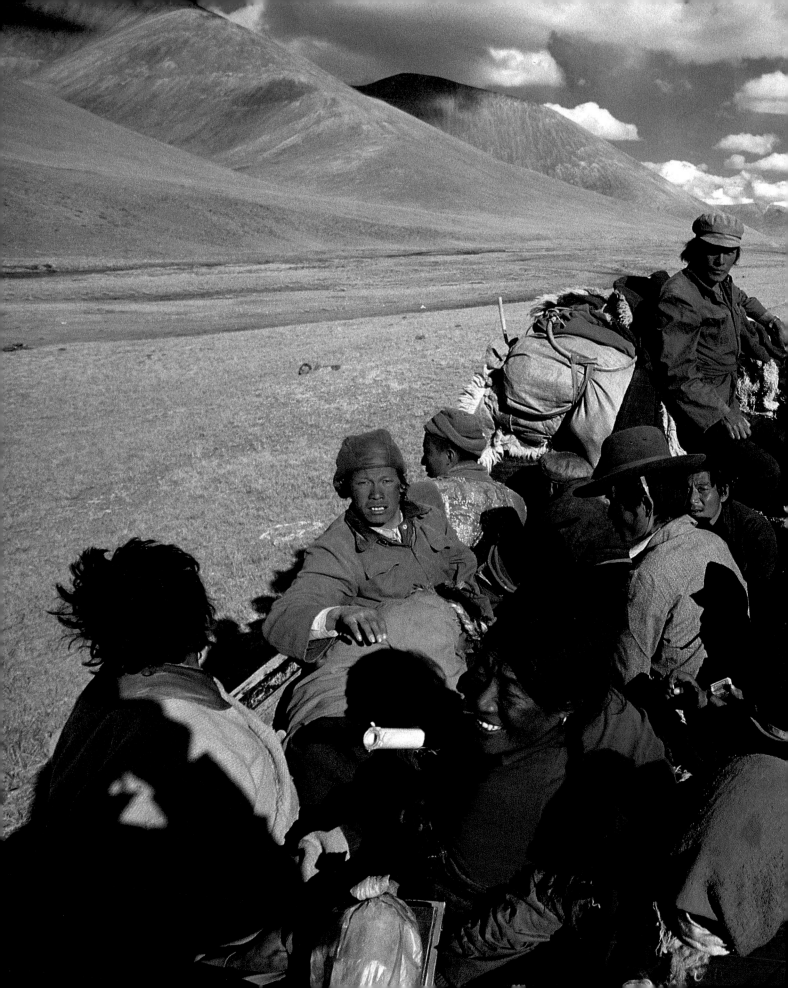

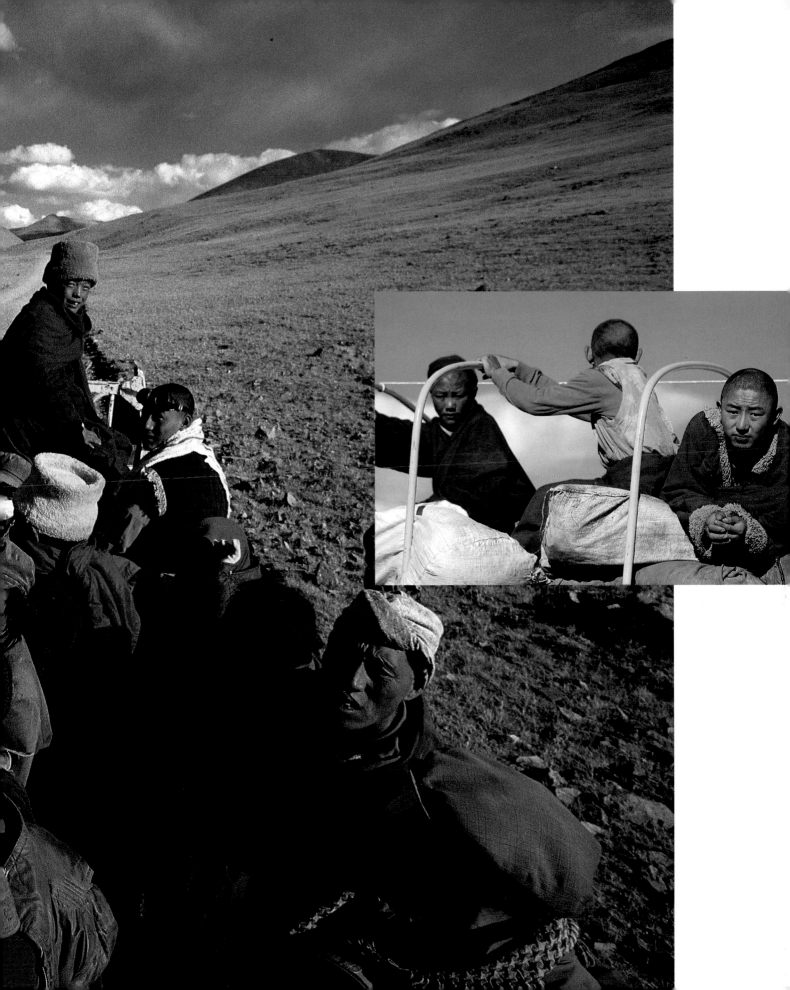

Kailas pilgrims are a mixture of faiths and cultures. *Top row, left to right*: Hindu *saddhu* or wandering ascetic; Tibetan nomad with amulet box; Purangi woman spinning yarn. *Middle row*: Hindu woman at prayer; Tibetan boy with pilgrim flag; Khampa man from Eastern Tibet. *Bottom row*: Nepali Hindu; Tibetan lama (a spiritual teacher); another lama, from the Amdo region.

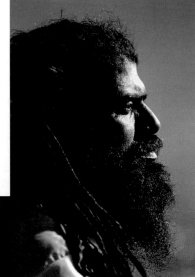
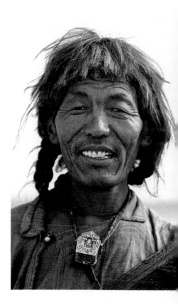
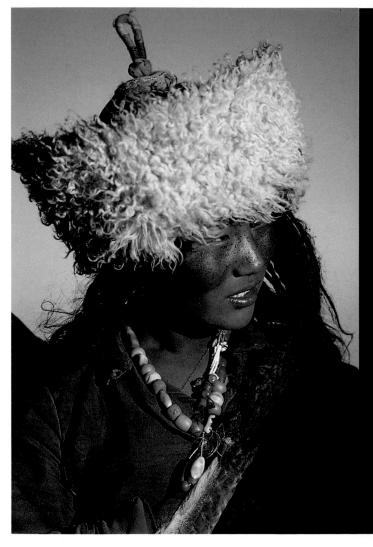
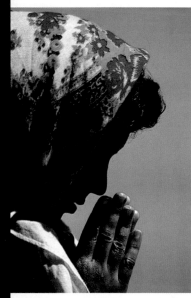
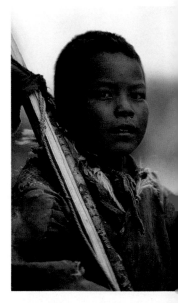
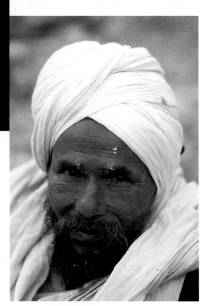
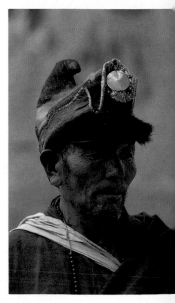

The toughness and pride bred by a life spent wandering open spaces show in the faces of Tibetan nomads. *Above*: A young woman whose family roams the area around Gertse. Her cheeks are smeared with a rouge of red ochre. *Opposite*: A boy from Rutok: his flawless complexion, braided hair and cool stare are all nomad characterstics.

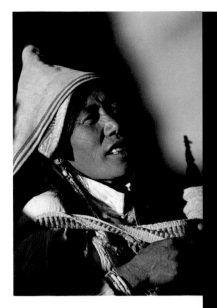

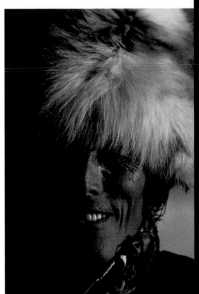

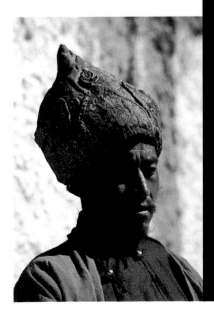

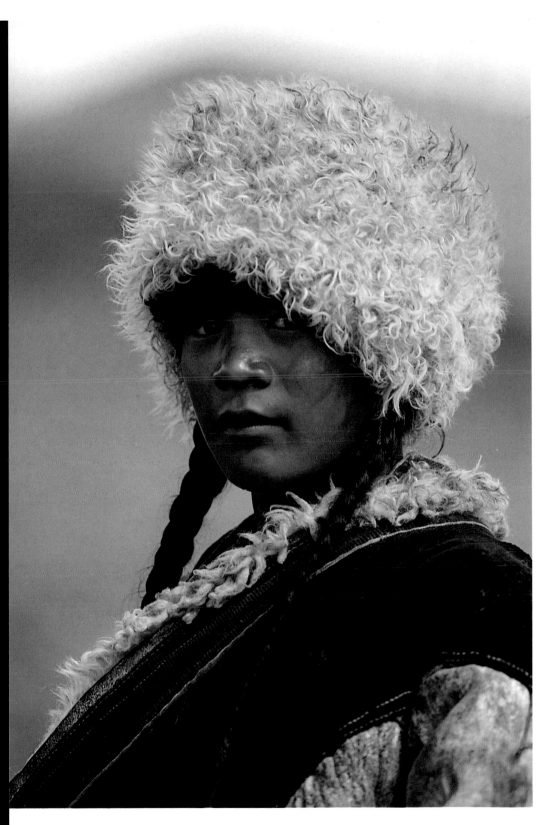

Overleaf: Rutok women on pilgrimage display their winter wear, vividly patterned felt cloaks lined with sheepskins. Each region of Tibet has its own distinctive costume and jewelry. These cloaks are typical of Western Tibet.

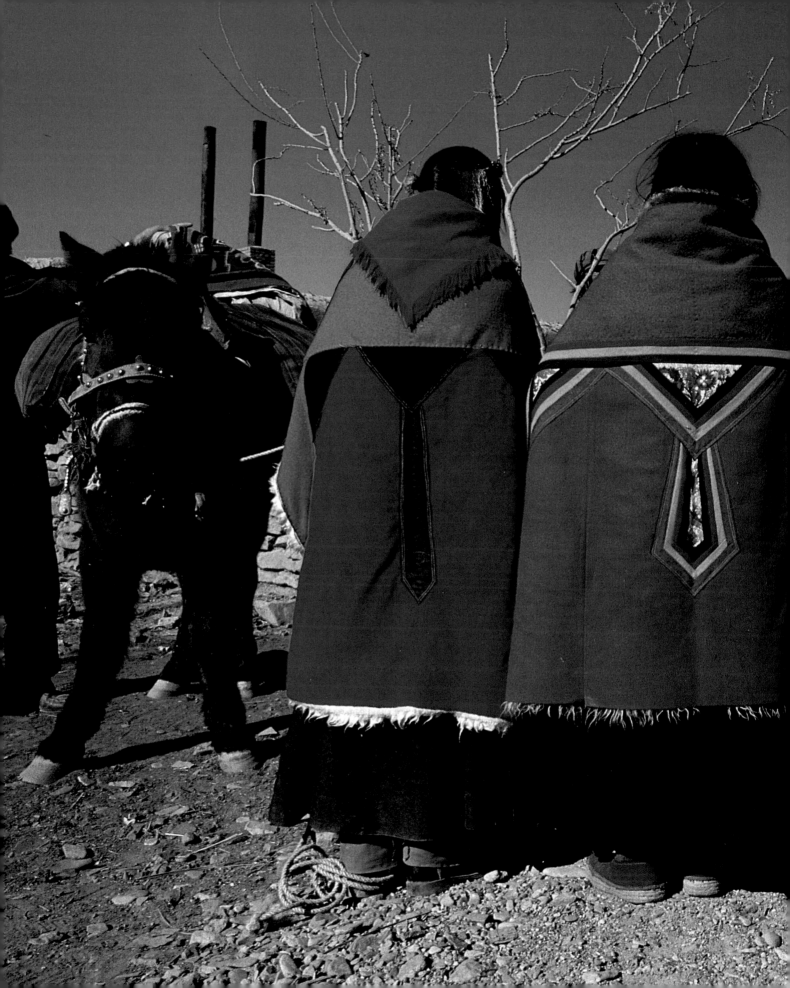

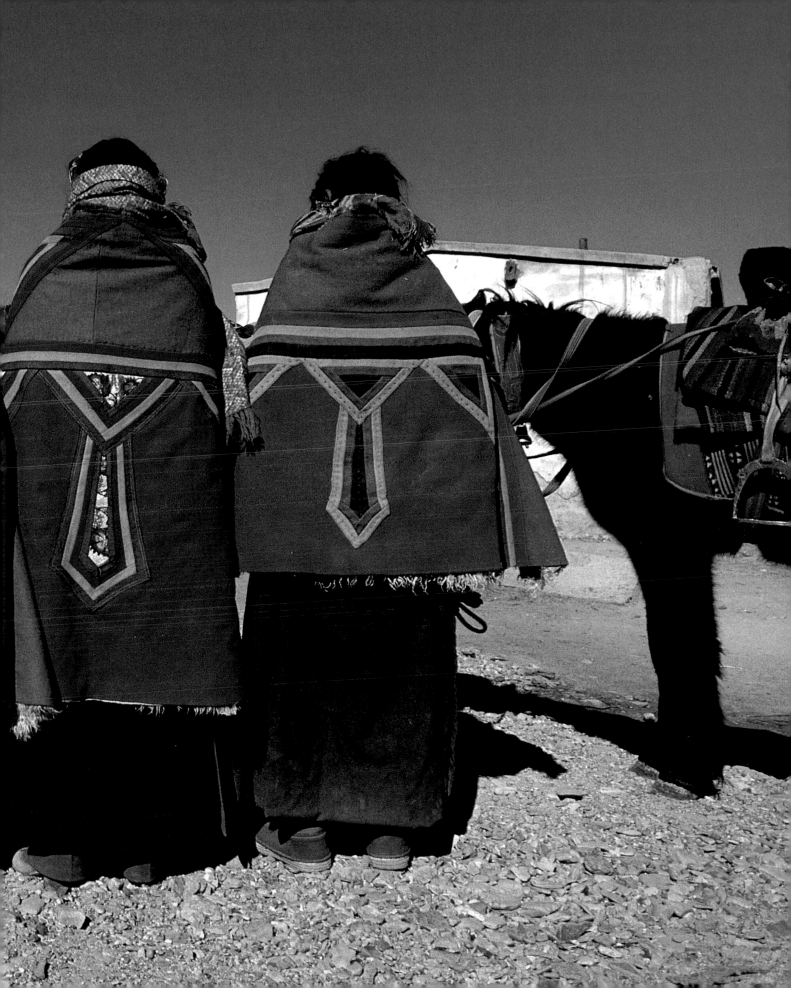

Life on the road is a rugged affair for travellers in Ngari Province, but resourceful Tibetans rise to the challenge. *Right*: Smoke from cookfires clouds the morning air at Tarchen as Khampa traders prepare morning tea. Groups of traders travel across Western Tibet every summer, doing business with pilgrims, villagers and nomads. *Below*: The red tassel wound about his head identifies the Eastern Tibetan origin of this Khampa man stoking a cookfire at a roadside stop. Firewood is scarce in treeless Western Tibet, where grass, scrub and dried yak dung all serve as fuel.

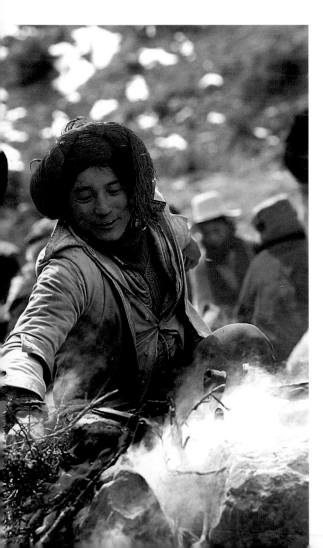

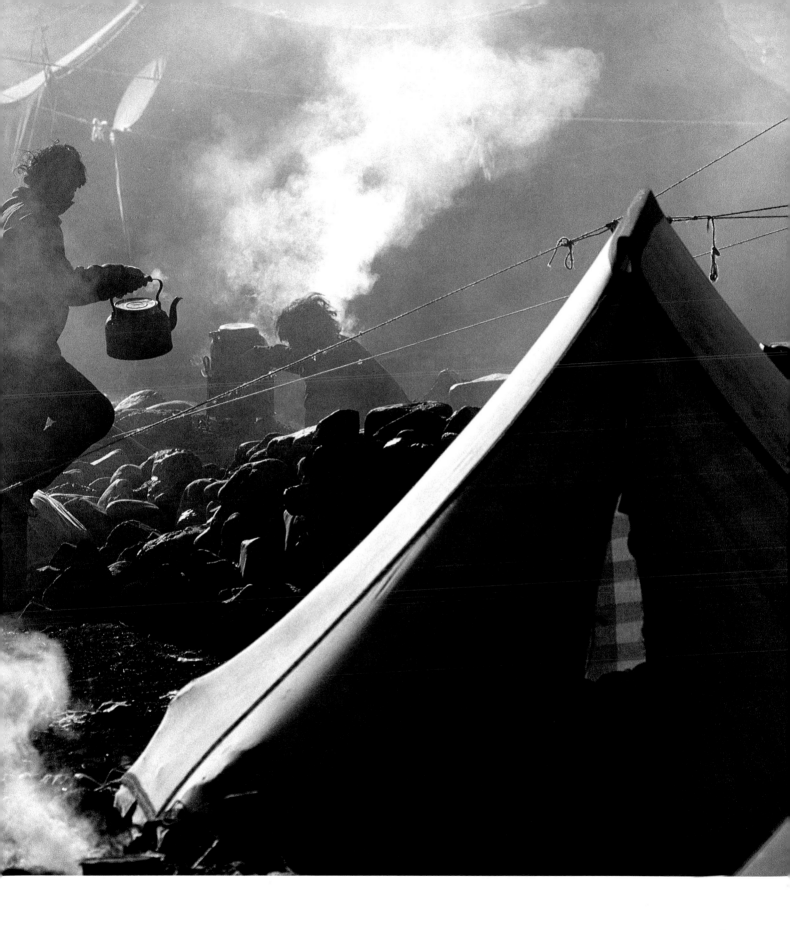

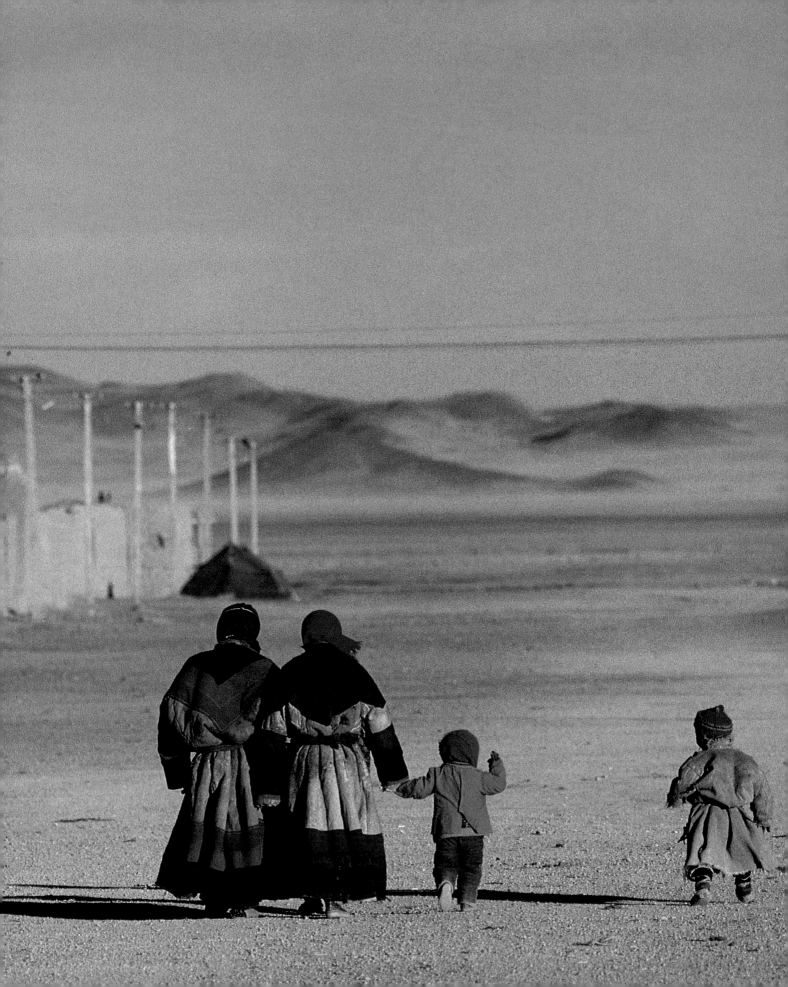

A Tibetan family walks down the wide empty main street of Gertse, a Chinese-built settlement on the north road to Kailas. Small towns like these are scattered along the nine-hundred-mile highway joining Kailas to Central Tibet; cargo trucks keep them supplied and connected with the outside world. *Below*: Bright colours enliven everyday life: two pilgrims return from the Tarchen Chu with water for tea. Their traditional costumes have changed little in modern times, except for the trousers worn beneath the long *chuba* for added warmth and the hightop sneakers replacing felt boots.

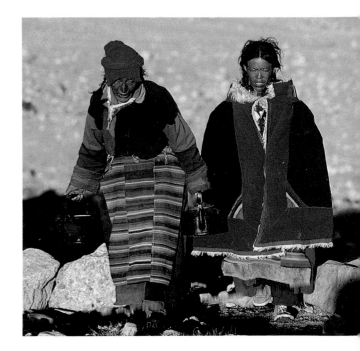

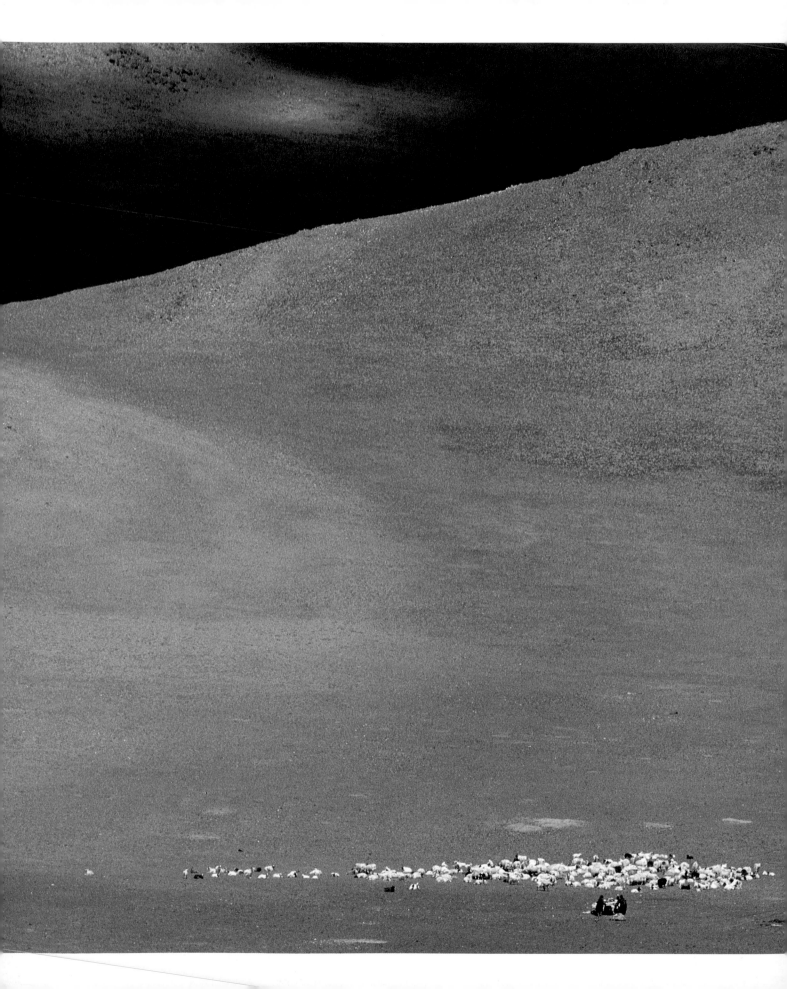

The life of a Tibetan nomad has scarcely altered over centuries. Small tribal groups roam the open plains of Western Tibet; scant pasturage forces them into an independent life forever on the move. *Left*: A nomad family's black tent and herds: a typical scene near Rutok. *Below*: Amid the dust of a roundup a nomad man wrestles with one of his flock. Like yaks, sheep provide meat, milk, wool and transportation; surplus wool is sold to the government and to Nepali traders. *Overleaf*: A cargo truck moves slowly across the vast expanses of Western Tibet. Until the arrival of the Chinese in the 1950s, Tibet had no roads. Today convoys of trucks have replaced the caravans of pack animals which once traversed the remote reaches of Ngari.

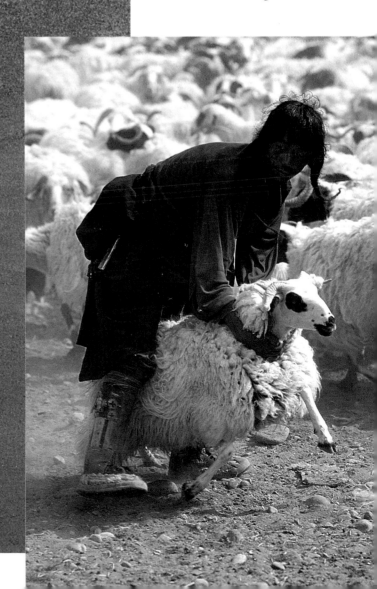

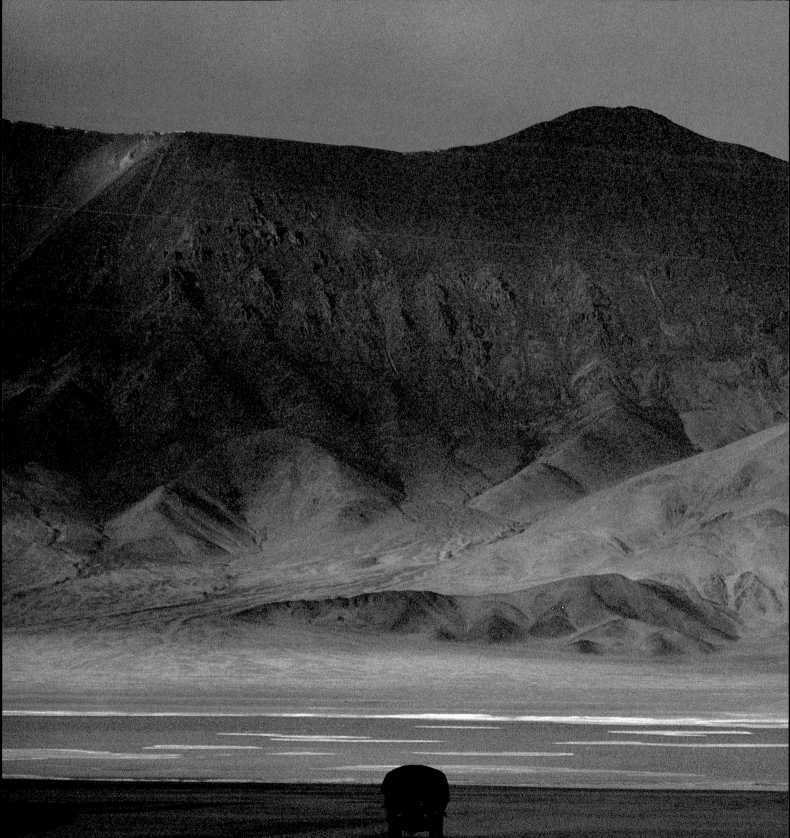

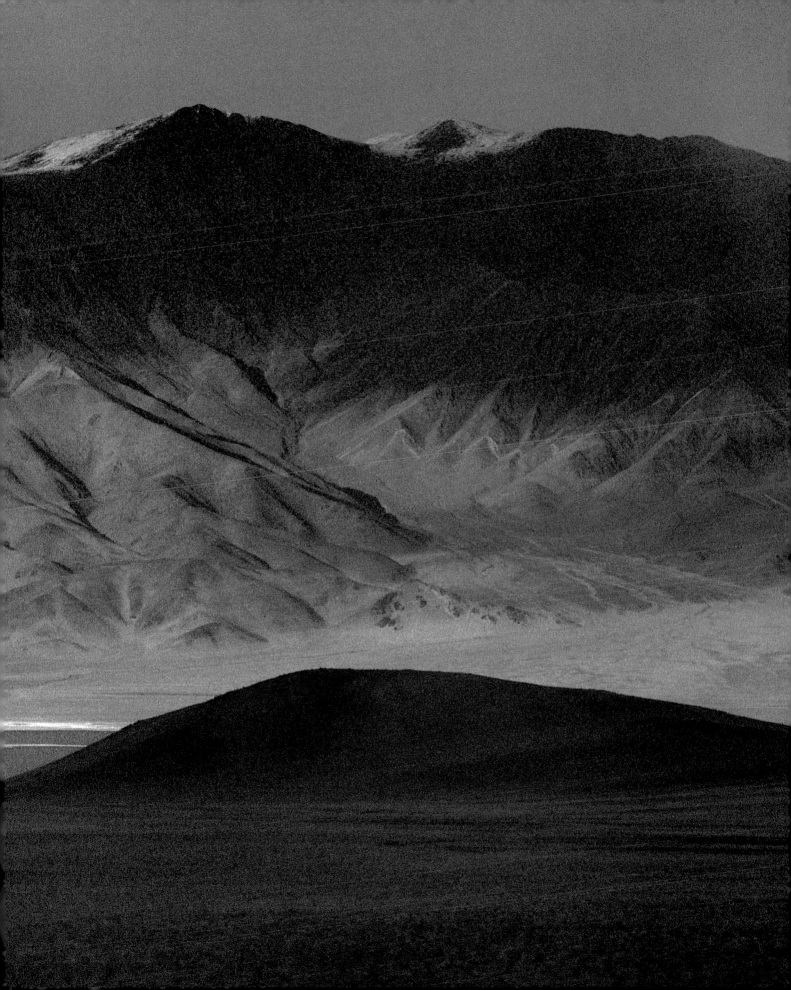

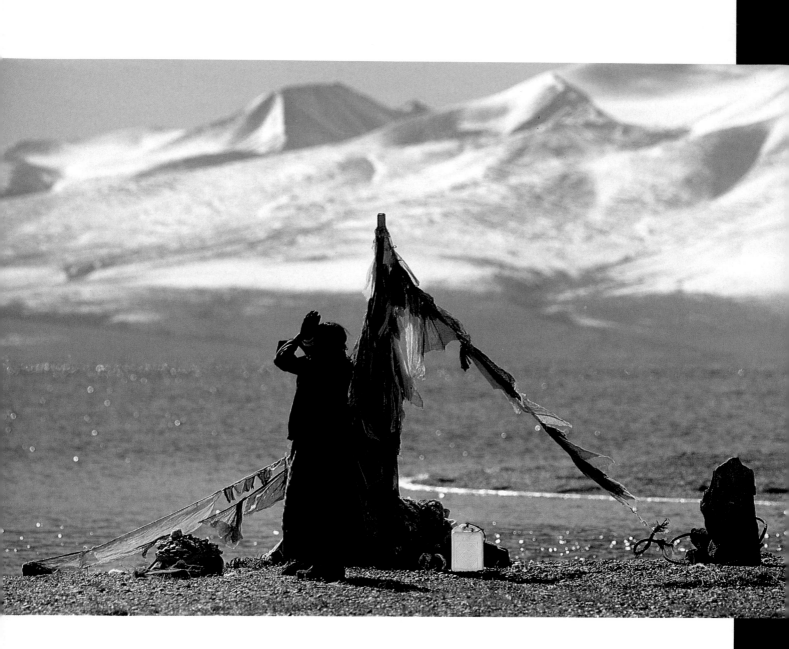

Prayer flags mark a prostration station at Lake
Manasarovar. A Rutok woman, from Western Tibet,
bows at the holy shore, hands raised in the first gesture
of 'eight-limbed obeisance' which will unite her with
the earth in worship. Tibetans call the lake Tso
Mapham, 'The Undefeated Lake', or Tso Rinpoche,
'The Precious Lake'. Its clear waters are reputed to
have miraculous healing properties. The woman has
filled the bottle behind her with holy water for use in
religious rituals back home.

3 The Precious Lake

'When the earth of Manasarovar touches anyone's body, or when anyone bathes in the lake, he shall go to the Paradise of Brahma, and he who drinks its waters shall go to the heaven of Shiva and shall be released from the sins of a hundred births. Even the beast who bears the name of Manasarovar shall go to the Paradise of Brahma. Its waters are like pearls.' (The *Ramayana*)

In the beginning were the waters. Before man was, before Creation came to be, before even the Gods were born, the primordial sea covered all. The Tibetan myth of Creation tells of a tremendous wind that came rushing out of the void to churn the cosmic ocean into waves. Like cream rising from milk the waves thickened into earth, and the mountain of the gods grew storey by storey at the navel of the new-born world. In Hindu texts too a cosmic sea precedes the world. The Lord Vishnu floated in it for an eternity, dreaming, until the life force stirred, and out of the water's infinite potential sprang forth all of Creation.

These ancient myths have their basis in geologic fact. Forty million years ago the Himalaya lay under the tropical Sea of Tethys: fish swam where mountains now soar, and Kailas' snowy peak was no more than layers of compressed mud on the ocean floor. Marine fossils are still found marooned in the bone-dry hills surrounding Kailas, and pockets of the ancient sea remain in the salt lakes which dot the vast Chang Tang, the Northern Plain.

The old belief in the infinite potential of the waters also remains, in the veneration of Lake Manasarovar, eighteen miles southeast of Kailas. Tibetans call it Tso Mapham, 'The Undefeated Lake', or simply Tso Rinpoche, 'The Precious Lake'. To them the meeting of Kailas and Manasarovar is beyond coincidence. The union of sacred mountain and lake marks a holy site for Bonpo, for the two are 'mother and father of the earth'. Manasarovar is Kailas' inseparable complement in every respect. The lake is female to the mountain's male, receptivity to its activity, depth to its height, a mirror to a proud statement; and Manasarovar's depths and colours contain a mystery equally sublime. Kailas is an immutable temple, a focus for adoration; Manasarovar is a shifting fluid mirror meant for contemplation.

The pilgrim approaching the region from the south, from India or Nepal, struggles to the top of the 16,200-foot Gurla Pass to find the holy land spread out before him. To his right lies the turquoise disc of Manasarovar. A narrow isthmus separates it from the darker crescent of its companion lake, Raksas Tal, on his left. Originally the two lakes were one, until an island in the middle grew into a dividing strip of land. Ahead on the northern horizon shines the ice-dome of Kailas. The vision shimmers with such unearthly beauty 'it makes the beholder wonder whether it is of this world or a dreamlike vision of the next', Lama Govinda wrote.

The landscape here encodes a symbolic message: natural form is imbued with supernatural significance. Manasarovar's disc is shaped like the sun and represents the forces of light; *manas* in Sanskrit means mind, the power of consciousness and Enlightenment. But just as consciousness is balanced by the unconscious, Manasarovar is matched by the curved moon-shape of Raksas Tal to the west. Named for the flesh-eating demons of Hindu mythology said to dwell within its depths, Raksas symbolizes all that is lunar, feminine and subconscious. On calm days its unrippled surface forms a splendid mirror for the ice-dome of Kailas, but pilgrims shun its lonely shore and only one monastery stands beside it. Scriptures advise Hindus to cast a single glance of veneration in its direction before hurrying past; the dark forces dwelling here are too powerful for travellers to linger.

Legend holds that originally Raksas Tal was poisoned. Then a golden fish from Manasarovar, fleeing the attack of a companion, tunnelled a narrow connecting channel between the

two lakes, and the inflow of Manasarovar's sacred waters redeemed Raksas. The channel is called the Ganga Chu; its waters ebb with the season and the year. It was dry for most of the last century, much to the distress of Tibetans, who interpret this as an ill omen. High water in the Chu is said to bode well for the entire world, for it links the bridegroom Manas with his bride Raksas and signals the underlying forces are in harmony.

Manasarovar, the lake born from the mind of Brahma, is among the most ancient and holy of Hindu pilgrimage sites. Hindu legend tells of twelve Rishis, wise 'Seers' of pre-Vedic times who retreated to the remote region for meditation and prayer. They stayed many years performing penances and austerities, and were awarded a vision of Shiva and Parvati, the divine Lord and Lady of Kailas. But still they lacked, in this dry land, a suitable place to perform the daily ablutions required of devout Hindus. The Rishis prayed to Brahma so that they might fulfil their duties. From the infinite depths of his all-encompassing mind Brahma created Manasarovar, the Lake of the Mind, as a mirror of his greatness. At the moment of its creation, it is said, the Rishis worshipped a golden linga, the generative symbol of Shiva, rising from the midst of the new-born waters.

This pilgrim (*right*) carries medicinal herbs gathered from the hills around Manasarovar. *Below*: Raksas Tal, the 'Demon Lake', is Manasarovar's symbolic counterpart, representing the dark, hidden half of existence.

No records tell when the first Hindu pilgrims crossed the Himalaya to bathe ritually in Manasarovar's waters and circumambulate its shore. The origin of the lake's sanctity is buried deep in the unconscious mind where it first struck a resonant chord. References to the divine lake stud the pages of the Hindu classics as well as early Buddhist literature. It is 'the most excellent lake of the mind' and the 'only true paradise on earth'. 'I behold Manas, and there in the form of a swan dwells Shiva', says the *Ramayana*. 'This lake was formed from the mind of Brahma: there dwell also MahaDev and all the gods.'

Manasarovar is depicted as a divine paradise: royal swans, the emblem of Brahma, float on its transparent waters beside Bodhisattvas and Buddhas enthroned on giant lotus blossoms. The *Mahanirvana Tantra* describes Kailas in similar lush terms:

The enchanting summit of the Lord of Mountains . . . clad with many a tree and many a creeper, melodious with the song of many a bird, scented with the fragrance of all the season's flowers, most beautiful, fanned by soft, cool and perfumed breezes, shadowed by the still shade of stately trees.

In reality, these desolate highlands contain no such luxuriant beauty: flowers, trees and cool and perfumed breezes are as alien as to the Sahara. But the wide spaces and dazzling light harbour an unearthly intensity, and create a stripped and simple setting for the natural jewels which crown it.

'Kaley pep!' 'Yagpo pep!' We shouted farewells to our companions as the truck pulled away, then shouldered our packs to begin the long march towards Manasarovar. Fat jackrabbits exploded from the brush, bounding off in balletic curves. Other than these there was little sign of wildlife. Once we sighted three kyang from a distance, but the dun-coloured wild asses had seen us first and were already galloping across the plain. We were fortunate to catch that glimpse, for much has changed in fifty years, when the region was described as teeming with vast herds of kyang and antelope. Govinda wrote of birds landing at his feet and kyang grazing peacefully within sight, but that was a time when hunting was forbidden and the entire Kailas region was protected as a holy land. With the construction of roads and the arrival of the Chinese, the wildlife population has been decimated. Even Tibetans now hunt and trap animals in the area, and in the district market of Ali there is a brisk trade in fox skins – they make impressive fur hats.

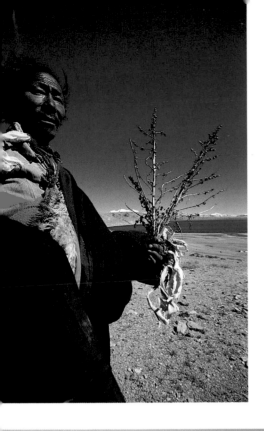

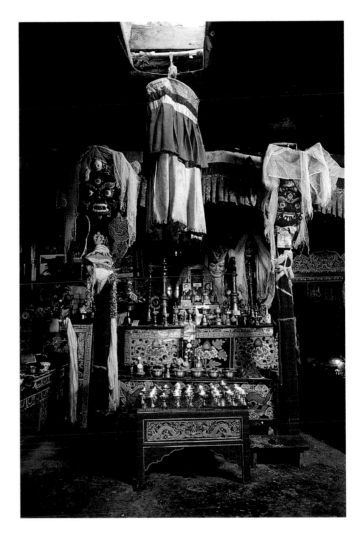

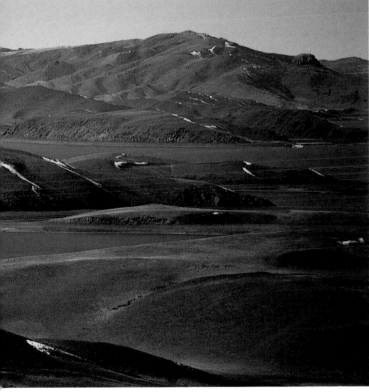

Butter lamps flicker before the altar of
Seralung Gompa, *above*. A photograph
of the Dalai Lama (*right*) is enshrined in
a pilgrim's amulet box.

Rolling plains stretched out all around us, pinned under the blue bowl of sky. The vastness of the scale was intoxicating; so was the rarefied air, which caused perspective to lose its normal meaning. Rock outcrops on a distant hillside stood out with uncanny clarity. From the sparse grass underfoot to the jagged serried peaks on the horizon, all shone like crystal in the dazzling light. Golden-green plain, purple mountains, white snow peaks; all were textured and deepened by the shadows of big-bellied clouds sailing overhead. From the direction of the lake, still no more than an ultramarine slash on the horizon, low-hanging streamers of grey and silver vapour rose, to be snatched up by the wind and tossed into fantastic forms. A backlit, ragged-edged dragon pursued its hapless prey across the sky, driven by an invisible force that quickly shredded both forms into formlessness and turned them into something new. At dusk the sky became a theatre. Storm and sunset collided at the same moment, and the swollen clouds caught and held the light. Hanging curtains of fiery mist descended onto mountain ranges, joining sky and earth. For a brief moment all things, even the grass tips, were aflame, and all of nature was still before the spectacle, but for three white cranes flapping heavy-winged into the wind.

The next day the lake seemed to be playing games with us, receding farther the longer we walked. High tributary streams forced us to detour miles inland from the northern shore, and I finally understood why local Tibetans chose to make the circuit in winter, when rivers and lake alike were frozen and they could walk directly to the shoreline. We trudged for hours through hilly pastures and marshlands, superb grazing for the horses all around but hard going for us. At last the grass gave way to sand dunes. Slithering down the sides we arrived at Manasarovar's shore.

I stood on the shingled beach with the clear waters lapping at my boots and gazed over an infinity of blue. What struck me first was the lake's size. Fifteen miles wide, fifty-five miles in circumference, Manasarovar was a true inland sea, big enough to swallow the devout intentions of most pilgrims. Only the sincere attempted this *kora*, for its length was nearly overwhelming, unconquerable in a single day, and few companions were found en route. Manasarovar's size, its isolation and its self-generated weather created a sense of superhuman scale. It was a repository of raw, uncontained power, the power of the mind of Brahma to create and destroy and create again in never-ending waves.

Walking along the shoreline, I began to glimpse the magic of the lake. An inexhaustible treasury of gem-like hues – turquoise, sapphire, lapis, emerald, malachite – dwelt within its depths, rising at the slightest provocation of light or weather. Manasarovar's colours and moods shifted as swiftly as the flickering light of an opal. In early morning, when the air was calm and the sky clear, the smooth water was a delicate cornflower tint. As day moved on this deepened into a hue so intense even the Tibetan sky paled in comparison. A light breeze ruffled the surface into glinting ripples that flashed diamond reflections back at the sun; gentle wavelets began to lap the smooth-pebbled shore. As the sun heated the lake's vast expanse, water vapour flowed invisibly from the surface to the sky. Clouds were born from the depths, and the lake absorbed and magnified their power to become a storm-tossed, raging sea. By mid-afternoon breakers would be crashing onto the beach, their raw power balanced by the delicate lace of white foam etched onto the glossy surface.

Bird Gompa, Elephant-Nose Gompa, Monastery of the Hailstone Valley, Southern Gate of Head-Washing: their small buildings dot the shoreline of Manasarovar. Originally there were eight monasteries; after the destruction of the Cultural Revolution there were none. Since 1981 five have been rebuilt with government funding and the donations of pilgrims and local people. Once again they offer shelter to pilgrims walking the circuit about the lake.

We arrived at Seralung Gompa on the auspicious day of the full moon to find a monk and layman celebrating an all-day ceremony in the temple, droning prayers from a pile of oblong scriptures. Bell in his left hand, *vajra* (the ritual 'thunderbolt' symbolizing the Absolute) in his right, the monk turned the objects in graceful gestures, shaking a small skin-covered drum as the chant rose to a crescendo. Four times nine butter lamps burned in front of an altar bearing a collection of photographs of Tibet's exiled leader, the Dalai Lama; lacquered masks stared from the back recesses. Seralung was rebuilt three years ago, in a location slightly west of the old monastery. The external trappings of religion have been replaced easily enough but, as in most of Tibet, the human element has proven more difficult. The head monk reciting prayers, Kunchok Chophel, told us that when he was a boy he lived there with forty monks; today there are three.

As evening fell Rinchen, one of the workers on the new temple under construction, beckoned us into the large kitchen attached to the living quarters of Seralung. A single oil lamp shed light on the collection of faces: a pair of boy-monks, two Nepalis from Limi passing by Manasarovar on their way home, and an ancient withered old woman who sat by the fire spinning her prayer wheel. The Khampa woman in charge of the kitchen bustled efficiently about stoking the fire and pouring out endless cups of tea. Rinchen was busy wrapping lumps of minced yak meat in dough, making what seemed like the best *momo* in Tibet. Waiting for the dumplings to steam we listened to the casual conversation, the crackle of the fire and the squeak of the old woman's prayer wheel. A gust of wind rattled the single small window, increasing the feeling of warmth inside.

After dinner Rinchen opened his embossed silver charm box to add his new photograph of the Dalai Lama to the collection of blessings inside. He was delighted with the way the 'Precious Protector' peered out from the small window, and in exchange presented us with a small fragment of dried fish from Manasarovar. 'Not killed', he insisted – to take life would be a sin – but a gift of the gods washed up on the lakeshore, valued as a powerful medicine. From a small bag he poured a few grains of *chema ne-nga*, five-colour sand, into our palms, which we solemnly swallowed as another blessing.

The next morning sunlight streamed into the kitchen where the Khampa woman vigorously churned goat-milk, sleeves rolled up past her elbows, white flecks spattering her striped woollen apron. With pilgrims, travellers and workers we shared a Tibetan breakfast of a sort found only in a *gompa* – conical dough cakes of barley flour, the left-over offerings from the temple. In Kunchok Chophel's small room for a final goodbye, he draped an extra prayer scarf over Russell's camera bag and knocked forehead with us in a parting blessing. 'Go slowly', 'Stay well'; we exchanged farewells and set off once again over the endless sands.

Colour wove its sorcery around the entire circuit, with burnt-orange bogs and the red of frost-touched brush set against the double blue of sky and lake. The trail took us along the shoreline, where our steps were slowed by gravel and loose sand. All the while the lake seemed to mock our effort; progress was nearly imperceptible measured against its immense scale. We waded barefoot through countless streams, passed long rows of engraved *mani* stones and prostration points where Tibetans bow to the greatness of Manasarovar. Always there was the sound of waves and wind, the murmur of waterfowl, and always there was sweet water from the lake, so clear the pebbles near shore glistened in an invisible liquid.

The shoreline was strewn with the gifts of the gods washed up by storm and wave; strange fish, odd pebbles, seaweed. Along one stretch of beach was Rinchen's five-colour sand, said to be made of turquoise, silver, gold, coral and iron. On the surrounding hills grew medicinal

herbs and fragrant incense. Pilgrims gather all these carefully, for they are holy blessings, in Hindi called *prasad*, with the power to heal many illnesses. Of all the divine gifts of nature the greatest is Manasarovar's clear water, said to possess miraculous healing properties. To raise the head after a long drink was to feel purified inside and out. This was something beyond plain water, more like drinking in light, as if the essential purity of wind, space and sky had somehow been captured and condensed into liquid form.

As if to confirm the lake's holiness, Manasarovar was blessed by the presence of two great mountains. The first was Kailas, its tremendous form towering above lower peaks. The natural swastika etched upon the mountain's southern face was clearly visible from this distance, and I sensed how strongly this ancient symbol of power must have struck the first pilgrims, who interpreted it as a supernatural sign that here was no ordinary mountain, but the abode of the gods.

On Manasarovar's southern shore rose the five sister peaks of Gurla Mandhata. Viewed from Tarchen the great white mountain floated on the horizon like a cloud; from the lakeshore its gently curving summits formed a Sleeping Beauty draped in velvet-smooth robes of sparkling snow. The mountain's Tibetan name is Memo Namgyal, 'Son of Victory', but the spoken language has many variations, so it is also called Memo Nangnyal, after the legendary forests said to have blanketed its slopes, and most lovely of all, Memo Dang Ay, 'She Has Two Fashions' – at times beautiful and peaceful, at others storm-ridden and fierce. This she-mountain is the abode of Lhamo Yang Chen, the region's agricultural goddess; Purang farmers pray to her for rain. Her mountain is destined to become a pilgrimage site according to an ancient prophecy which predicts the arrival of a holy man, who will unlock the mountain's mysteries just as a Tibetan monk did for Kailas a thousand years ago.

Beneath the slopes of Gurla Mandhata stood Trugo Gompa, the 'Holy Head-Washing Gate'. Hindus plunge into the lake for ablution even on the coldest days, for there is a saying that he who immerses completely in Lake Manasarovar earns an incarnation as a god. Tibetans, on the other hand, shun bathing in the lake. 'We don't like to get the water dirty', a pilgrim explained to me. It was enough for them to drink a few mouthfuls of holy water and splash a dipperful on their heads at Trugo.

In front of the gompa a long row of *mani* stones carved with mantra and sacred texts ran along the lakeshore. The full power of the written word struck me as I walked beside it. OM MA NI PA DME HUM – every letter was sacred, each syllable possessed a special meaning beyond that of its sound. The letters were vehicles, containers of thought transporting ideas to a realm beyond ordinary speech. The miraculous nature of writing stays fresh in a land where the alphabet was not introduced until the seventh century. Like art, writing in Tibet is inextricably linked with religion, and great respect is displayed for the written word. Old prayers and scriptures are never tossed away, but carefully placed inside a holy receptacle such as a *chorten*. The Red Guard of the Cultural Revolution struck at the root of this 'superstition', shredding prayer books into shoe linings and using printing blocks to pave roads, but still the power of the word remains.

Prayer flags unfurled their bright colours against the azure of the water, on that day calm and clear enough to reveal schools of small fish darting amid the shadows. A breeze chased fretted patterns on the lake's smooth surface. At sunset three nomad men rounded the curve of the shore, driving a flock of sheep to Purang. They ducked inside a friend's tent while their flock continued on, tailed by a cloud of golden dust. Suddenly a shout came from the tent, and a figure raced away at to speed to head them off, sped by his companion's cheers.

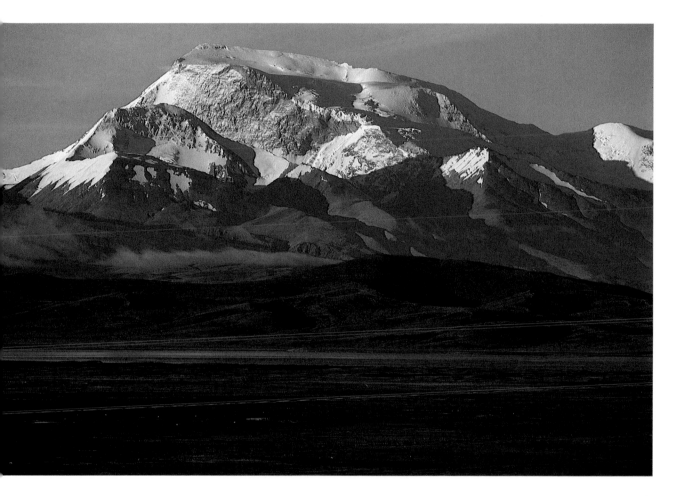

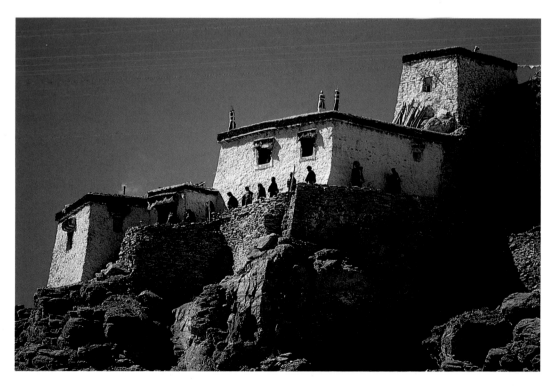

Horned yak skulls and flat stone slabs carved with sacred mantra form a *mani* wall on the shore of Manasarovar (*left*). On the lake's southern shore rises Gurla Mandhata (*above*), at 25,355 feet the third-highest mountain within Tibet. Nomad tents dot the Barkha Plain in the foreground; Raksas Tal appears in the distance. *Right*: A line of pilgrims circles Chiu Gompa before entering its temple for worship.

We met few pilgrims on the *kora*. Our most faithful companions were the migratory waterfowl that stop here on their long flight from Siberia to India. Yellow-billed swans, Siberian cranes, wild ducks and geese had reached their peak by September, and hundreds of birds haunted the small curved lakelet at the southwestern corner of Manasarovar.

Near Gossul Gompa we caught up with a large group of pilgrims of all ages from Gertse. They had come by truck and made the round of the lake in three days, carrying their belongings on their backs and staying in monasteries along the way. When we met them, they were admiring a large fish one of their group had pulled from the water. They were so gleeful at catching the giant holy relic that I refrained from asking whether it was dead or alive at the time of capture.

We joined the group for tea on the beach, then walked together the last few miles to their truck, which was waiting for them beneath Chiu Gompa. The crowd straggled out along the shore collecting seaweed and rocks, looking hopefully for another holy fish. We veered inland and crested over a steep hill, and Chiu Gompa – 'Bird Gompa' – appeared perched atop a pointed summit, streamers of prayer flags cascading down from three *chorten* at the very top. The white building atop painted cliffs was like a fairytale castle, a Tibetan Mont St Michel. The earth around the trail was littered with rocks as gaudily coloured as pottery shards from a kiln, brilliant fragments of pink, purple, rose and blue stacked up into cairns.

Past Chiu the trail split into two paths. One ran along the top of steep cliffs; the other, following the shore at their base, was so narrow we had to wade into the lake in places to pass around protruding outcrops. The cliffs were honeycombed with small caves patiently carved out of the rock by hermits, Buddhist and Hindu, who had come to absorb the immensity of the lake and listen to its wordless voice. I thought of them living in their tiny cells, seated on the lakeshore in meditation for hours, days, years. They took the lake's vast shifting expanse as a guide to plumb the depths of consciousness, using the exterior landscape as a visual metaphor for an interior realm. Like mind, Manasarovar is all-encompassing and capable of infinite moods, and the endless dissolution and recreation of thoughts is mirrored by the clouds which rise from the lake's depths, only to water them again with rain.

These meditators possessed the key to the mysteries of the lake. Its secrets are fathomable only after long sitting, attuning oneself to the depths and purity of this immense liquid mirror on the roof of the world. Ancient scriptures tell of the treasures of Manasarovar. In its centre grows the magical Tree of Life that marks the navel of Jambudvipa, our earthly world. The tree's fruit ripens into gold and drops into the clear deep waters, transmuting them into an elixir of immortality. The tree is invisible to mortal eyes, a metaphor for the intangible treasure contained in Manasarovar's depths. The lake's ultimate value lies in its role as a symbol, a key unlocking the hidden depths of consciousness which hold the ultimate treasure. Like Kailas, Manasarovar is no more than a means of approach – not an end in itself, but a support for an experience too deep to be contained in words.

An Indian *saddhu*, a holy man from Ramakrishna Ashram near Calcutta, performs his ritual ablution in the lake. Complete immersion in Manasarovar is believed to ensure an incarnation as a god.

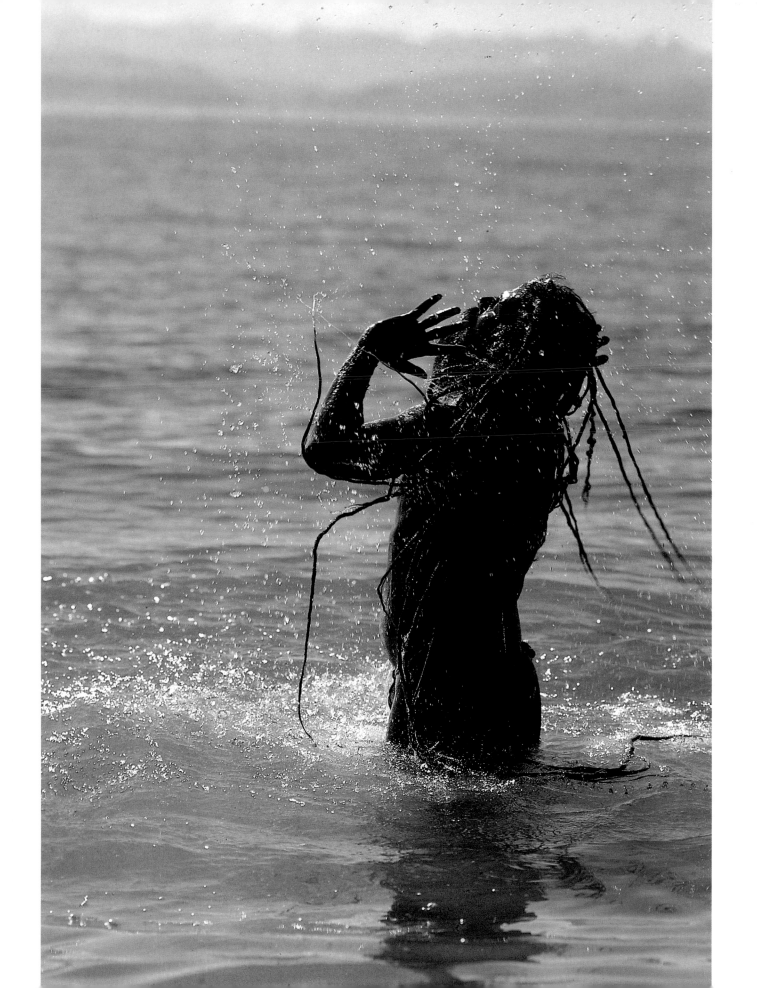

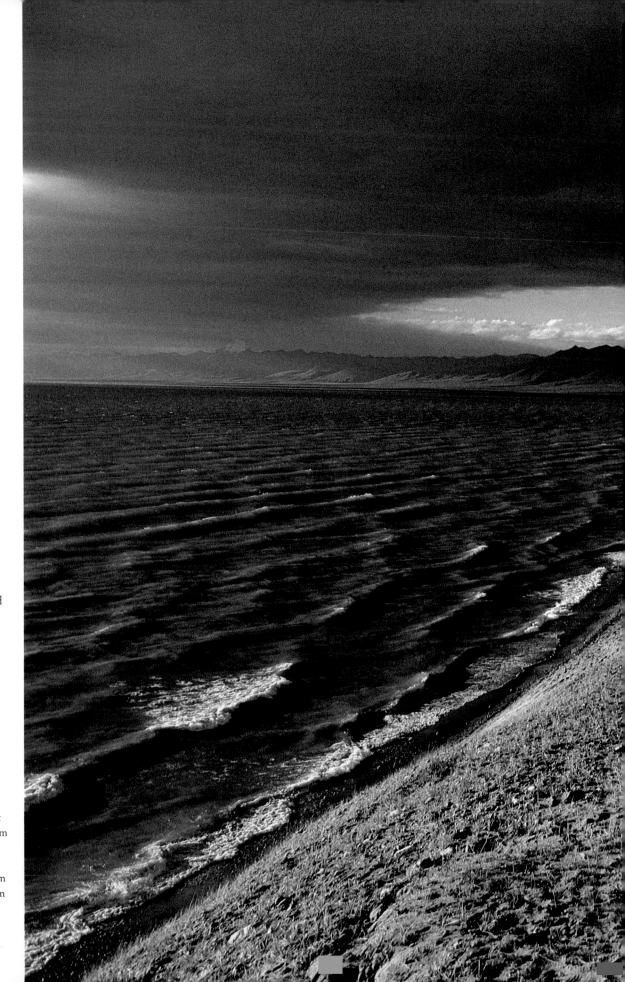

Afternoon winds churn waves from the depths of Manasarovar, transforming the lake into a storm-tossed inland sea. Seralung Gompa appears on the right. Hindu legend says Brahma created the lake as a reflection of the depth and power of his mind, *manas*. It is an inexhaustible treasury of colours and moods. A thousand years ago the Tibetan yogi Milarepa praised Manasarovar in a song, in which he calls the lake by its Tibetan name: 'The fame of Mapham Lake is indeed far-spreading: people say of it in distant places, "Mapham Lake is like a green-gemmed mandala!" . . . The water falling in it from the heavens is like a stream of milk, a rain of nectar.'

50

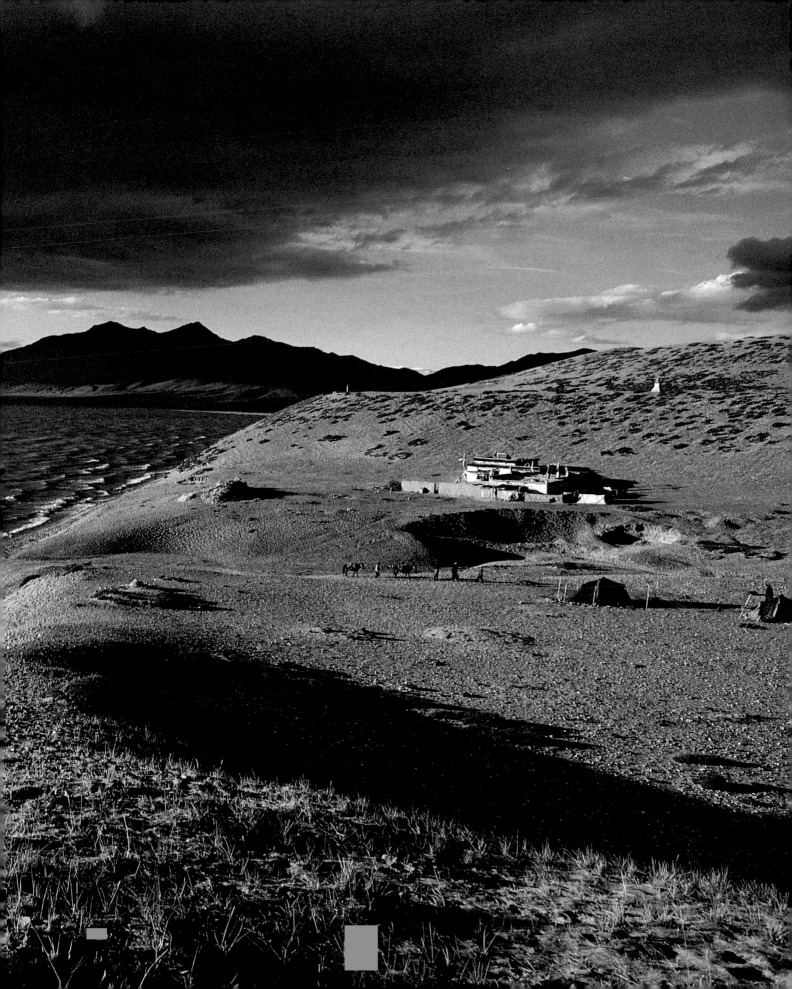

A small band of travellers (*below*) takes a shortcut, moving counterclockwise along the eastern shore of Manasarovar towards Seralung Gompa. Because their passage is against the auspicious 'right-hand' Buddhist path, they earn no religious merit from their walk along the lakeshore. Compared to the parade of devotees circling Kailas, few pilgrims complete the sixty-four-mile circuit of Manasarovar: the lake's tremendous scale swallows up any sense of progress. Most pilgrims are content to worship in a brief ceremony on the western shore before journeying on to Purang or Kailas.

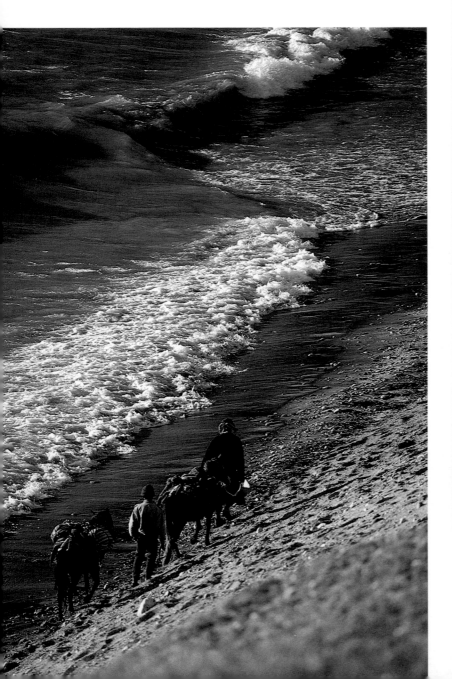

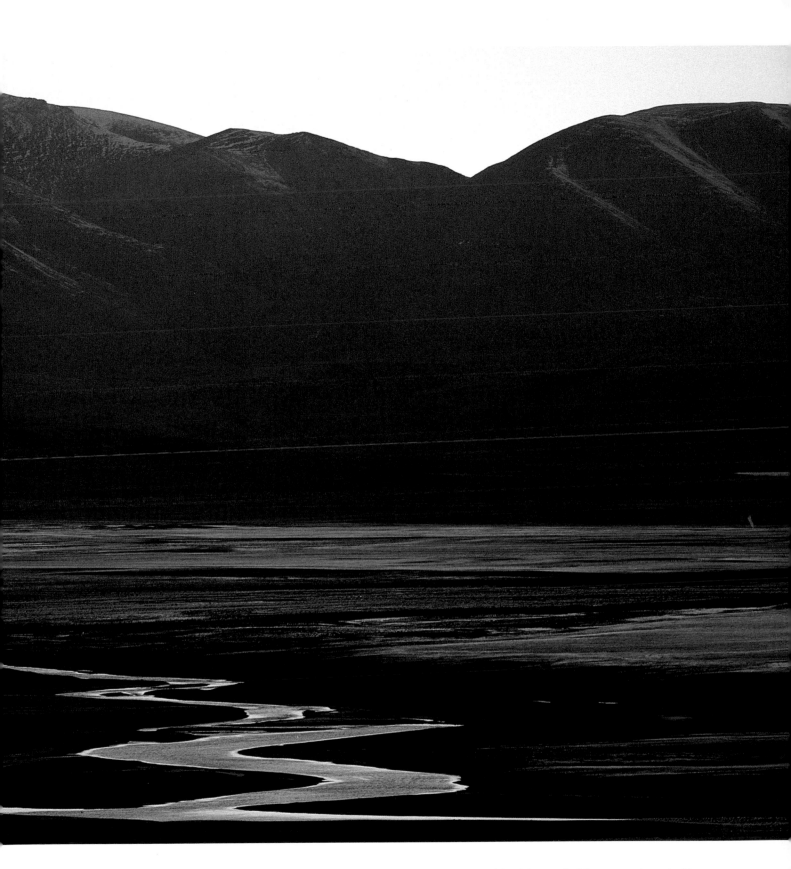

Legend says a golden fish tunnelled the zig-zag channel of the
Ganga Chu connecting Manasarovar to its dark twin lake,
Raksas Tal. The water level of the channel fluctuates with the
season and the year. It was dry for most of the last century,
causing explorers to question its very existence.

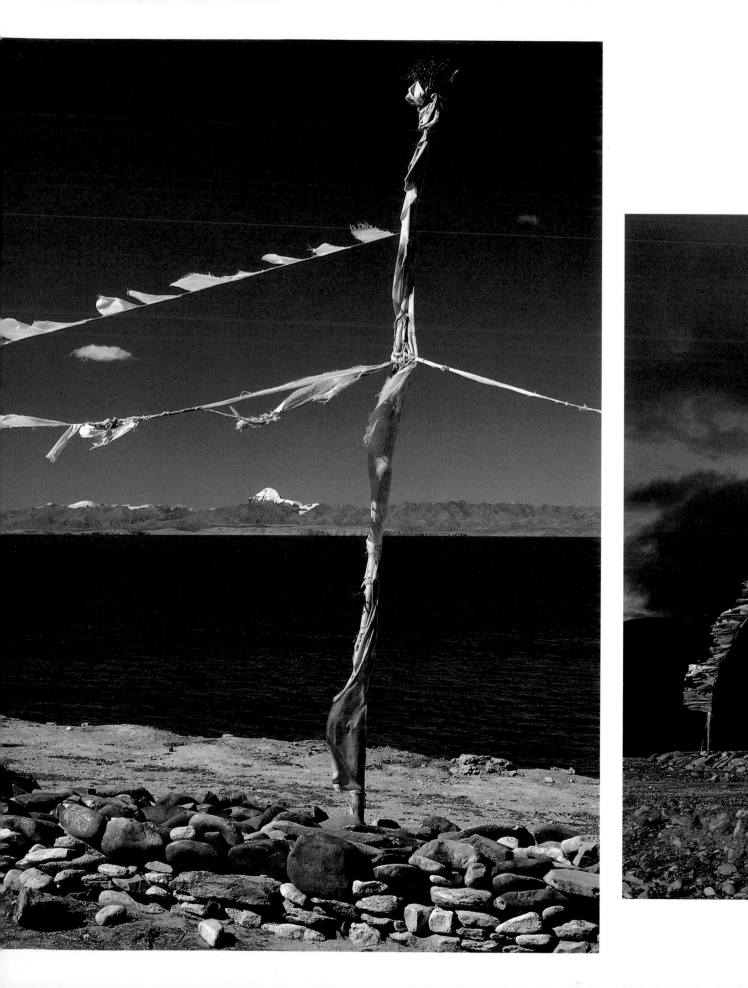

Man-made symbols pointing to a greater reality mark the shore of Manasarovar. *Left*: With every flutter, prayer flags at Trugo Gompa release their blessings to the wind. The flags are printed with auspicious prayers and the image of the 'Wind Horse', which carries on its back the flaming jewel that grants all wishes. *Below*: Evening and storm collide at a *chorten* at Horchu on the north end of the lake. Originally a reliquary mound, the Buddhist *chorten* (in Sanskrit, a *stupa*) has become a means of salvation in itself: circumambulating the monument brings great religious merit. It is the physical representation of the Buddha's Body, sanctified by the holy images, relics and writings placed inside its hollow interior.

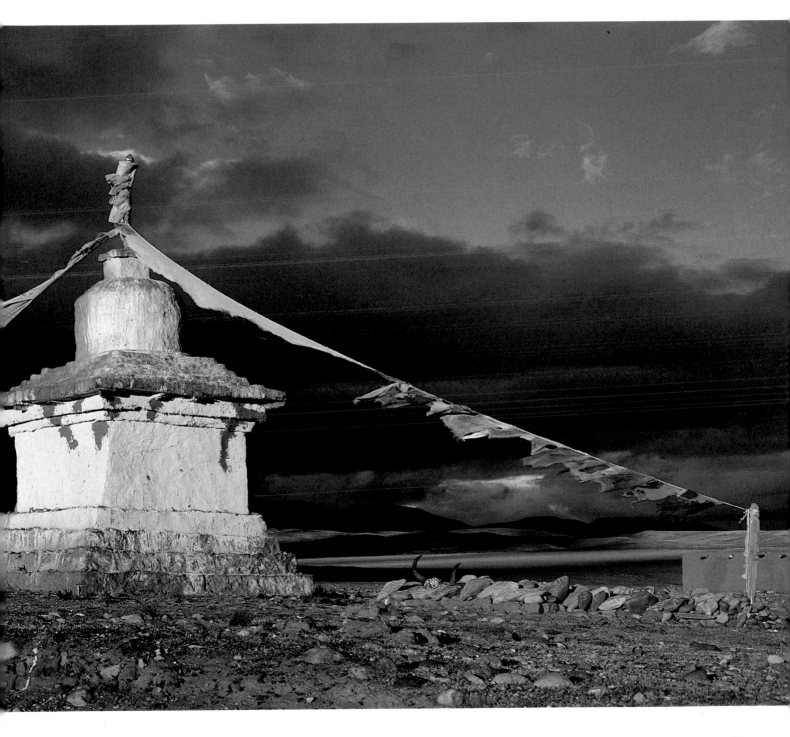

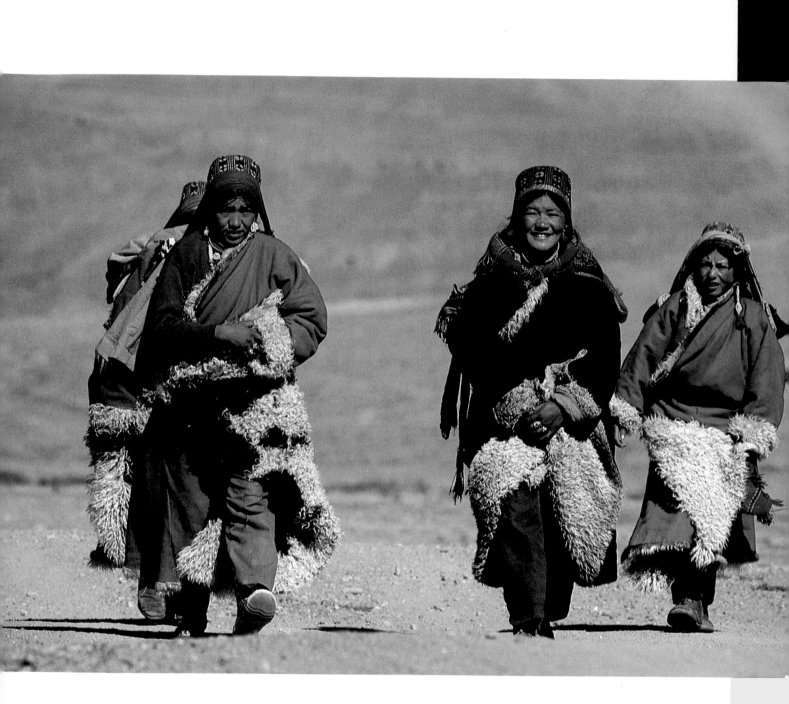

After the barley harvest is finished in September farmers
come to Kailas for their annual pilgrimage. Too impatient to
wait for a slow truck, these women from Purang set off on foot
to the mountain, a three-day journey for determined walkers
such as these.

56

4 Nature's Grand Mandala

'Verily, verily it was a natural mandala . . . the things mentioned in the scriptures cannot be seen with our mortal eyes.' (Ekai Kawaguchi, *Three Years in Tibet*)

The journey began long before daybreak. We dressed by candlelight and stepped out into the immense silence of the night. The trail began at the Tarchen *chorten*, marked by a narrow border of white stones. After a half-mile the line dwindled and vanished, and I strained to untangle the path from the shadows. Above gleamed more stars than I had ever seen, extravagant handfuls spangling the midnight fabric of sky. Each time I raised my eyes, another light was arcing across the velvety blackness: the heart-stopping slow slide of a shooting star, so many it seemed the heavens were raining fire.

On earth too a light moved; the lamp of a lone pilgrim, an old Tarchen woman bound, she told us, on the sixtieth *kora* of her life. For a long while I walked beside her, listening to the low hum of her mantra, trying to sense her life, her beliefs, what moved her to make this difficult circuit in a single day. She walked through the shadows led solely by faith, following a circle of tradition in which each pilgrim and every step forges a new link. The rock cairns lining the way were silent testimony to the generations gone before, the stones placed as a guide and a blessing for those who followed.

We walked without pause for three hours before dawn began its silent approach. Gradually, slowly, the sky lightened; the clouds streaked blue and violet, then brightened in the north ahead into ribbons of rose and gold. The shapes of mountains became distinct, awakened from their nightlong vigil. A fresh light breeze lifted the air and I stopped to catch the quickening changes. New light reflected off pools on the valley floor, mirroring clouds and mountain. The grey landscape shaded into delicate pastels, then, so imperceptibly that the exact moment of change could never be pinned to 'now', the full spectrum of colour blossomed from earth, and it was day. We were ten miles into the heart of the Kailas *kora*.

Kailas' thirty-two-mile pilgrim path begins at Tarchen, where a range of buttressing hills hides the mountain from view. The route runs westwards through a land of dry scrub and golden dust. To the left unfurls the Barkha Plain, a smooth flat canvas of earth dappled by shifting cloud shadows. Far in the distance the land crests into waves of mountain ranges which continue for nearly eighty miles, until the jagged peaks of the Himalaya rise in an abrupt barrier.

The path skirts the northernmost edge of this vast expanse. Countless heaps of stone piled up by pilgrims mark both sides of the trail, offerings that clear the way for those who follow. The cairns multiply as the path climbs a slight rise and swings to the north. Here Kailas makes its appearance, and all bow before the sight at the first of the path's four *chaktsel gang*, prostration stations that anchor the pilgrim route with prayer.

The mountain's white cone glitters like a great ice-diamond in the sky. The intense light and clear air give it a brilliance rivalling the mythical Mount Meru, 'the Mountain of Blazing Appearance' as the Aryans called it. The sight recalls the splendid description of Meru in the *Mahabharata*: 'Kissing the heavens by its height, shining like the morning sun and like a fire without smoke, unmeasurable and unapproachable by men of manifold sins.'

As I drew slowly nearer up the narrow valley, the feeling of penetrating a sanctuary was intensified by the utter silence. Months in Tibet taught me the immensity of true silence. It is not tranquil and soothing as we like to imagine it – that is merely quiet, its vastness reduced

by a comforting murmur of sound, birdsong or wind-rustled leaves. In the sweeping emptiness of Tibet these familiar props are stripped away, and one is confronted with a stark and total absence of sound, dizzying in its purity. The ears ring, straining for reassurance, but there is nothing, a void, and the feeling heightens with each step that one is entering into an unknown realm.

The silence deepened, and then the birds came – also, oddly, silent; only the sound of wings cutting through the air. For the first time I *heard* the differences of flight: the heavy slice of a raven's wing, the hawk's single controlled ruffle of wingtips, the whir of a flock of tiny finches rising as one from the brush. Their fluttering wings reflected light like bits of silver paper tossed into the air, like the small printed paper squares Tibetans toss at the top of mountain passes, offering their prayers to the wind.

On certain days the leaden flap of vultures' wings breaks the hush. The sight of one wheeling overhead draws two, then more, until an entire flock circles lazily above. They alight atop a flat-topped cliff rising at the head of the golden meadow. Here in the shadow of Kailas, the sky burial ceremony is performed when a death occurs among local people. Bodies are ritually dismembered and fed to the birds in a last act of compassion, a final offering to living beings.

Below the cliffs rises the thirty-foot flagpole of Tarboche, a brilliant fluttering mass set against black-shadowed canyon walls. Pilgrims parade about it in single file, a wheel of ritual beneath the mountain, while prostrators stretch out on the path around it, inching about more slowly. Nearby the sun-moon pinnacle of Chorten Kangnyi glows in the slanting light. The monument's ochre-stained body and slender spire counterbalance the snowy bulk of Kailas rising above. Colour and form speak more clearly than words of the presence of a holy place to which this *chorten* is the gateway.

The real journey begins here, as the pilgrim passes beneath the 'Two-legged *Chorten*' to receive its blessings and enters the Lha Chu Valley, the Valley of the River of the Gods. The air is charged with a growing expectancy; one senses immediately this is a realm where everything is somehow more than it appears. The rock cliffs carved with mantra inscriptions, the streams that water the lush meadow and the wildflowers starring its long grass – these are rock, water, blossom and something more; in the heightened reality the pilgrim moves in, they are manifestations of the Infinite, and those who sense this unwittingly follow the instructions of the *Demchog Tantra*, the text of Kailas' highest divinity:

> One should regard oneself and all that is visible as a divine mandala . . . every audible sound is to be regarded as mantra and every thought arising in one's mind as a magic manifestation of the Great Wisdom.

To see every thing as sacred, to recognize whatever occurs as a step on the spiritual path; this is the goal of Tantra, and it comes of its own accord here, a place where nature has set divinity in tangible form. From the valley floor I looked up in wonder at the cliffs that lined both sides, their towering walls of soft reddish sandstone sculpted by wind and water into a gallery of fantastic forms. Battlements, parapets, terraces and towers were piled atop one another in an extravagant fantasy, 1500 vertical feet of Nature's wildest hallucinations frozen into solid stone. Atop the ridgeline the silhouetted ruins of abandoned cities appeared, only to vanish within the space of a few steps, an illusion of this strangely architectural rock. The scene had all the grandeur and intricacy of a gigantic palace, constructed on a scale far beyond human conception.

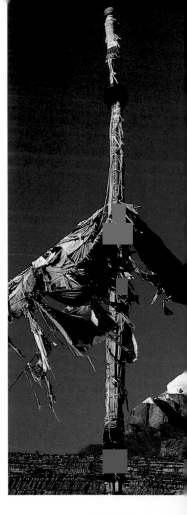

The colour of the rock alone was a sufficient marvel, subtle striations of orange and rose shot with mineral veins of greenish-blue. High up, silvery ribbons of waterfalls laced the sheer rock face. In autumn they would freeze into a solid torrent of icicles, and snow crystals would dust the fretted edges of the rock cliffs, etching strange hieroglyphs.

The total effect was of having entered another realm, and the travellers encountered on the path only increased the feeling of timelessness. Out of nowhere a horseman on a white pony appeared, a long dagger thrust through his sash. 'Tashi delek!' he shouted in greeting, and trotted off, the jingle of the harness trailing behind. From across the Lha Chu came the sound of whistles and shouts, as a nomad family urged forward a flock of pack-sheep loaded with salt for trade in the high remote valleys to the north. A pair of monks from distant Amdo passed by, maroon robes swaying from side to side like the swinging of a bell. Far ahead, the tiny figures paused to adjust their loads and tramped off again into the vastness of the canyon.

All pilgrims had the same destination, a small ochre building clinging to the side of the massive mountain across the river. Chukku Gompa, the first of the *kora*'s three monasteries, was the same dusty rose-dun as the rock it seemed to spring from. The mountain it was built into was also a gigantic natural temple, the dwelling of Kangri Lhatsen, the supernatural Protector of the Kailas region. In the past he was known to manifest in the bodies of certain men 'close to his heart', in an oracular tradition passed down from father to son. Today the oracle is silent, but Kangri Lhatsen is honoured in a special small shrine of Chukku set off from the main temple. Like all such *gonkhang* devoted to fierce deities, its doors are shut to women; laymen enter only on special occasions.

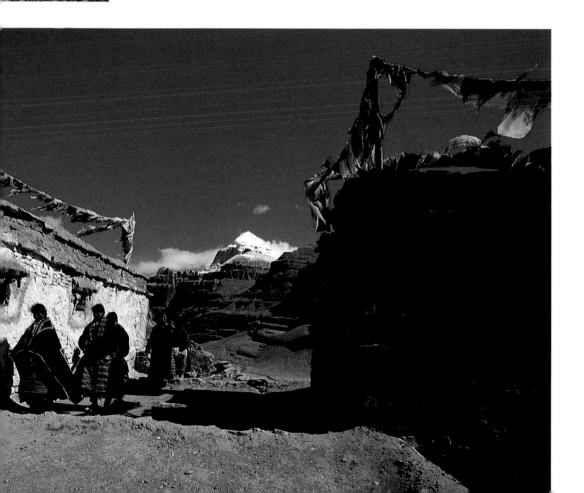

The flagpole of Tarboche (*top*) is raised every year on the full moon of May to commemorate the anniversary of the Buddha's birth, Enlightenment and death. *Left*: Pilgrims circumambulate Chukku Gompa. The ochre building at right is the temple of Kangri Lhatsen.

The path to the *gompa* twisted uphill through a maze of multi-coloured boulders carved with mantra. At the very top waited a woman; silver coins braided into her hair identified her as a Golok, one of the nomadic tribespeople of northeast Tibet. Three children dressed in miniature *chuba* peered solemn-eyed from behind her skirts. We sat together on the temple steps and she talked of her long journey. It had taken her nearly a year to reach Kailas, and she listed the pilgrimage sites visited along the way: Lhasa, Tsari, Samye, Sakya . . . The litany of sacred place-names evoked a vision of an invisible net of pilgrim paths flung over Tibet, distant places linked in an unseen web of power. As we talked the children lost their shyness and began to play, pitching pebbles over the edge of the terrace and giggling as they ricocheted down the steep slope.

Eventually a monk emerged from his quarters to unlock the door of the main temple, the *lhakhang* or 'god-house'. Inside, the dim air was heavy with the scent of incense and melted butter. Pools of light spilled over the edges of silver butter lamps into the darkness. The walls were lined with silver *chorten* and gilded images – all that remained of the treasures of Kailas' six monasteries, gathered together here when Chukku became the first *gompa* to be rebuilt after the Cultural Revolution. Niches on the back wall held the 108 brocade-wrapped volumes of the Kanjur, the records of the Buddha's speech. As the woman circled the temple the children imitated her actions, bowing their heads against the holy scriptures.

At the centre of the room on the main altar a single image sat amid ivory tusks and peacock feathers, its features nearly buried by a blizzard of prayer scarves. The squat white figure was utterly unlike the serene gilded Buddhas usually found in Tibetan shrines; with its topknot and almond eyes, it faintly resembled the Tirthankara images of Jain desert temples. Its blank-eyed stare was oddly disturbing; it seemed alien, out of place among the ritual Tibetan paraphernalia surrounding it. The Golok woman prostrated three times before the statue, then stood a long moment hesitating. Slipping off her bright necklace of polished stones she handed it to the monk, who draped it over the image in offering.

This statue is called Chukku Rinpoche after the Gompa's sixteenth-century founder, but its legend goes back even further, into the timeless realm of myth. From the cloudy waters of a Milk Lake in India's Lahoul region seven white images were magically self-born. One of these made its way to Kailas, where it was enthroned as the central treasure of Chukku Gompa. 'Outside, what is important is Kang Tise [Kailas]', an old saying has it. 'Inside, Chukku Rinpoche is the most important.'

The presence of this strange statue seems to inspire a climate ready for miracles. In addition to it, the *gompa* possesses a silver-inlaid conch shell magically flown from Lake Manasarovar and an immense copper vessel said to have been brought from India by the Buddhist missionary Tilopa. These three objects represent the Buddha's Body, Speech and Mind; their union is a sign that religion will flourish in Tibet. The Cultural Revolution scattered the treasures of Chukku; later the image and the conch were returned, but the copper bowl had disappeared – stolen, perhaps, or melted down for scrap metal like so many other precious artifacts. Then, in 1985, on the day of a religious festival, the vessel of the Buddha's Mind appeared in a cave beneath the gompa. 'We looked there many times before without finding it', the monk told us. 'It was Kangri Lhatsen who reunited the three treasures', he added with conviction. And like the thick ice cap crowning Kailas and the deep waters flowing in the Ganga Chu, this is taken as an auspicious omen that the Buddhist Dharma, the Way, will again flourish in Tibet.

Watching the pilgrims' spellbound faces as the monk told his magic tale, I marvelled again at how easily Tibetans seem to slide between different realms of reality. A tale of the

incredible is related in the same matter-of-fact tone as a comment on the weather, and is accepted with the same trust. To challenge such statements is out of place in Tibet, where philosophy and faith combine to blur the boundaries of the possible.

This is a land where the supernatural naturally resides, and the veil separating ordinary reality from other realms draws even thinner at Kailas. As the trail moves northwards up the Valley of the Gods, the miraculous and the natural continually meet and merge, until the distinction between legend and fact, belief and truth, wavers and finally melts away altogether. A natural hollow scooped into the rock becomes 'Milarepa's Food Bowl'. On the opposite bank, the wind-whipped waterfall plunging 800 feet straight down in a twisting spiral is the tail of the legendary horse of the legendary King Gesar of Ling. Guru Rinpoche's gigantic *torma*-cake offering to the deities of Kailas is frozen in the form of a massive rock dome; nearby, Hanuman the Monkey King, a Hindu creation, kneels atop the ridgeline in homage before Shiva's throne.

The surrounding mountains themselves are temples, gigantic natural shrines with a grandeur that readily evokes unseen presences to inhabit them. The Three Long-Life Gods, the Sixteen Sattvir, the Seventy-Two Palgun – legions of supernatural beings dwell in the cliffs and summits, invisible but sensed by pilgrims who pray to each. Old prayers to Kailas run on with pages of listed deities:

> . . . On the right, at the palace like a victory banner
> I pray to the deities of Chenrezig.
> Behind, at the palace like a white silk hanging
> I pray to the one thousand Buddhas of the good Kalpa.
> On the left, at the crystal palace of small snow
> I pray to the deities of the Medicine Buddhas.
> In front, in the palace like a mount of jewels,
> I pray to the deities of the five hundred Arhats . . .

This traditional prayer is still recited today, not just to increase the pilgrim's store of religious merit, but for the benefit and liberation of all sentient beings:

> With an unchanging mind I have faith
> I prostrate in homage and do circumambulation . . .
> Bless us so that we have the power to do limitless good to beings
> Bless us so that we are bound to act for the supreme liberation of beings
> Bless us so that we accomplish both our own and others good.

In this rich forest of symbols, the narrow categories of legend and fact, belief and reality cannot encompass the whole. The immense pantheon of Tibetan Buddhism springs from the philosophic concept of Emptiness, *tongpanyi*, said to be the ultimate reality. When all appearances are empty of inherent being, how can one draw lines between illusions? The deities dwelling in their mountain temples and the blue-skinned, twelve-armed Demchog enthroned atop Kailas are at once as real as the solid rock of the mountain's summit, and as illusory as the 'self' that perceives all of this.

What makes it real is the perception, the belief, and this pilgrims have in full measure. Upon a strangely shaped boulder they sit in the 'Saddle of Faith' to pray for a high rebirth in their next incarnation. They bow before a natural image of the fierce protector Tamdin

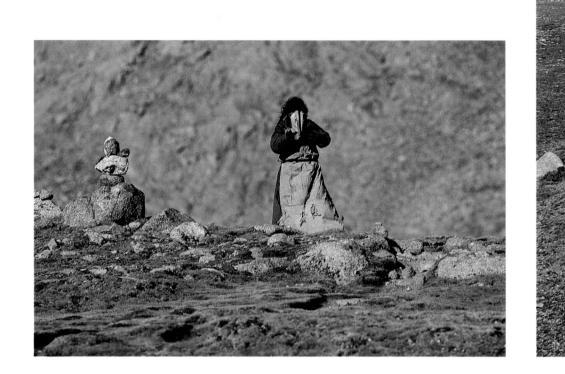

etched on a black boulder, and move on to circle the footprint of a Buddha embedded in a stone slab. The route is lined with reminders of a spiritual reality, signs left by gods and Buddhas and holy men of such power that the rocks they stood upon still bear the imprint of their feet. Each time I made a circuit I discovered more of these places, head and hand and footprints being circled or bowed to or rubbed with butter. There are so many it seems impossible for a single pilgrim, however devout, to tend to them all in a day; and on a one-day journey the multitude blurs into a single overwhelming impression of sanctity and power.

Four Nepali women, Buddhists from a remote northern border region a week's walk south of Kailas, were circling the heap of stones that marked the second prostration station. They paraded about three times then began their bows, rising and falling in ragged unison like waves breaking on a shore. Hands rose, folded, to touch forehead, mouth and heart in quick succession; the women knelt and stretched out full-length face down on the ground until the eight points – knees, stomach, chest, mouth, forehead and hands – touched the earth, and they rose and repeated the process. It was a complete offering of the self, uniting

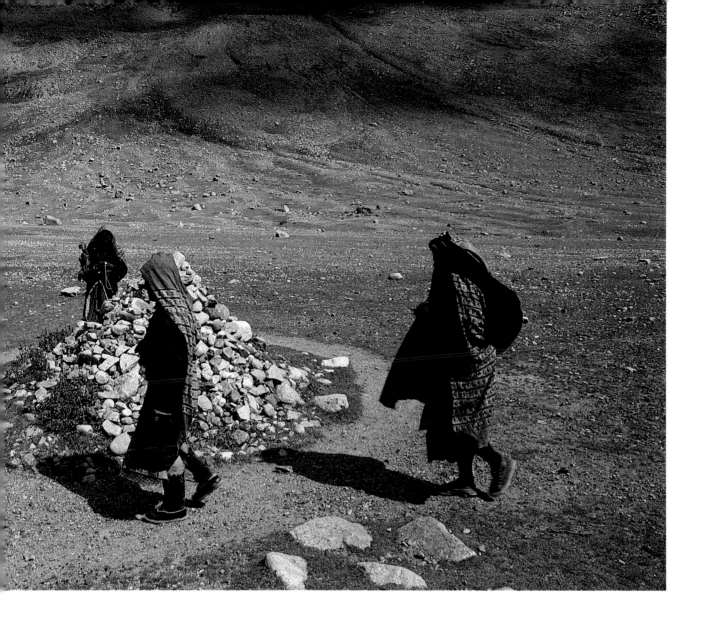

body with earth in total submission before Kailas, which rose up here from encircling bands of ice and rock like Saturn surrounded by its rings. A little further down the trail the north face appeared in profile. To glimpse two of the mountain's four sides at once gave the impression of a faceted jewel, the 'rock-crystal *chorten*' of Bon legend.

Here the *kora* path turned eastwards in its great circle, following the curve of the Lha Chu. In abrupt contrast to the sandstone fantasy left beind, the northern valley was granite, all rounded forms of grey. Like a mandala design, Kailas is four-sided, set within the circle of its pilgrim path; and like a mandala each of its four faces has its own uncannily distinct character. Lama Govinda compared them to the symbolic figures of Dhyani Buddhas, each of which is associated with a particular colour, mantra, element and psychic centre in the human body. The pilgrim who walks around the mountain experiences the equivalent of a spiritual rebirth', he wrote.

He approaches the mountain from the golden plains of the south, from the noon of life, in the vigour and full experience of life. He enters the red valley of Amitabha in the mild

In an act of supreme devotion, some pilgrims prostrate themselves the entire thirty-two-mile path around Kailas. Protected by a canvas apron and wooden mitts, a Bonpo woman (*opposite*) raises her hands before sliding down into a full-length prostration, one of more than 20,000 she will perform in her two-week circuit of the mountain. *Above*: Nepali women circle a rock cairn marking a *shapje*, one of four footprints of the Buddha along the pilgrim trail.

light of the sinking sun, goes through the portals of death between the dark northern and the multi-coloured eastern valleys when ascending the formidable Dolma La . . . and he descends, as a new-born being, into the green valley of Aksobya on the east of Kailas . . . and again emerges into the open, sunny plains of the south, assigned to the Dhyani Buddha Ratnasambhava, whose colour is that of gold.'

At the heart of this great spiritual diagram rises Kailas, its appearance constantly changing, its presence pervading the entire region. Of the mountain's infinite variety of forms the most splendid is the north face, a sheer-walled monolith rising 5000 feet straight up like a gigantic temple hewn from rock and ice by supernatural hands. 'The grandeur and sublimity of the view and the spiritual atmosphere pervading there is simply indescribable', Swami Pranavananda wrote in his guidebook. Two smaller sentinel hills flank the tremendous pyramid, their balanced forms complementing its symmetry.

Directly across from this vision stands Dirapuk Gompa, built in a setting to awe the spirit. On this spot Tantrik initiates meditate on Demchog's Mandala of Supreme Bliss, hoping to gain a vision of their devotional deity, be it Shiva or Buddha or any of the legions of presences who inhabit the region. Ordinary pilgrims know little of such mystic practices, but they too are awed by the mountain's holy presence and repeat their mantras all the more fervently. In a dirt-floored room of the monastery they share a simple meal and sleep under their sheepskin *chuba*, while outside Kailas glows in unearthly beauty in the cold moonlight.

One evening I sat alone atop the flat roof of Dirapuk, watching dusk's slow slide into night. Darkness pooled in the valley's crevices and spread in an inky wave to lap against the circles of light cast by nomads' campfires. More fires were kindled; they seemed to call forth answering lights from the sky as stars pinpointed the darkness overhead. Atop the monastery I felt suspended between earth and sky; warm flames below, cold fire above.

Between the two realms Kailas rose in icy silence, power etched upon its broad rock face in an inscrutable statement. For a few minutes I tried to reduce somehow that tremendous vision into words. Then I laid my notebook down. The mountain possessed a self-contained reality that rendered it impervious to all attempts to describe or explain. It was as impenetrable as the adamantine *vajra* which to Buddhists symbolizes the Absolute.

The mountain was perfect, perfect beyond the right of any natural thing to be, and the deliberateness implied in its form pointed to a higher reality – a realm which man in his imperfection cannot directly approach, and so must resort to symbolism to speak of the unspeakable. It is perfect, but we are not, and so it is a statement only dimly comprehended by our present minds, a power sensed yet unarticulated, inaccessible to reason. Words can never contain the immensity of such an experience; they only reduce its integrity. In the icy moonlight the mountain glowed with a beauty beyond human reassurance, something deep and cold.

Kailas viewed from the shore of Raksas Tal. According to *Kangri Karchak*, an old pilgrim guide to the region, the Kailas area is 'the centre of all countries, the roof of the earth, the land of jewels and gold, the source of the four great rivers, dominated by the crystal pagoda of Kailas and adorned by the magic turquoise disc of Manasarovar'.

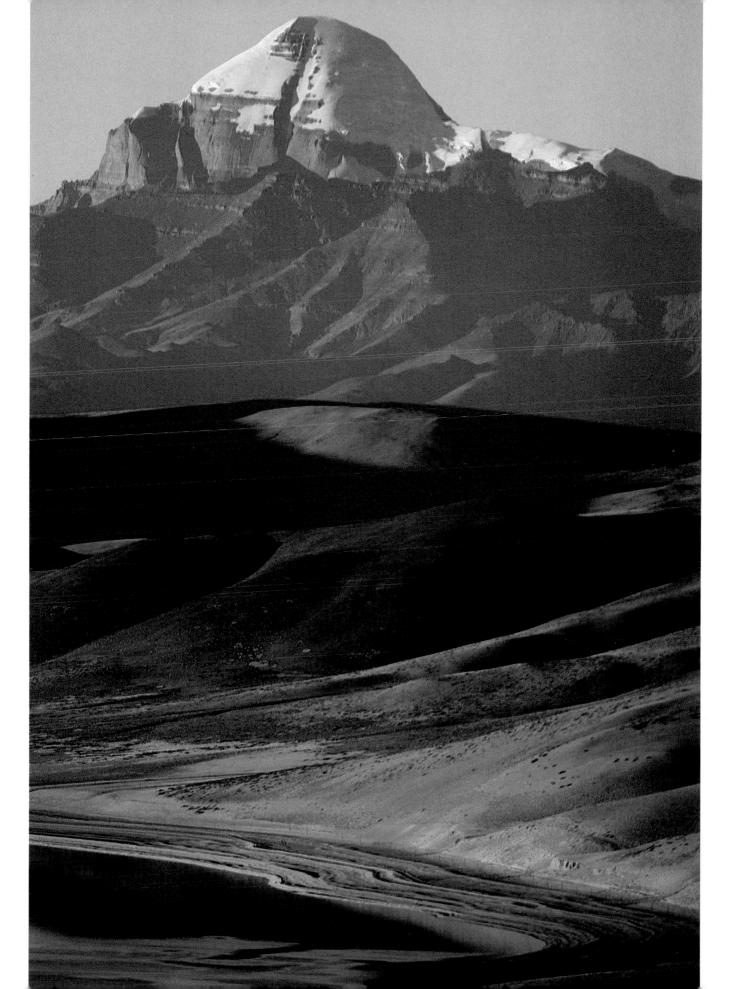

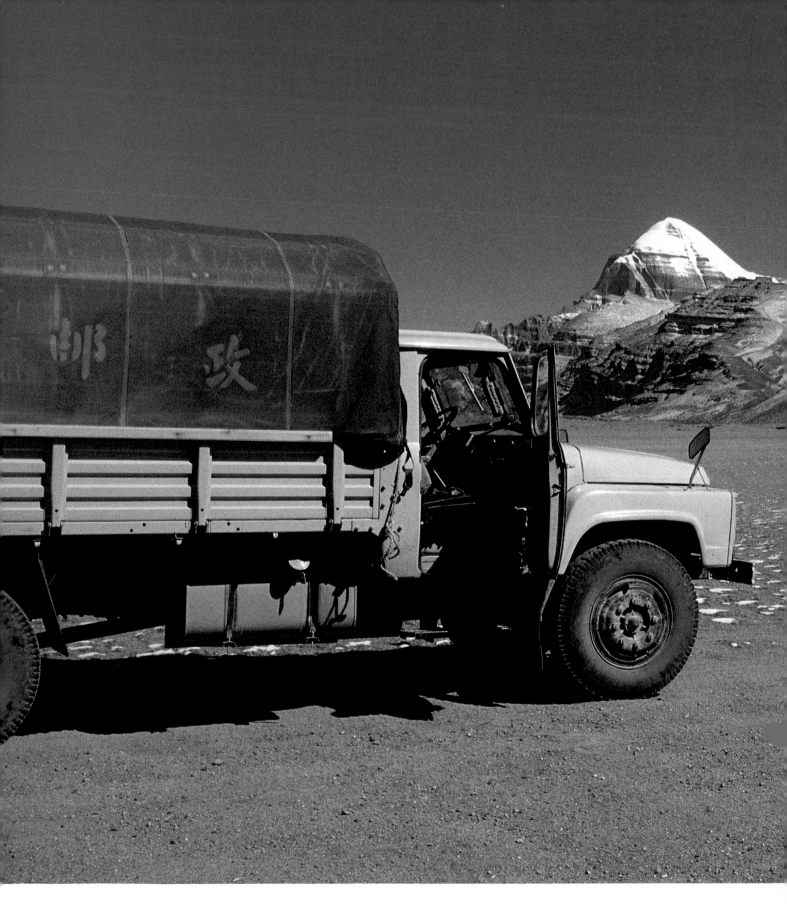

This truck has halted at the first sight of the holy mountain to allow pilgrims to prostrate in homage by the roadside. The appearance of Kailas crowns their religious aspirations with a tangible reward: a vision of divinity incarnate in a

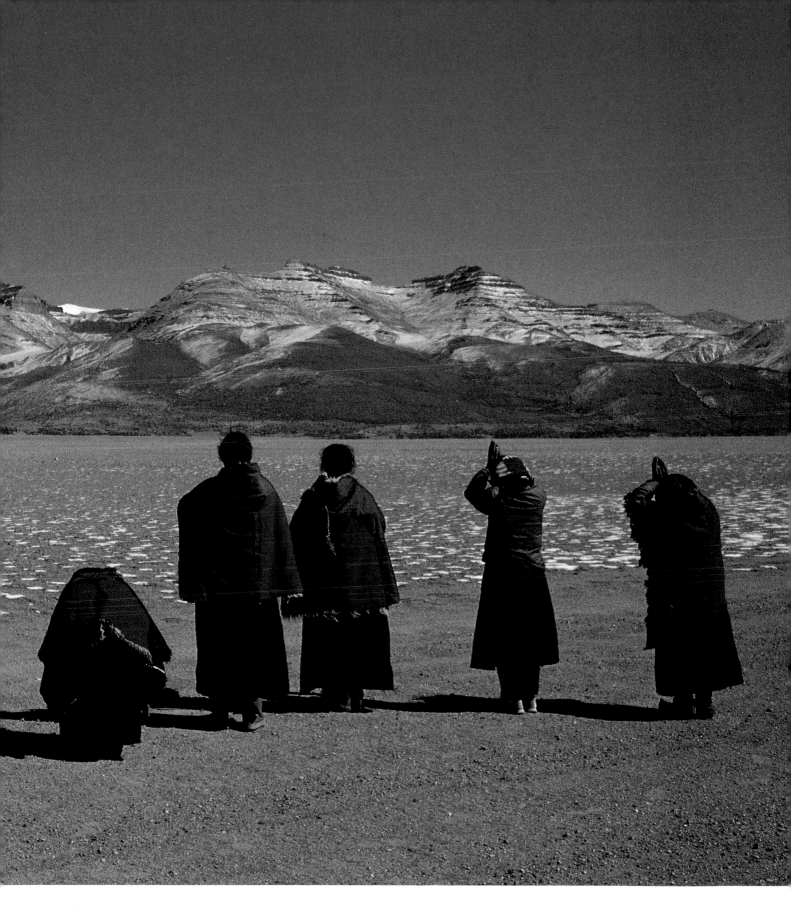

mountain of rock and ice. Just to see Kailas is a blessing; to circumambulate the
mountain once is said to erase the sins of a lifetime.

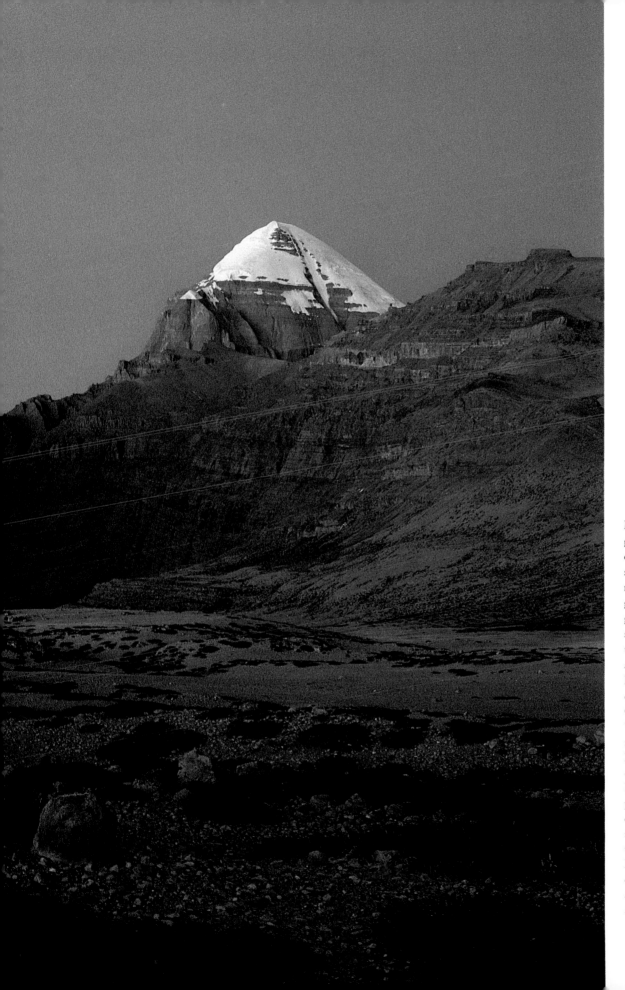

Evening light glows on the great gateway to the Valley of the Gods on the west side of Kailas. The mountain's regular form gives it the appearance of a gigantic natural *chorten*; surrounding valleys allow it to be circumambulated like a *chorten*, increasing its holiness. *Overleaf*: Nomads drive a herd of sheep past Chorten Kangnyi, the 'Two-legged *Chorten*' marking the entrance to the Lha Chu Valley. The circuit of the mountain is believed to bless and protect the sheep against disease. The *chorten* and the *mani* wall before it are kept to the right out of respect. Early explorers noted how even Tibetan pack animals automatically passed sacred objects on the left.

69

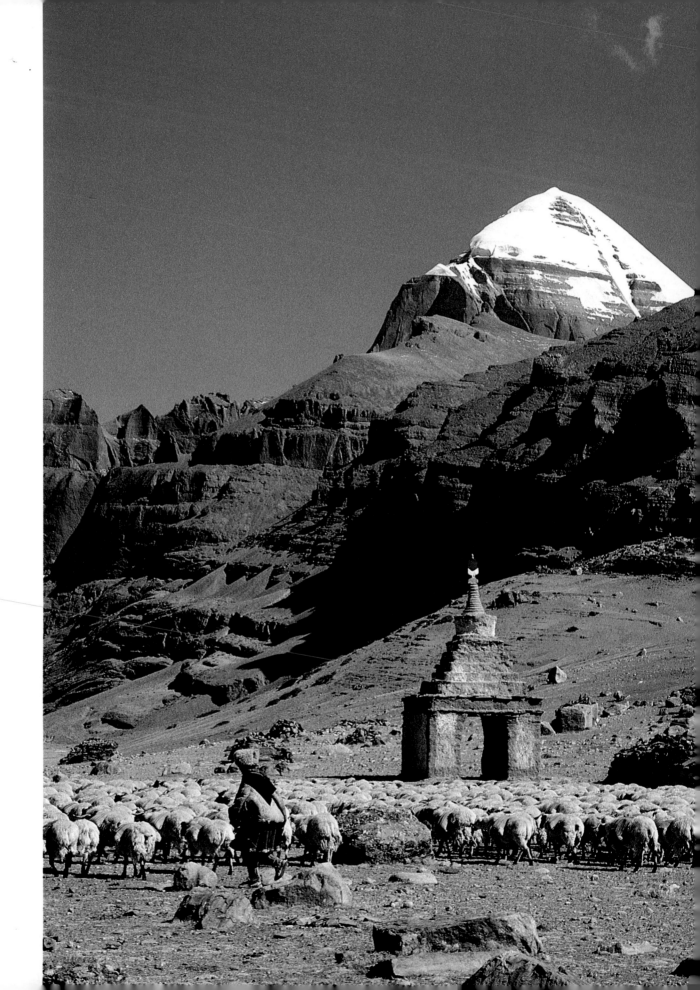

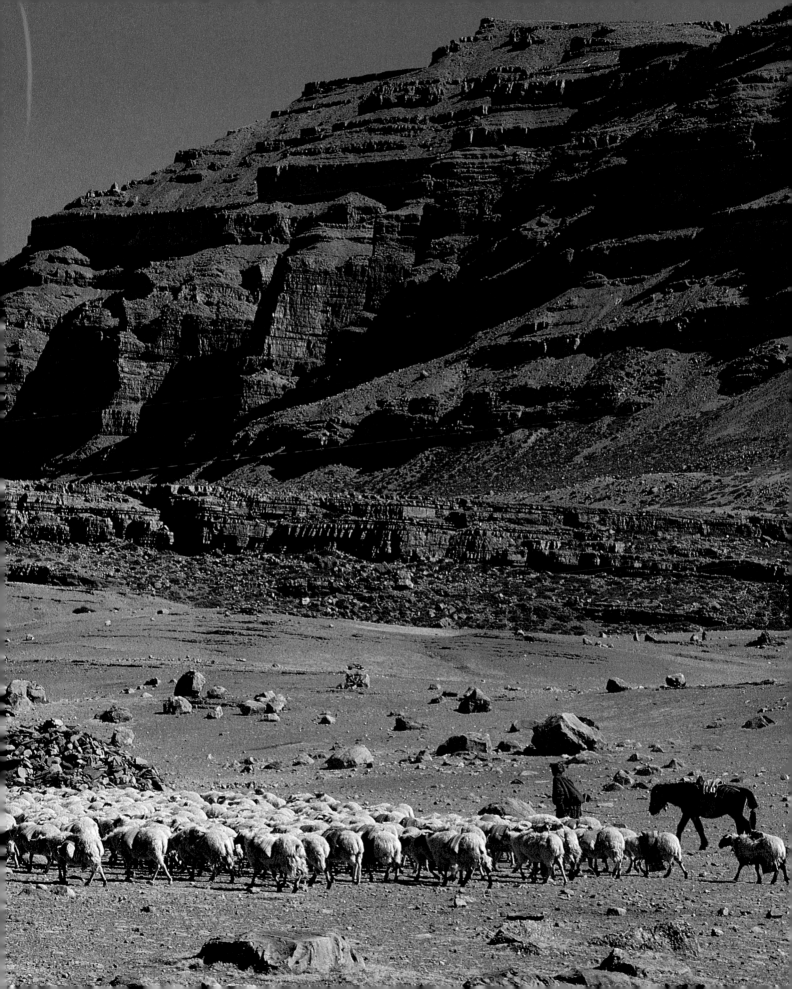

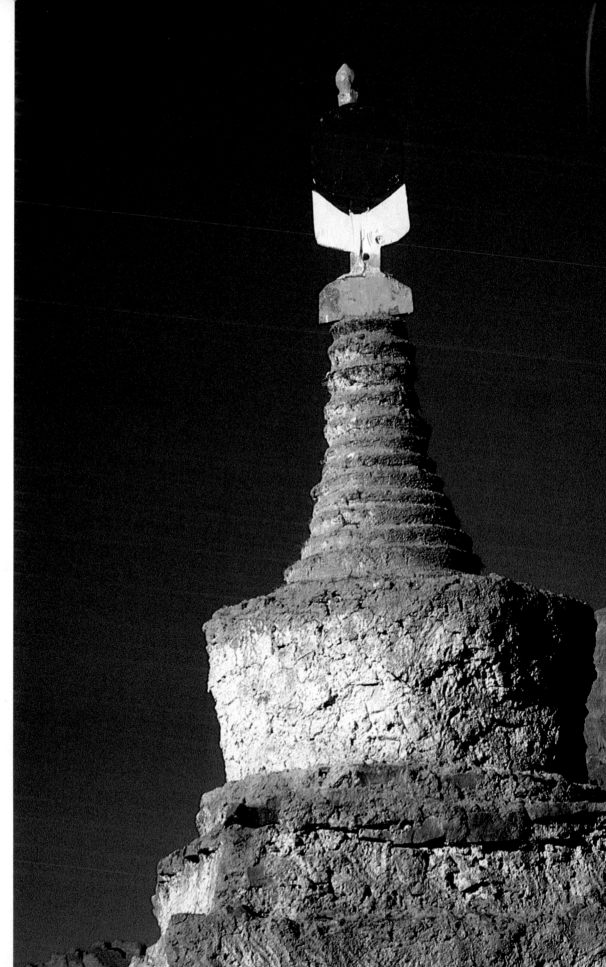

Newly rebuilt, the dome
and spire of Chorten
Kangnyi counterbalance
the snowy bulk of Kailas.
Consecrated objects sealed
inside the monument are
said to have the power to
heal any being, man or
beast, which passes
underneath. The sun-moon
shape topping the pinnacle
is an ancient Tibetan
symbol representing the
union of opposite forces:
Manasarovar and Raksas
Tal embody the same
joining of opposites, as do
Kailas and Manasarovar.

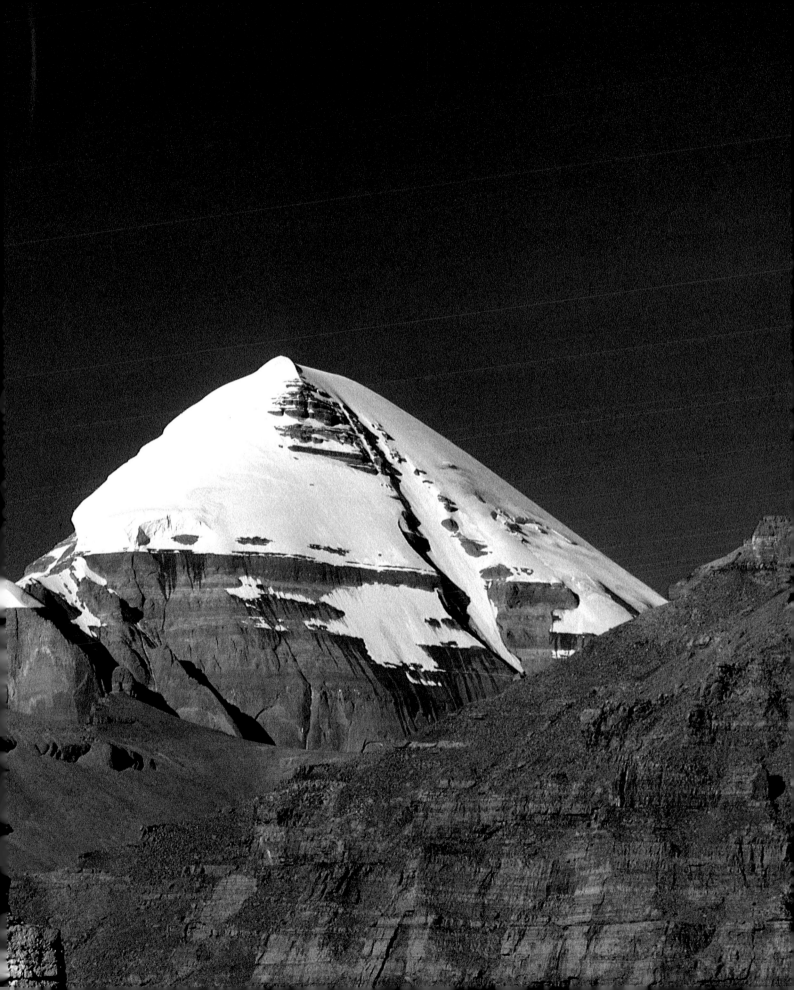

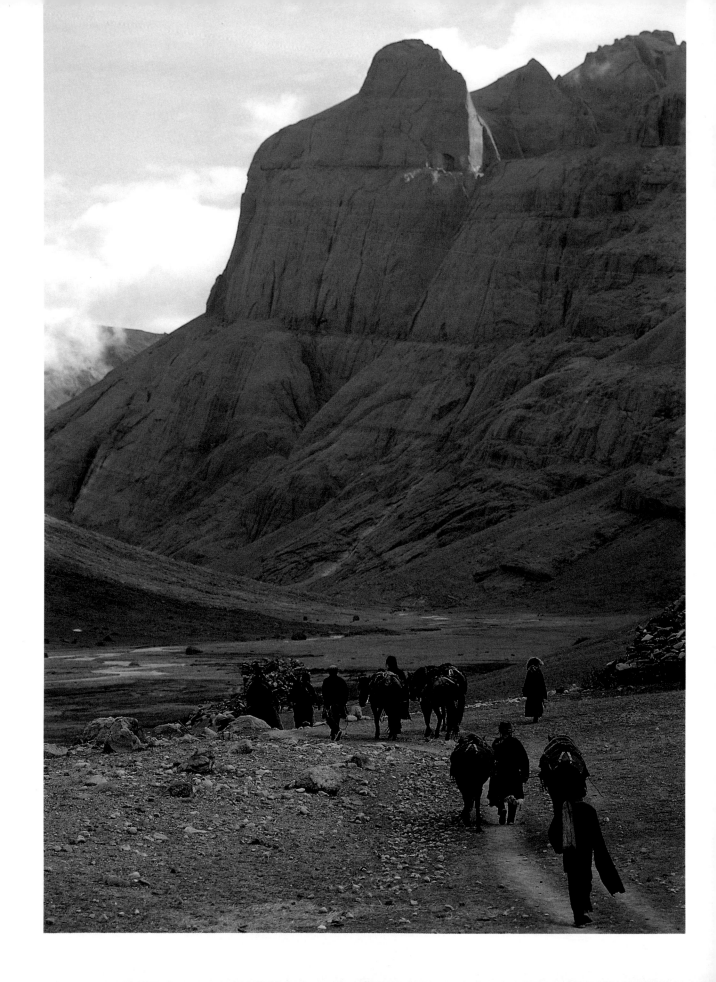

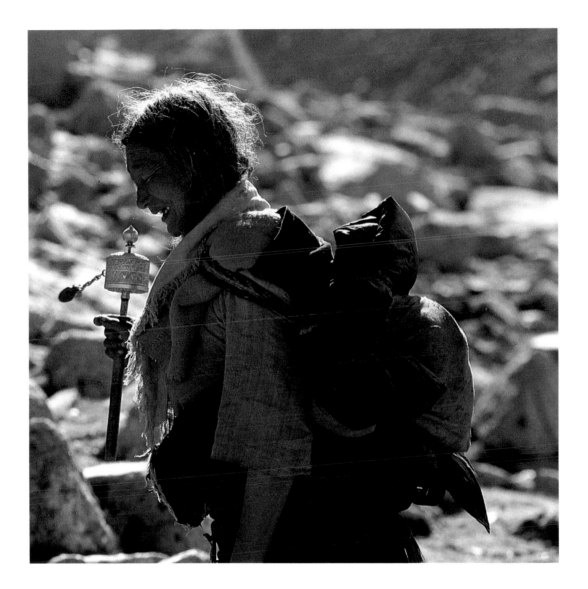

By tracing the circuit around Kailas, pilgrims link the natural and the spiritual worlds. Ritual circumambulation is practised by both Hindus and Buddhists as an act of reverence and a means of delineating the boundaries of the sacred. *Left*: Pilgrims drive their horses up the path into the western valley. The great rock dome before them is Gombo Pang, the embodiment of a powerful protector deity. *Above*: A Tibetan woman, silver prayer wheel in hand, follows her clockwise course around the mountain, spinning the wheel in the same direction that she walks. Actions such as mantra, prayer and prostration combine with walking to bring the pilgrim into contact with the divine. Every step becomes a prayer in the *kora*, a tangible progression towards liberation.

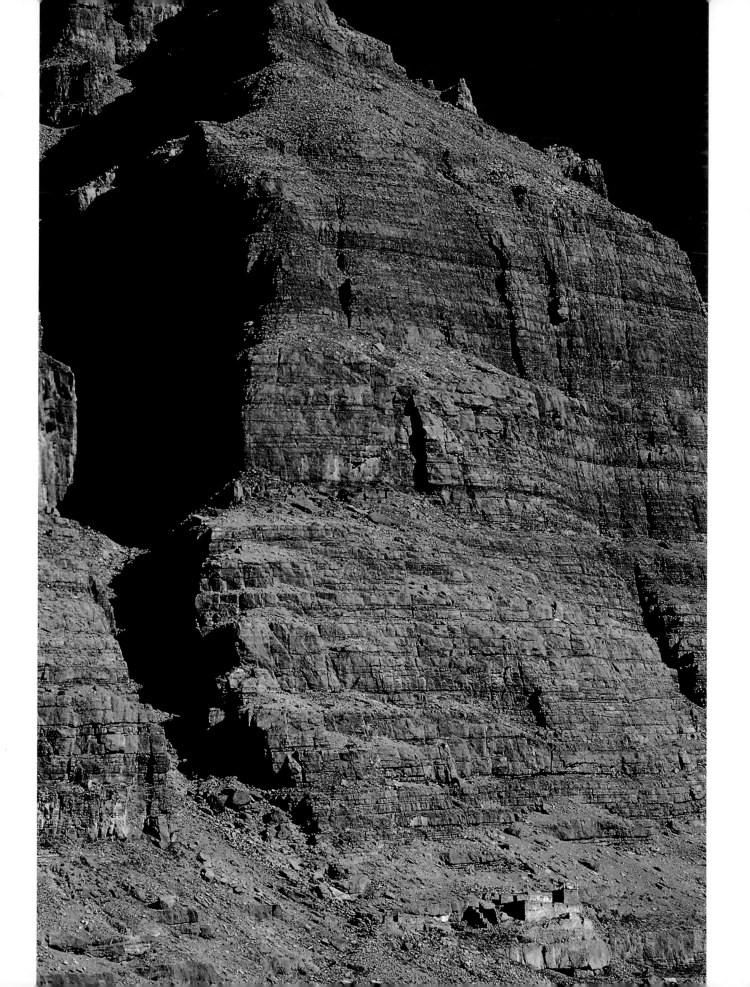

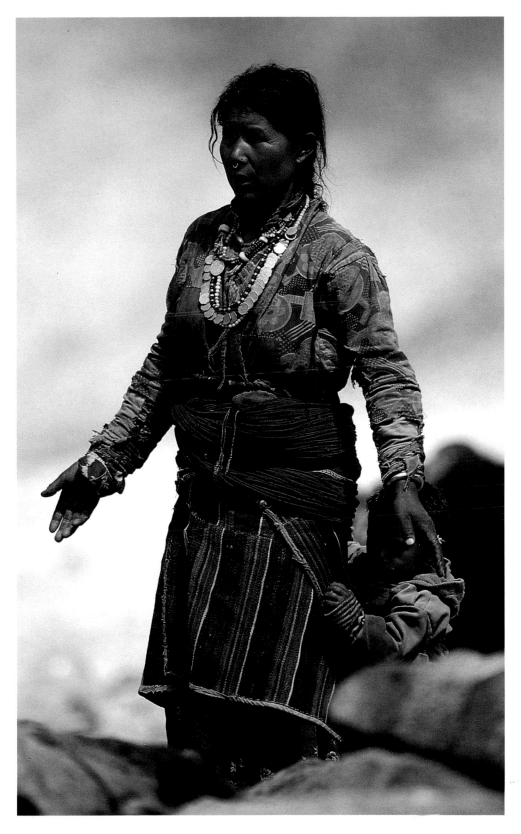

The restored buildings of Chukku Gompa (*opposite*) are dwarfed by the massive bulk of Nyenri mountain. Nyenri is believed to be the abode of the supernatural protector of the Kailas region, Kangri Lhatsen; one of the monastery's shrines is dedicated to him. *Left*: A Nepali pilgrim, her small son clinging to her skirt, prepares to bow in devotion at one of the prostration stations marking the *kora* route.

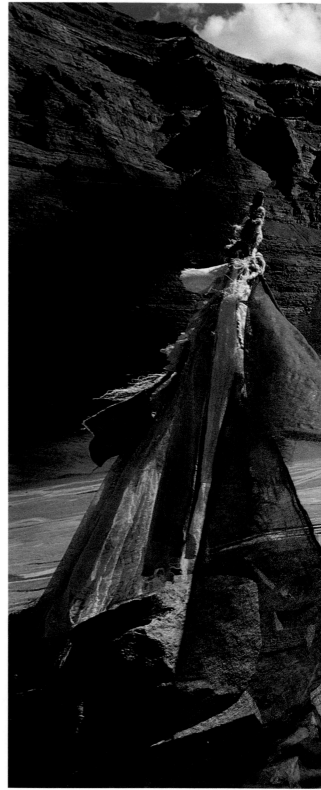

Gompa – 'solitary place' – is the Tibetan word for monastery, but traditionally gompas were much more than centres for meditation. Monasteries were the focus of worship, education, culture and art in Tibetan society. At Kailas and Manasarovar they had the added function of providing shelter for pilgrims. Destroyed in the Cultural Revolution, the monasteries have been rebuilt on a smaller scale with government funds and the contributions of individual Tibetans. *Below*: Rich colours of ritual glow in the dim light of butter lamps, kept filled with the offerings of the faithful. A white prayer scarf is draped in offering over volumes of scriptures stacked on the altar of a Kailas monastery. *Right*: Looking down from Chukku Gompa, the silver ribbon of the Lha Chu unfurls along the flat valley floor.

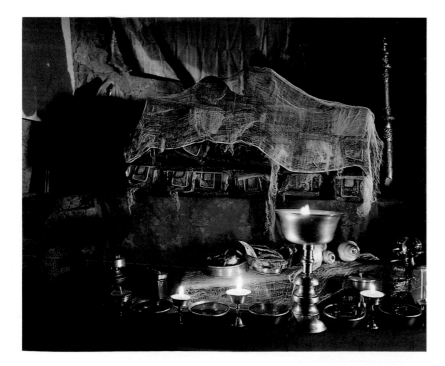

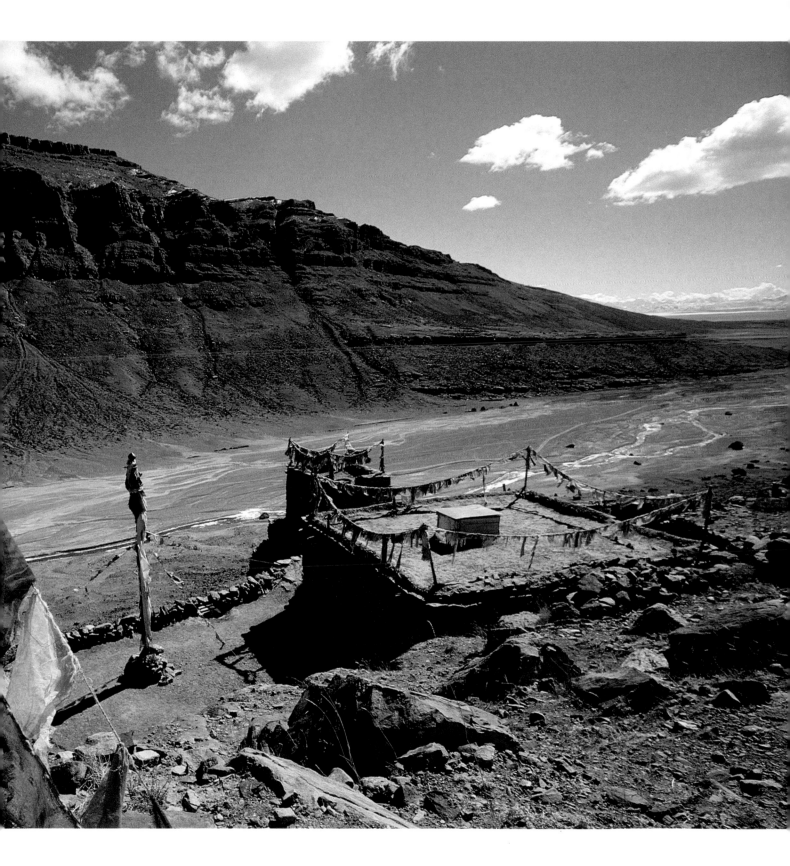

Overleaf: The western valley is also a trade route, providing access to the high remote valleys north of Kailas where nomads graze their herds in summer months. A nomad family drives a herd of pack sheep upriver. A single sheep can carry ten kilos of barley or salt packed in woollen saddlebags. *Inset*: Proud as a Mongol warrior of centuries past, a mounted nomad splashes across the Lha Chu.

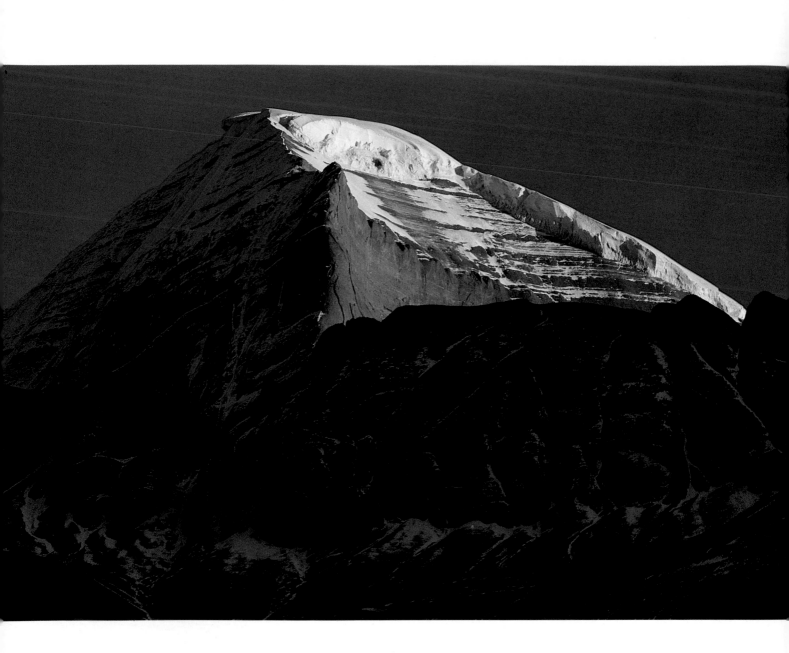

The west and north faces of Kailas gleam at sunset in a rare
view of two of the mountain's four sides. Bonpo texts compare
the mountain's uncannily symmetrical form to a 'rock crystal
chorten' or a 'crystal pagoda'. Kailas' appearance mimics that
of the legendary Mount Meru, the great 'World Mountain'
with its four faces of gold, crystal, ruby and lapis lazuli. Meru
began as an archetype of the divine centre of creation. By
some mysterious process it descended to earth, to be
embodied in the ice peak of Kailas. To the pilgrims circling it,
Kailas incarnates the divine mountain in earthly form.

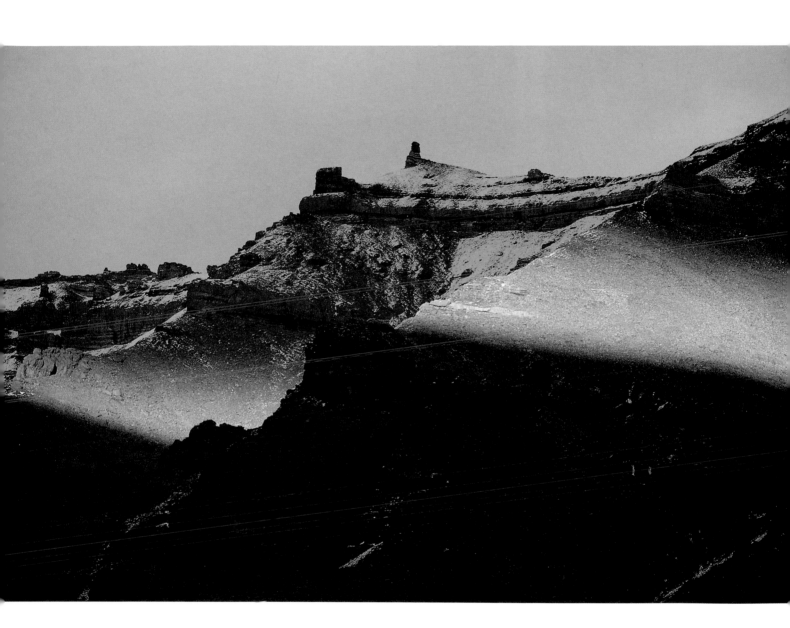

Fantastic rock formations carved by wind and water line the
high cliffs of the western valley; the rocks suggest abandoned
fortresses and monasteries which appear and vanish in a
hallucination of nature. The cliffs and mountains of this valley
are temples of the gods, gigantic palaces inhabited by invisible
yet palpable presences. Pilgrims worship these unseen powers
with perfect faith, confident in the belief that reality manifests
on multiple levels, some of which cannot be reached by the
senses. Like the mirages created by the rock formations,
visible reality is 'an illusion, a dream, a fairy city in the sky',
said the Buddhist teacher Nagarjuna.

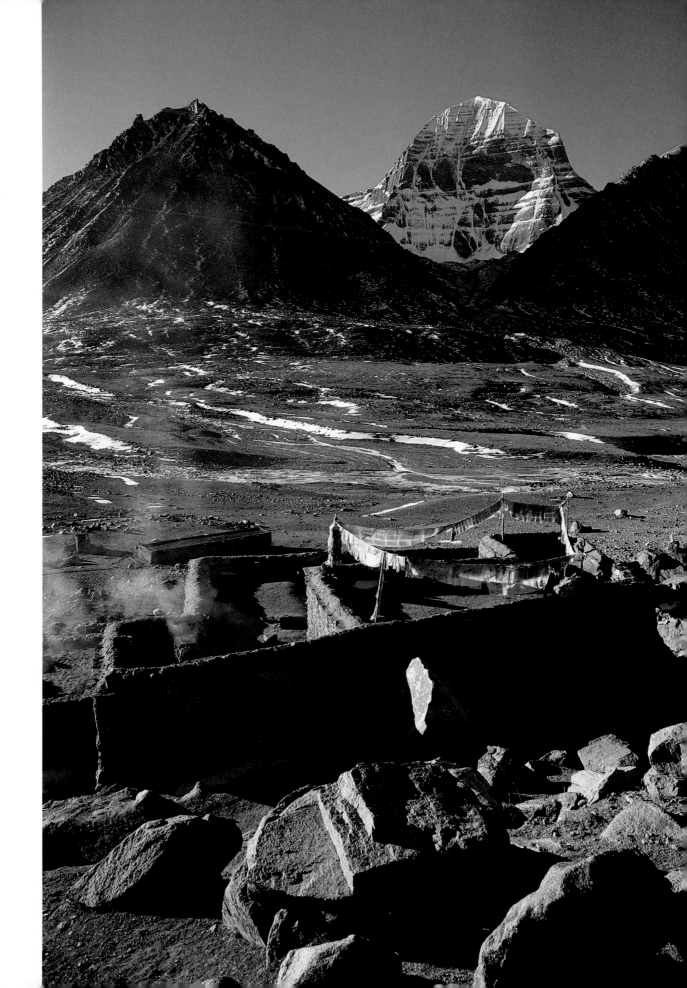

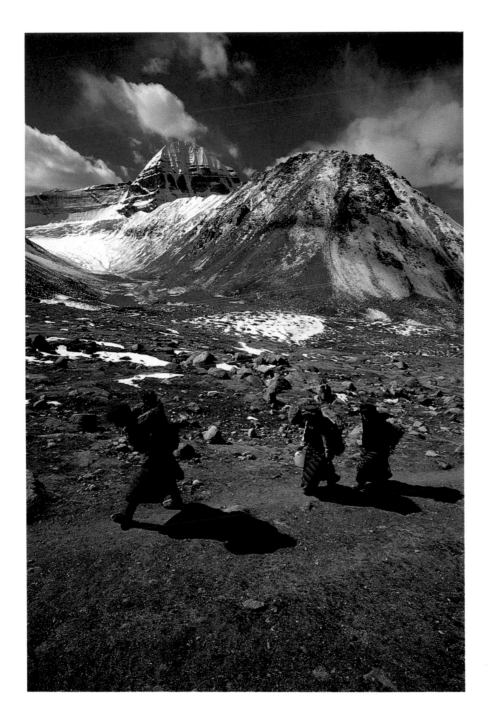

The sheer north face of Kailas rises 5000 feet straight up in a frozen monolith. Of all the views of the mountain, this is the most awe-inspiring. *Left*: Dirapuk Gompa is built in a setting to awe the spirit: caves cut into the rock cliffs behind it once housed hermits and meditators. *Above*: Pilgrims stride down the *kora* path, bound on a one-day circuit about the mountain. By the time they reach this point shortly after sunrise, they have walked twelve miles.

Overleaf: Kailas rises behind the jagged ridge of the guardian peak of Jambayang. To climb the mountain would be an act of desecration for those who worship it. No man has ever set foot on its 22,028-foot summit – except, say Tibetans, for the Buddhist yogi Milarepa, who magically flew to the top.

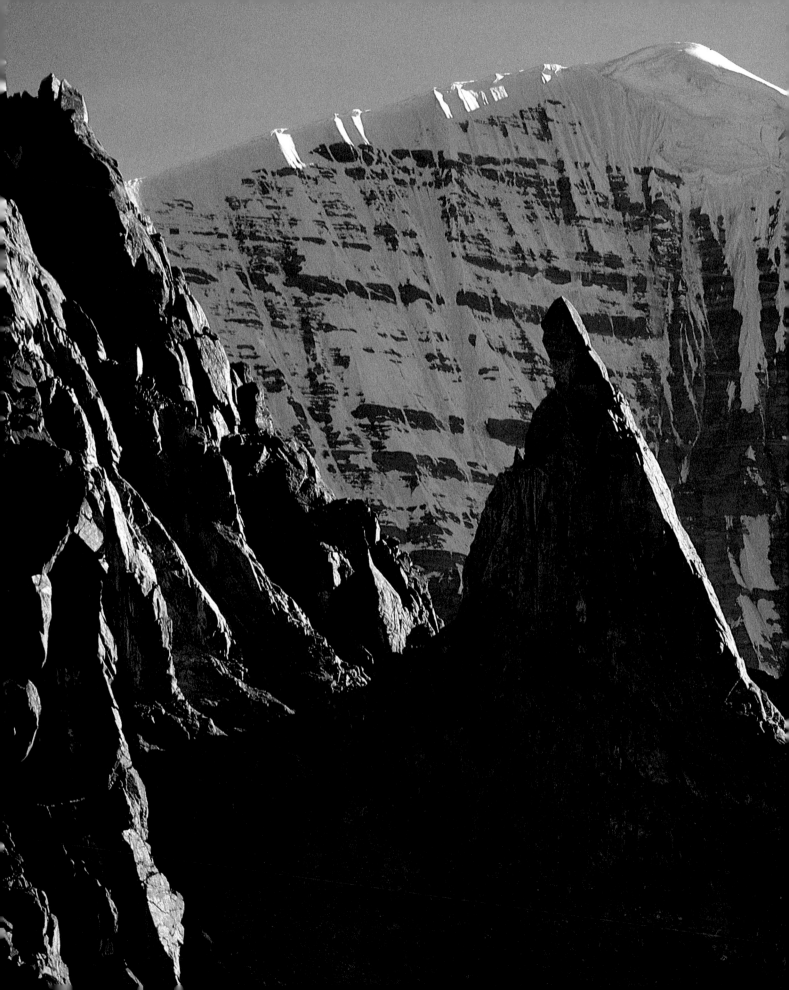

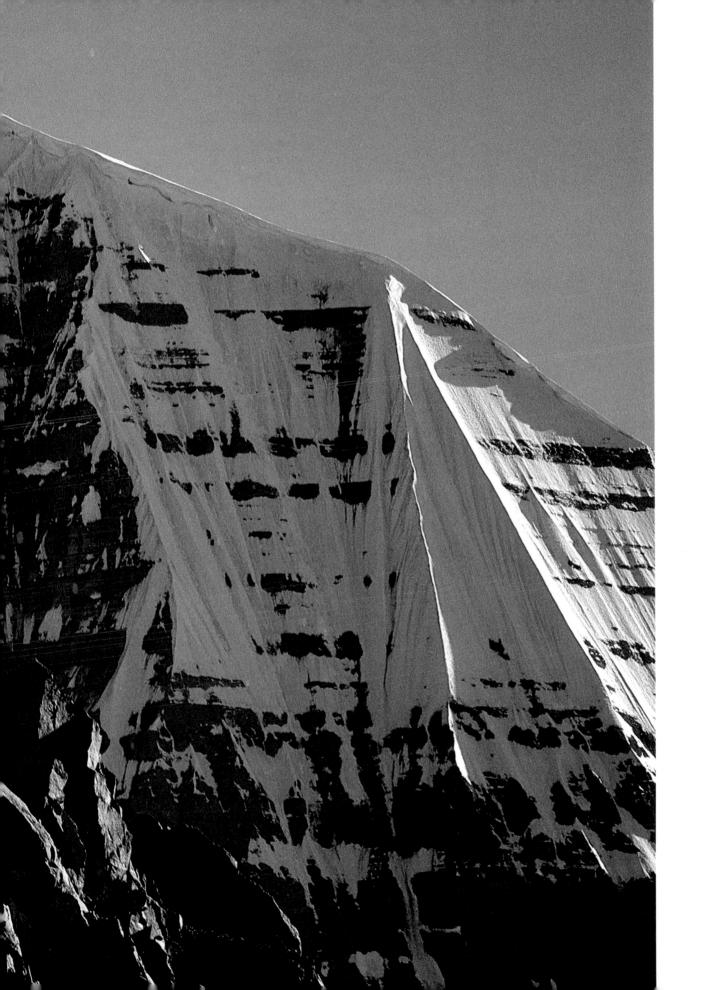

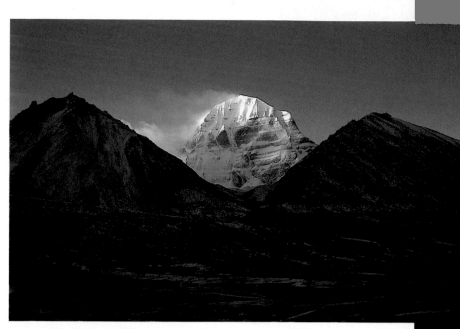

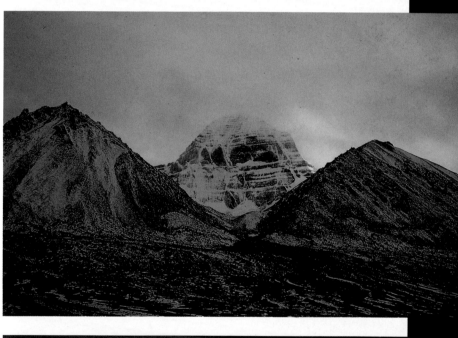

'To see the greatness of a mountain, one must keep one's distance, to understand its form, one must move around it; to experience its moods, one must see it at sunrise and sunset, at noon and at midnight, in sun and in rain, in snow and in storm, in summer and in winter and in all the other seasons. He who can see the mountain like this comes near to the life of the mountain, a life that is as intense and varied as that of a human being.' (Lama Anagrika Govinda, *The Way of the White Clouds*)

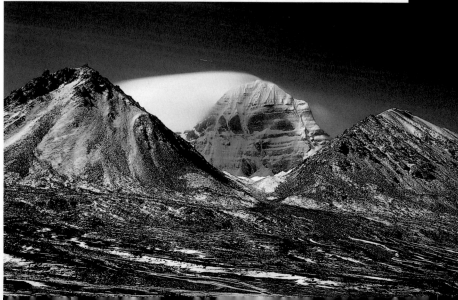

'He who performs the *Parikrama*, the ritual circumambulation of the holy mountain, with a perfectly devoted and concentrated mind goes through a full cycle of life and death.' (Lama Anagarika Govinda, *The Way of the White Clouds*)

Dirapuk means 'Cave of the Female Yak's Horns' and the monastery's small temple is built around a rock cave, its walls marked with indentations made by the *dri*'s horns. On the altar inside is the doll-like image of Gotsangpa, the discoverer of the Kailas route. His tale is the typical blend of myth and fact. According to records of the Kargyu sect, a famous monk named Gotsangpa did indeed live in a cave at Kailas from 1213 to 1217. Legend portrays Gotsangpa as a pilgrim-monk who journeyed to Manasarovar. On his return he paused at the entrance to the great Lha Chu canyon to begin the traveller's ritual of making tea – but the place was so holy not a single rock could be used to support his kettle; every stone he picked up was marked with a sacred mantra. Abandoning his cookfire Gotsangpa set off on the journey around the mountain, guided by a series of deities disguised in animal form. The entire length of the Lha Chu Valley he chased a female yak: cornered in the cave of Dirapuk she revealed her true nature as a *dakini*, one of the magical legions of female spirits who are the keepers of mystic intuition.

This same *dakini*, she of the 'Lion Face', Senge Dongpa, guards a half-hidden sacred pass connecting the northern and eastern valleys. The path over the Khamdo Sanglam La is shorter than the usual pilgrim route, but the presence of its fierce protectoress bars pilgrims from crossing until they have performed a dozen regular circuits of Kailas. Only on the auspicious thirteenth *kora* will they traverse the sacred pass.

From Dirapuk the pilgrim trail ascends to an 18,600-foot pass guarded by a more benevolent female divinity, Dolma, the Saviouress of Tibetan Buddhism. In spite of her infinite mercy the ascent to her pass remains a test of faith and determination. More than a few pilgrims have died on the approach, where a blizzard can strike almost without warning and rage for days.

On our first *kora*, a slow four-day round, we waited an extra day at Dirapuk for threatening weather to clear. When the clouds remained, we and several other pilgrims joined up with a nomad family from Amdo saddling their yaks below Dirapuk. In a snowstorm, the yaks could be counted on to break trail. Our new companions were Dorje, his wife Mingmar, their three sons and Dorje's sixty-eight-year-old mother. The oldest boy was able to walk on his own, the middle son rode strapped in a warm nest of quilts atop a yak, and the year-old baby gazed out from the warmth of a sheepskin carried on his mother's back.

The pass we were aiming for lay four miles beyond and a half-mile above Dirapuk. It is known as the Dolma La, and spiritually its passage marks the transition from this life to a new one, for atop the pass the pilgrim is reborn, all sins forgiven through the mercy of Dolma, among the most beloved of Tibet's deities. Literally translated, her Sanskrit name, Tara, means 'She Who Helps Cross' – not just to the opposite side of the pass, but to the 'other side' of spiritual realization.

The path twisted across a rock-strewn slope awash in fog. The line of pilgrims stretched out ahead, their small forms merging with the mist-edged silhouettes of stacked stones. Rock cairns sprouted by the hundreds along the trail, raised in offering to Dolma and in mimicry of Kailas. Their stones were fitted and balanced into unabashedly phallic forms, a forest of linga sprung from the bare earth.

High up to our right the mountain's summit glowed white with diffused sunlight, then vanished into the swirling mist. With its base hidden in fog the huge rock form was unexpectedly ethereal. It seemed to float in the air, a ghostly presence that drifted in and out of focus. Searching for it, I found nothing, and when I least expected it a casual glance upwards would stop me dead in my tracks: the floating icy pyramid was like an apparition from another world.

A sharp crack rang out, reverberating in the still air: ice tumbling off hidden cliffs high above. 'Senge', someone murmured – 'lion' – and we halted for a moment to peer up the veiled slope. The scene was so extraordinary, all swirling mist and grey granite peaks, that I half-expected to see the mythic turquoise-maned snow lion appear above us. Tibetan folklore says its light-footed bounds from peak to peak send avalanches cascading down.

We moved steadily up the shrouded path, climbing higher into the heart of the mystery. Footsteps followed the even rhythm of the mantra of Tara: 'OM TARE TU TARE TURE SO HAH', and with each repetition another step was taken, another breath drawn, another prayer bead slipped between the fingers.

Ceremonies mark every step of the path. A pilgrim kneels in prayer atop Shapje Datok (*far left*), a boulder bearing a footprint of the Buddha. A Nepali woman (*below*) reverently touches a natural indentation in a rock, believed to be an *u-je*, the headprint of a saint. Drum and bell in hand, a *lama* (*bottom right*) chants prayers over the prostrate bodies of pilgrims at Shiwa Tsal, in a ritual to aid their spirits' journey after death.

Kang pu, a fragrant plant used for incense, grows along the ascent to the Dolma La (*left*).

Halfway up we stopped at a boulder-strewn flat by the side of the trail marked with an odd litter of discarded clothing. The old woman sank down wearily into the heap of rags, glad of a warm place to rest. All about vertical rocks projected from the landscape, bizarrely clad in a shirt or a child's dress. This was Shiwa Tsal; it bore the name of India's famed cremation grounds for this too was a place of death. To be reborn one must first die, and here the pilgrim faces Yama, the King of Death, whose judgement purifies him for the new life awarded atop the Dolma La.

Our companions paid obeisance by cutting off strips of clothing and locks of hair and adding them to the untidy heap on the ground. Dorje ran his thumbtip over the edge of a knife and squeezed out a few drops of blood into the earth, muttering prayers. These offerings were meant to create a physical link between the spirit and this holy site, and to prepare the soul for its long journey between this life and the next. The unexpectedness of death is compensated, to some degree, by the advance preparation afforded by the rituals here at Shiwa Tsal. Some say the offerings made here earn the spiritual merit gained by dying on pilgrimage. Others believe they ensure a rebirth in Tibet – a life which, for all its hardships, is blessed with the teachings of the Buddha.

On one *kora* I witnessed a death ceremony performed at Shiwa Tsal by a young monk. His pilgrim flock lay stretched out full-length in a semicircle around his feet, hands clasped over eyes or clutching prayer beads, so motionless it was difficult to tell if they were feigning sleep or death. The monk began a rhythmic chant, punctuated by the hand drum and bell grasped in each hand. His voice rose and fell for minutes, lulling the sleepers into a trance. Not one stirred a muscle until the final shout of 'Phat!' dispelled any lingering evil spirits. Then all stood, straightened their robes, replaced their hats, and departed uphill without a single word being spoken.

A little past Shiwa Tsal we watched a parade of Indian pilgrims file past on yak-back. Swathed in sweaters, mufflers and goggles against the cold, they made strange sorts of cowboys astride the short-legged yaks. One of the animals rebelled and began to buck; the rider clung helplessly to the wooden saddle, shouting Hindi imprecations. Most dismounted as the climb steepened and walked the rest of the way, pausing every few seconds to gasp for

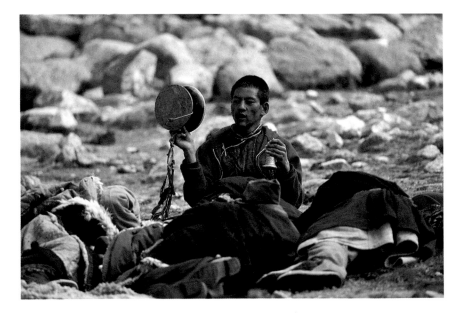

breath. Despite their fatigue, they still had enough energy to make wry jokes. 'It is the dream of a lifetime, but I may not live to complete it', one man muttered grimly.

Ahead lay the Hill of Salvation, the final ascent, and the steepest. Another hour and the climb had become serious business. I was reduced to counting out each step under my breath and pausing after fifty or seventy-five. The air was painfully thin, but the entire way up a woman sang without a pause, wordless wailing crescendoes sliding up and down the scale. The wildness of her song utterly suited the bareness of the surroundings, and I felt a shiver run up my spine.

Yaks scrabbled for a hoofhold and were encouraged upwards with loud shouts. Dorje hoisted his tired son aboard his shoulders and carried him on. Twenty more steps, a hundred more – and a triumphant shout drifted down from above: 'La, so so so so so!' – the cry shouted to the spirits guarding windy passes across Tibet. Raising my eyes I saw prayer flags and painted mantra splashing the colours of celebration onto the monochromatic landscape: at last the Dolma La, the pass of redemption and salvation.

The first man to reach here was again Gotsangpa, who struggled up the climb led by Dolma herself. At the great boulder which marks the pass she disappeared in the form of twenty-one wolves; the rock is known as the 'Dolma Stone'. Pilgrims reverence it with the same devotion they lavish upon temple shrines, circumambulating it, bowing before it, stringing prayer flags from the top. A strange miscellany of offerings was stuck onto the sides of the boulder: lumps of butter and pinches of *tsampa*, Chinese paper money and coins; portraits of pilgrims captured solemn and wide-eyed in a Chinese photographer's studio. And again there were strands of hair, old clothing, even a rosary of human teeth wedged into a chink of the rock.

A steady procession of pilgrims circled the Dolma Stone, clambering atop to hang still more red, green, gold and blue prayer flags until the supporting pole sagged from the weight of so many offerings. More gifts were strewn around the boulder: old clothing, severed braids of hair, horned sheep skulls. Tradition demands one both leave and take an object here; the strip of prayer flag thus obtained becomes a lucky amulet.

Rituals completed, the celebration began. This geographic high point was the emotional peak of the entire *kora*. We sat in a circle on the ground to share a high-altitude communion of special food: fried bread, dried cheese, sweets and chunks of raw brown sugar, all liberally passed around and heaped even higher in front of those foolish enough to refuse. At the edges of the party a bedraggled dog with prayer flags tied into his matted fur nosed about for leftovers. Ravens kept their own sharp watch on the progress of the food, swooping down to carry off any bits left atop the Dolma Stone.

More pilgrims kept arriving at a steady rate: extra merit came from a *kora* performed the day of the full moon, and from noon onwards the barren pass was alive with bright colours, laughter and shouts. Cresting the top from the opposite direction came a group of Bonpo, their counterclockwise *kora* crossing the Buddhists' right-hand path at this halfway point. The first of the Indian pilgrims struggled over the ridge and slumped down exhausted, a dazed smile lighting his face. When his companions arrived the group began a Hindu *puja* in front of the Dolma Stone, offering incense and dried coconuts which curious Tibetan boys cracked open at the first opportunity.

We all lingered as long as possible atop the pass, savouring the rest, the food and the astonishingly fierce warmth of the sun, which broke through the clouds to add to the sense of celebration. Too soon, though, it disappeared back into a chilly grey sky. A rising wind and the slanting angle of the light told us it was time to leave.

The trail dropped down past Tukje Chenpo Tso, the Lake of Great Mercy, a frigid green gem nestled into a setting of fluted ice cliffs. At 18,400 feet it is among the highest lakes in the world. Some years it remains frozen all summer long, and pilgrims hurl boulders against the ice in a vain attempt to break through and baptize themselves in its chilly waters. More often, they ignore the ablutions mandated by scriptures and hurry past.

We moved rapidly down the steep trail into a new and different land. This northeast side was lined by vertically compressed cliffs, their cracks etched with the sharpness of a pen-and-ink sketch. Great angular blocks of stone were stacked atop one another like giants' toys thrown carelessly about. One of these top-heavy formations reared its menacing silhouette against the skyline. Tibetans call it the 'Axe of Karma', a final symbol of the karmic processes of cause and effect, action and reaction nullified by the mercy of Dolma.

We dropped down more than an hour before the path levelled out into a pastoral green valley. The soft grass carpeting the ground was a relief to weary feet, the liquid whisper of rivulets and stream welcome after the dry grey dust of the pass. Nomads' black tents dotted the green slopes of this gentler side of the *kora*, and their yaks grazed placidly by the trail. Nomads can live anywhere, it seems; fresh water and grass are all their herds need, and this gives them an enviable independence. 'Where is your home?' I would ask, just to hear the pride in their reply: 'We live in *tents*', delivered in a tone that said a tent was the finest palace in the world.

One evening we camped in this eastern nomad valley near the riverside, a little below a gathering of nomad tents. At twilight the children rounded up the scattered herds with long, drawn-out whistles that hung in the dimming air. Shouts and cries, the smoke of cooking fires and the sound of a drum drifted over to the hillock where I sat. The scene was timeless: for a moment I sensed how little had changed in their way of life. Darkness drew their world small around the fire into a circle of warmth and flickering light, and when the fire dimmed to embers the tent dwellers slept, while the stars turned in their ancient round above and Orion the Hunter, a nomad also, stalked his prey across the firmament. In the dead of night there was nothing but what had always been: black tent against bare mountain, snow-capped peak and stars, and a frozen wind that cut like a knife.

Although the eastern valley was not as spectacular as the other sides of the *kora*, it possessed its own subtle beauty. The cloudy skies matched its muted mood: dun hills washed by mist, snow-dusted pinnacles floating above. Everywhere was the sound of water, gurgling in rivulets and dripping off rocks. The moisture drew out the scent of wildflowers underfoot and the soft palette of natural colour. Kailas, last seen on the ascent to the Dolma La, appeared briefly; the third *chaktsel gang* honoured the single glimpse of its eastern face.

On the bank of the Zhong Chu we halted for a tea stop. Dorje shredded a few cakes of dried yak dung for fuel, dropped on a handful of dried grass and carefully coaxed it into flame. He tended the fire with a pair of sheepskin bellows, an ingenious way to supply the extra oxygen necessary for yak dung to burn well at high altitude. The yak were unsaddled and strayed off to graze on the lush grass while the children sat in a row on a blanket, the eldest splitting open the pits of dried apricots with a stone and passing us the almond-flavoured kernels. Soon tea was boiling in the battered black kettle. We drank the salty brew gratefully and contributed our remaining crumbled biscuits to the meal of *tsampa* and dried cheese, then went ahead while the yak were being resaddled. Dorje told us they would probably camp in the valley, but we hoped to reach Tarchen by nightfall.

This valley belonged above all to Milarepa, Tibet's beloved saint and troubador. Wrapped in the thin white cloth that earned him the name Repa, 'The Cotton-Clad One', Mila

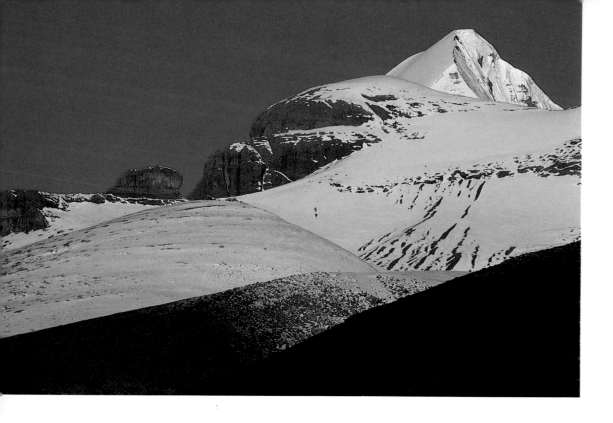

The rarely-seen eastern face of Kailas (*left*) appears at only one point on the *kora*. *Below, top to bottom*: Striated peaks lining the eastern valley; Zutulpuk Gompa beside an immense boulder said to have been lifted by Milarepa; sheep bones painted with mantra hanging over the entrance to Zutulpuk.

roamed the Nepal-Tibet borderland mixing miracles with meditation, using the yogic technique of 'inner heat' to survive the freezing winters. His time was nearly a thousand years ago, but his miracles and simple, direct songs are still alive in the minds of Tibetans today. One song tells of Milarepa's encounter with the Bonpo shaman Naro Bon Chun on the slopes of Mount Kailas, a meeting which transformed the mountain from a Bonpo holy site to a Buddhist one.

Naro Bon Chun was a powerful shaman who had practised in the region for many years when Milarepa and his band of disciples arrived at the shores of Lake Manasarovar. Each magician claimed the region as his tradition's own: the Bonpo by right of being first; Milarepa citing prophecies of the Buddha regarding a great snow mountain destined to become a major centre of religion. To resolve the dispute Naro Bon Chun suggested a magical contest, which he immediately began by straddling Manasarovar, one foot planted on either shore. Milarepa wasted few words on a response. First he hovered over the lake, covering its entire surface with his body; then, for good measure, he balanced the entire lake upon his thumbtip. And the competition continued in this vein, the Bonpo always losing.

The two magicians adjourned to Kailas, where the *kora* route still bears the marks of their battles. A flat boulder to the east of the Dolma La is pocked with indentations said to be the footprints of Milarepa and Naro Bon Chun. Each had embarked on the *kora* proper to his faith: they collided atop the boulder and began a great tug of war, which Milarepa naturally won – and dragged the Bonpo clockwise, in the proper Buddhist direction, all the way to Zutulpuk Gompa.

Contests of strength, of stride, of house-building, Milarepa won them all. Exhausted, Naro Bon Chun proposed a final match: he who reached the summit of Kailas at dawn of the full moon day would earn ultimate victory. Early on the appointed morning, Naro Bon Chun appeared in the sky flying atop his magic drum. Milarepa's disciples were greatly disturbed at the sight. 'Master, he is approaching the summit!', they warned, but their teacher

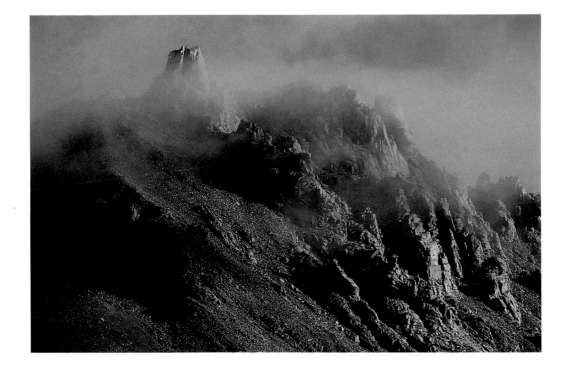

Pilgrims pause for a rest and tea on the green bank of the Zhong Chu. *Left, above*: The mist-shrouded mountain tops of the eastern valley.

remained calm, meditating. Suddenly the Bonpo found himself unable to ascend any further. It was as though he had come up against an impenetrable barrier – which the magical will of Milarepa indeed was. It was all the shaman could do to continue circling the mountain astride his drum.

As the first rays of morning sun struck the dome of Kailas, Mila merged with them and was instantly transported to the summit. The Bonpo was so startled at the sight of his competitor's sudden victory that he fell off his magic drum. It clattered down the length of the mountain's south face, etching a deep vertical groove, and the assembled local deities roared in laughter at the absurdity of it all.

Naro Bon Chun had no choice but to admit defeat. Humbly he requested Milarepa to give him a new holy site where his followers could continue to follow their own way. Picking up a handful of snow from the summit of Kailas, Milarepa tossed it eastwards in the direction of Manasarovar. It landed atop a variegated peak which even in summer is marked by four diagonal slashes of snow. 'There is your new mountain' Milarepa said, and although the Bonpo monastery built on its slope long ago became Buddhist, the mountain is still known as Bon Ri, Bon Mountain.

Zutulpuk Gompa, the Monastery of the Miracle Cave where Milarepa claimed one of his many victories over the Bonpo shaman, lay several hours down the trail. Mila's meditation cave is the gompa's main shrine. At first, the story goes, he found it too cramped and pushed the low rock ceiling up with his hands. Even wizards miscalculate sometimes. The cave had become too drafty, so he climbed atop to stamp it down with his feet, and his hand and foot-prints still mark the rock. Inside the small cave, pilgrims knelt to venerate an image of Milarepa seated in characteristic pose, right hand cupped behind his ear as if listening to an inner voice.

After Zutulpuk, the final seven miles to Tarchen became a push to completion. We matched ourselves against the sinking sun, legs moving automatically in a rhythm set since

dawn. By late afternoon a strong wind rushing up the narrow valley added its power to push against our slow progress. Concentration went into the next step and the one that came after it. I no longer saw the strange stepped ziggurat-like peaks that lined the valley; my eyes were on the trail, and somehow it was easier to continue rather than rest: to rise again after stopping was more of an effort than simply moving on.

Then came one last moment of the otherworldly. Just before the valley rejoined the Barkha Plain, the earth exploded in a last display of colour, as if in benediction and farewell. Tibetans call this place the 'Gold and Red Cliffs', a fairyland canyon splashed with explosions of mineral colour. Orange boulders tumbled down a blue slope; a few steps later the hues were green and purple, red and black, every possible shade summoned forth from the earth in a final display of the *kora*'s wonders. Each twist of the narrow path revealed new combinations of colour, but the grand finale was to turn and look back at the whole display spread out behind.

Every time I walked through here I expected familiarity to diminish the impact of the place, but the symphony of colour never faded. Tibet was wild like this: rainbows arced daily across the summer sky, and their hues appeared on the earth with increased intensity. It was as if God the painter had used the land as his canvas, scrubbing the bare hills clean in preparation, then laying down colour in thick swatches, striping the land with unexpected, never-seen combinations of mauve, pink and green, orange and purple; a master palette for all the tones of nature, intense, subtle and pure.

The last of the prostration stations marked the end of the rainbow passage. Exhausted past the point of weariness I sank down onto a boulder and looked back up the tremendous valley. Tiny figures picked their way single-file across the multi-coloured cliffs. Slowly they drew near, laughing and chattering gaily, young people on a picnic as much as a pilgrimage. 'Don't rest, come with us, or you won't reach Tarchen before dark', they shouted to me, so I joined them, and the remaining miles disappeared before their cheerful vigour.

The great circle was nearly closed now. On the right Kailas was hidden by hills, an unseen but strongly felt presence exerting an almost magnetic pull on the path, drawing it ever inwards in a constantly revolving circle. The symbolism of the *kora*, the great round, took visible form at this point: man revolving around the central fixing point like planets orbiting the sun, an arduous and active worship of days in which every step is a prayer, a tangible progression towards liberation.

To some it may seem superstition, but this tracing of a great circle – in itself the symbol of the indivisible, and therefore the divine – is an active form of meditation, serving to centre the mind on the axis. Its intent is to incorporate the individual into the cosmic pattern – the circular movement of the universe, which the great Asian faiths believe revolves about Mount Meru. As Meru is the fixing point of the universe, so Kailas is the linchpin of this earthly realm, Meru's physical counterpart, and by duplicating the universal order the pilgrim moves into harmony with its totality, no longer a fragment, but a part of the whole.

A greater effort is demanded of the pilgrim as the *kora* path nears the halfway point. From Dirapuk Gompa the trail ascends 2500 feet to the Dolma La, the pass of redemption where the pilgrim is said to be reborn. An old woman struggles up the approach to the pass aided by her grandson.

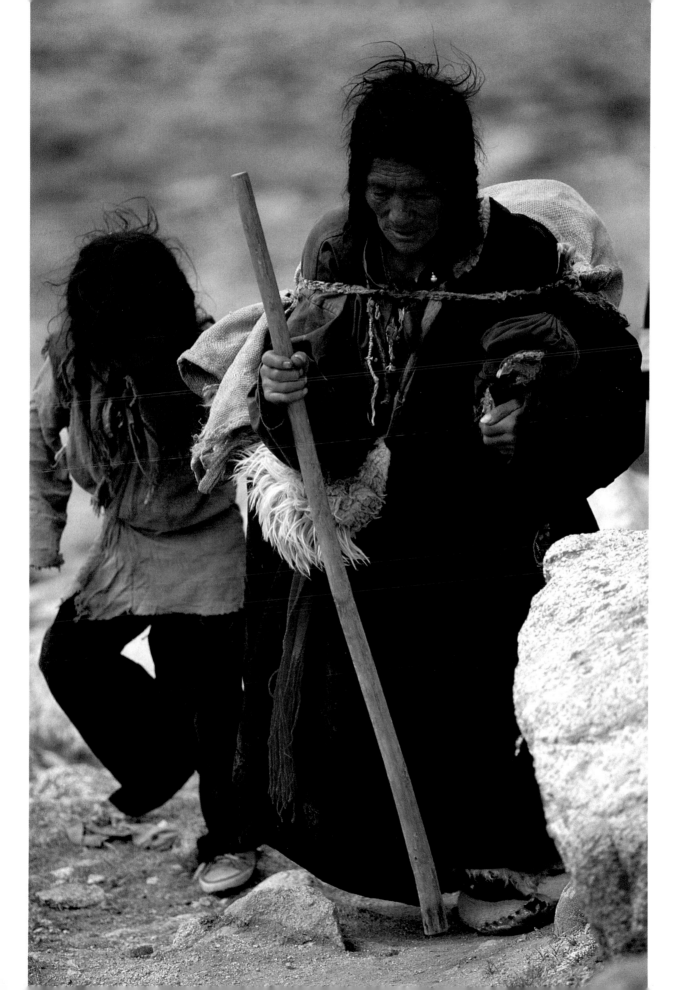

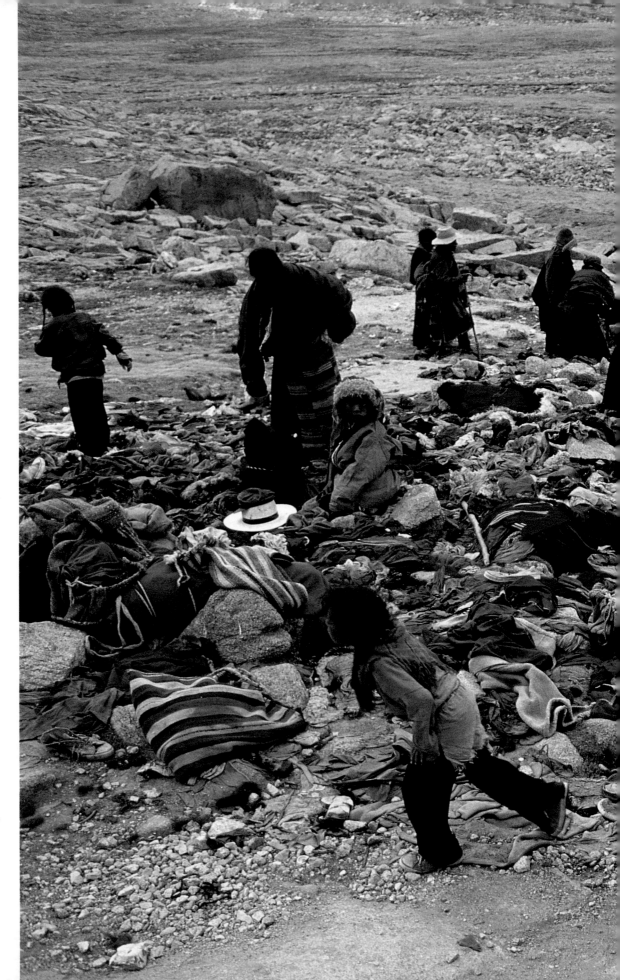

Chanting prayers, a group
of pilgrims circles the holy
site of Shiwa Tsal. All who
pass here leave a piece of
clothing, a lock of hair or a
few drops of blood –
personal offerings, meant
to create a subtle link with
this site which will aid the
spirit's journey after death.
In rituals like these,
pilgrims obey ancient
traditions. Few can explain
the meanings of their
actions, which they
perform impelled by faith.

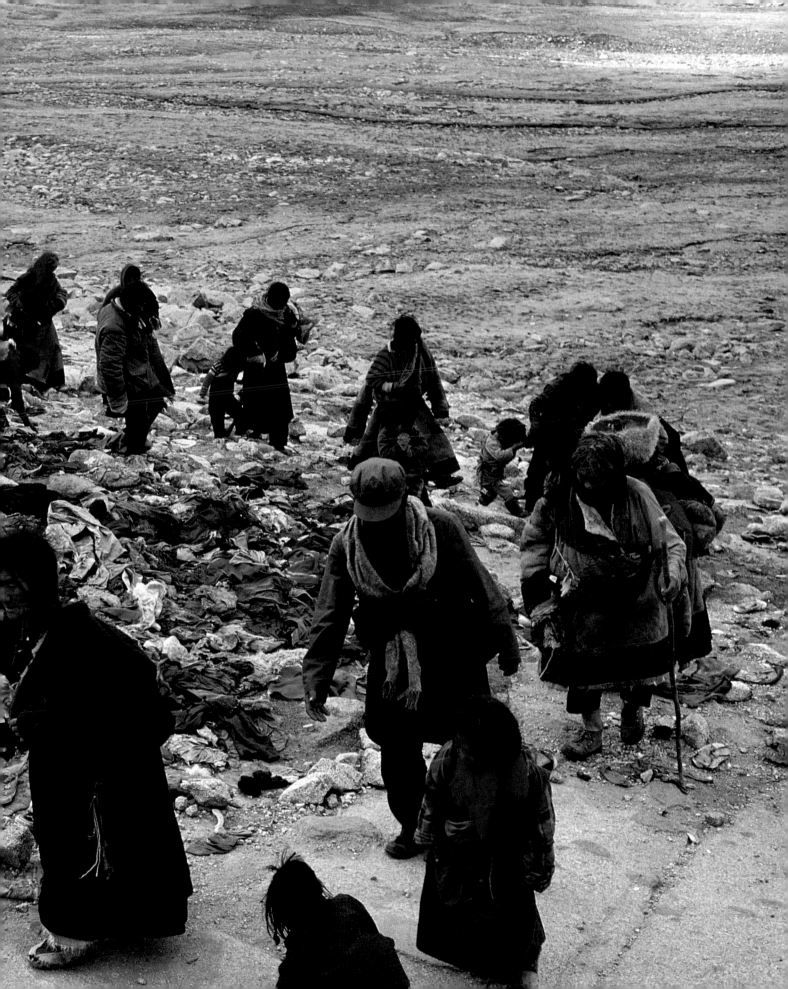

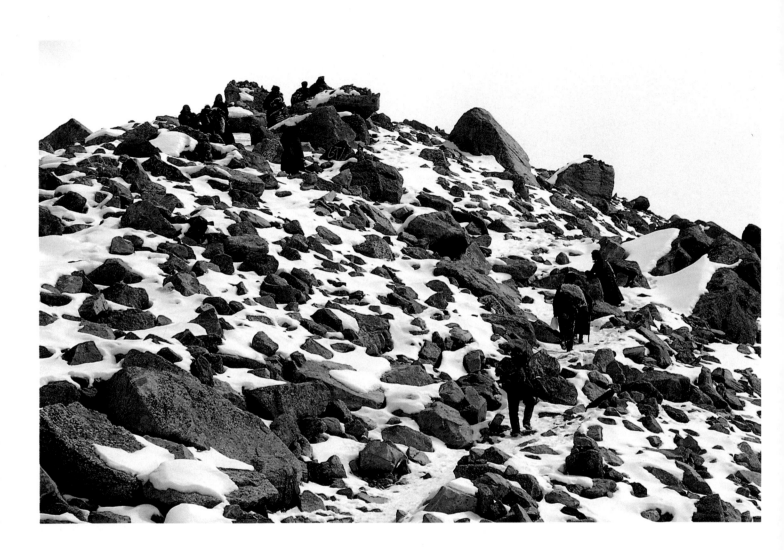

Each slow step becomes an offering as the trail winds up to the pass of Dolma, Tibetan Buddhism's beloved Goddess of Mercy. The hardships of the journey invest the pilgrim path with its power. Personal sacrifice is necessary to achieve a higher goal, and the difficulties of the journey are of little consequence compared to the spiritual reward earned atop the pass. *Above*: A line of pilgrims trudges up the Hill of Salvation past stone cairns raised in offering. The holy syllable OM is etched onto a rock at the top. *Right*: A lone woman climbs toward the Dolma La, carrying a copper prayer wheel on her back.

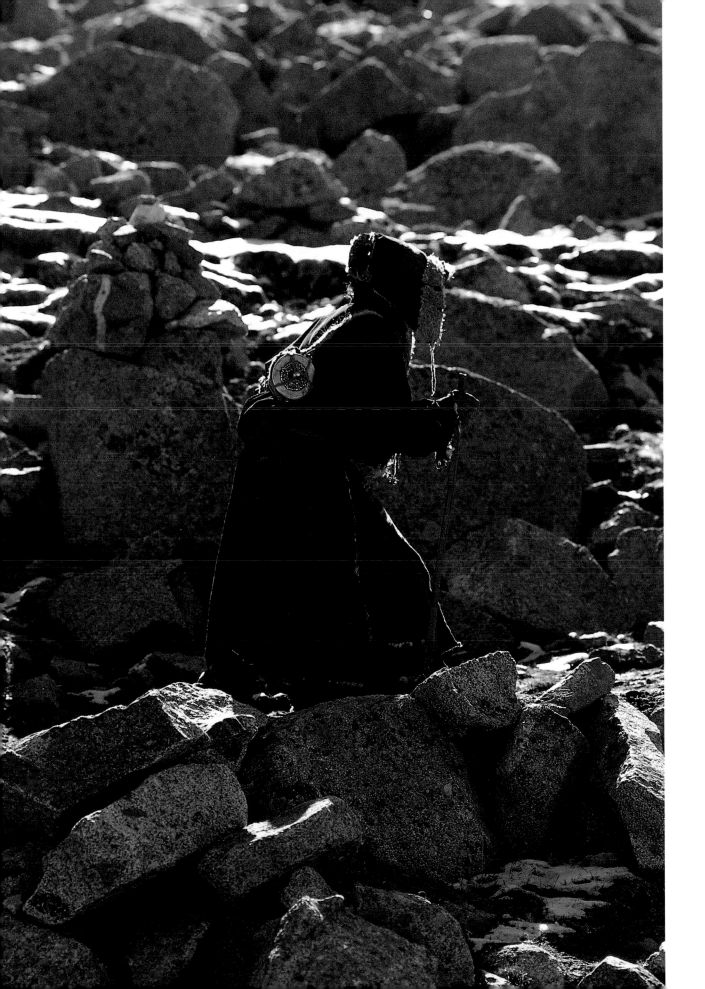

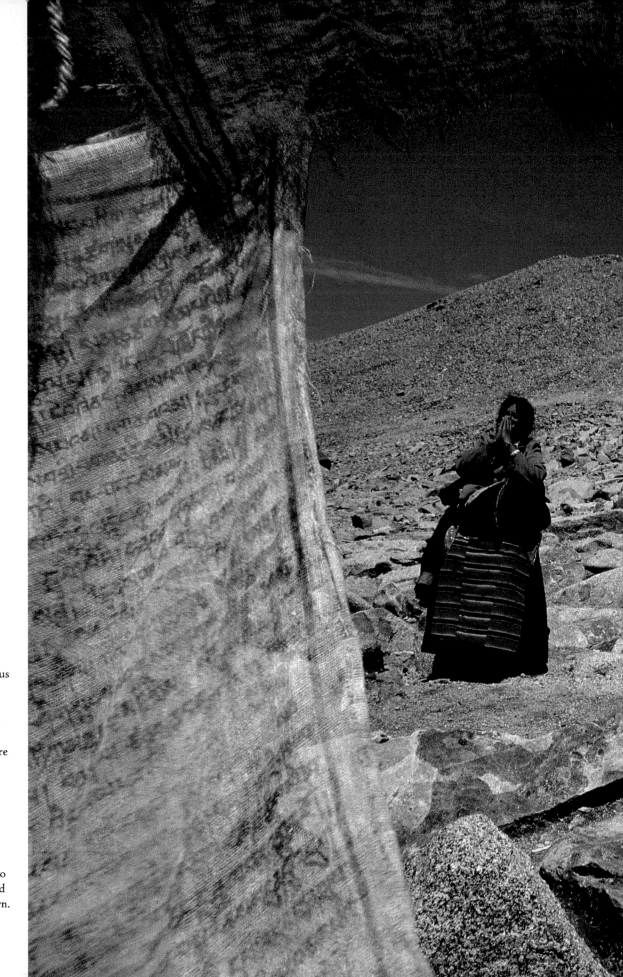

'La, so so so so!' Victorious cries and brilliant prayer flags greet pilgrims cresting the 18,600-foot Dolma La. Three women prostrate in worship before the gigantic boulder dedicated to Dolma. In ancient Tibetan folk beliefs, mountain passes were the abodes of gods: stone cairns, circumambulation and prayer flags pay homage to the invisible guardians and ensure a safe passage down.

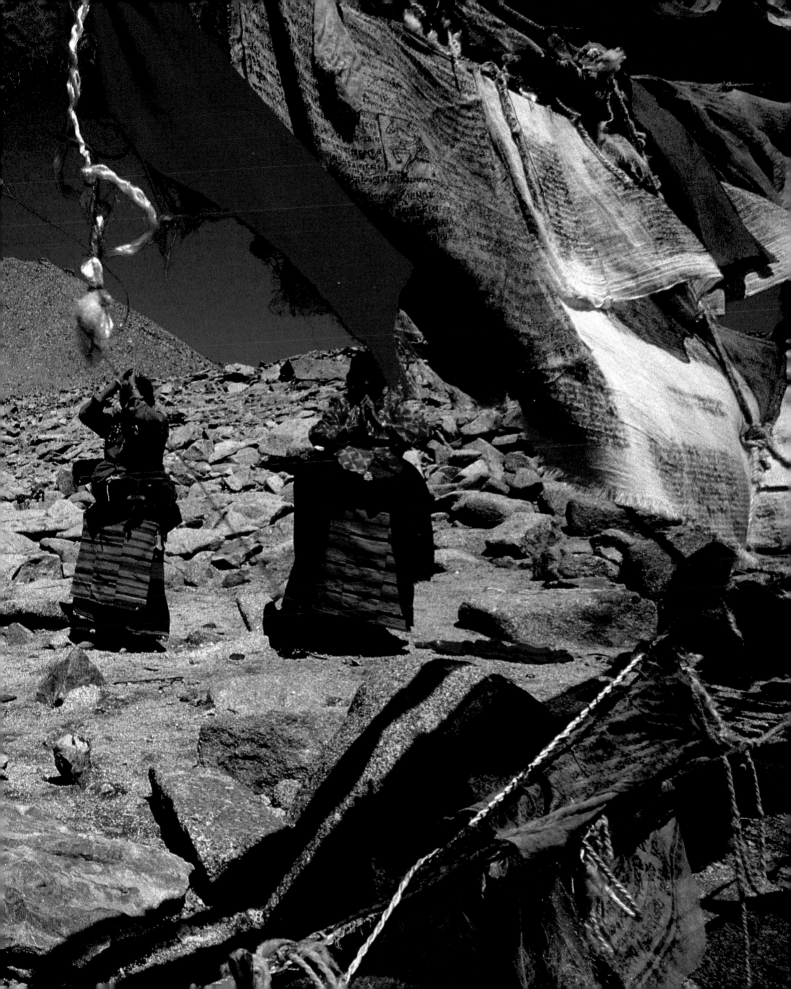

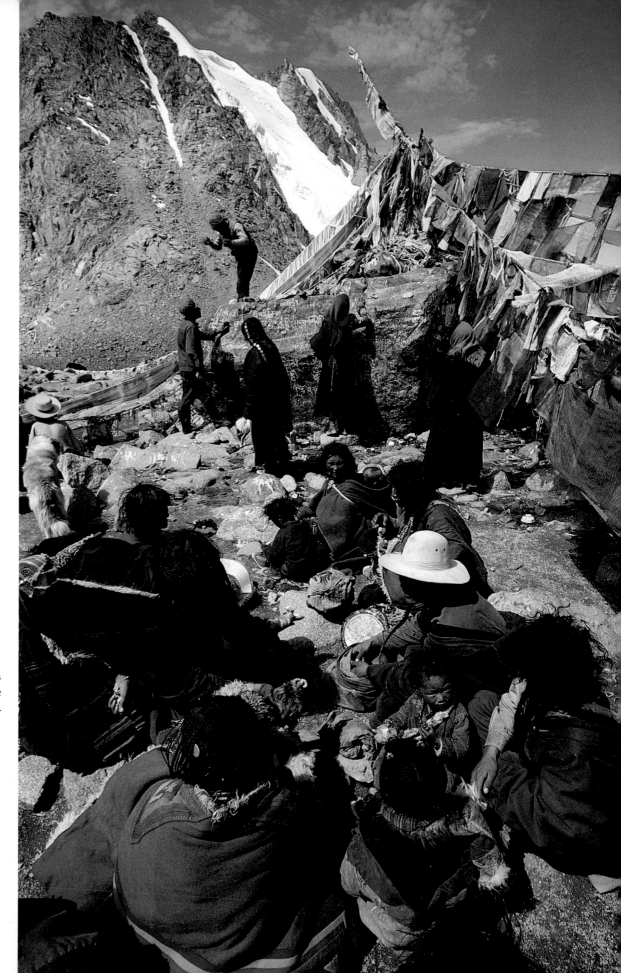

The Dolma La is the physical and emotional high point of the entire *kora*, and solemn ritual combines with joyous celebration. *Right*: Pilgrims celebrate their arrival at the pass with a communal feast. Pleasure mixes easily with prayer in Tibet, and a pilgrimage about Kailas often takes on the spirit of a picnic. *Opposite*: Pilgrims tie on prayer flags to ropes strung from the Dolma Stone. Each flag earns religious merit for the giver; as it flutters in the breeze, the blessings printed on it are spread over the earth.

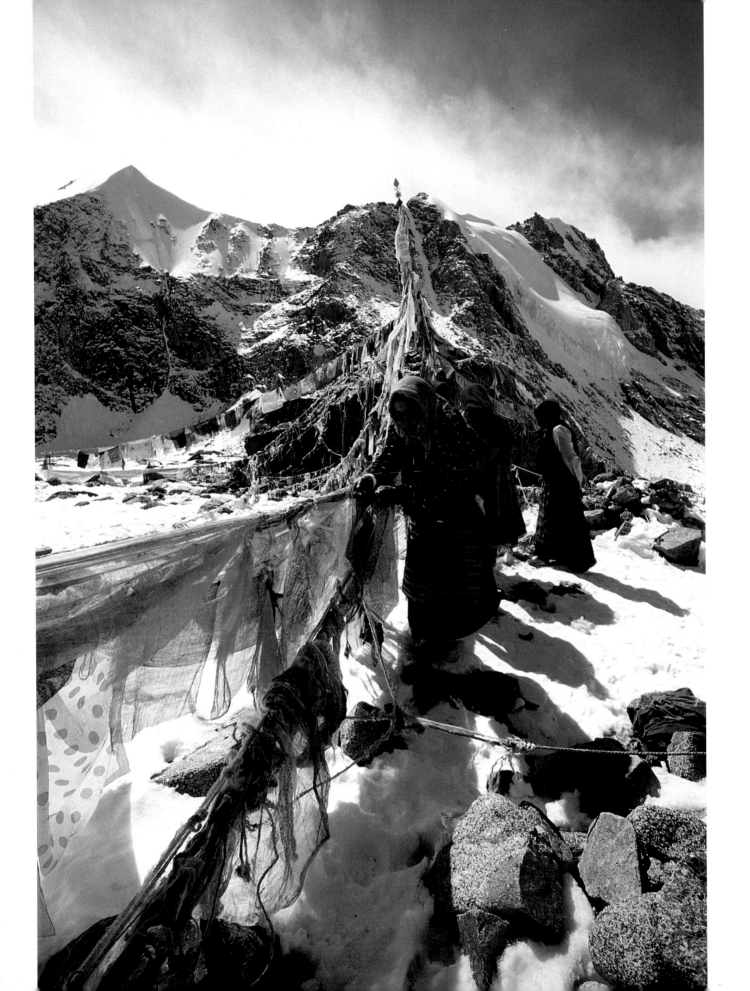

The focus of devotion atop the pass is the immense Dolma Stone (*overleaf*), painted with mantra, adorned with offerings and strung with prayer flags. Pilgrims bow to it in worship; their offerings litter the circumambulatory path about the rock. Legend says the Dolma disappeared beneath the boulder in the form of twenty-one wolves after leading the monk Gotsangpa to the very top of the pass. Tibetan women (*right*) anoint the Dolma Stone with butter and pinches of *tsampa* in offering. Possessed by his gods, a Nepali shaman (*opposite*) vibrates with high-strung intensity in an invocation performed atop the Dolma La. Local traditions of spirit possession are preserved in remote corners of Western Nepal, woven into an intricate tissue of Buddhist, Hindu and animist beliefs. Shamans, or *jhankri*, channel divine forces into the human world; they serve as healers, astrologers and diviners of the future.

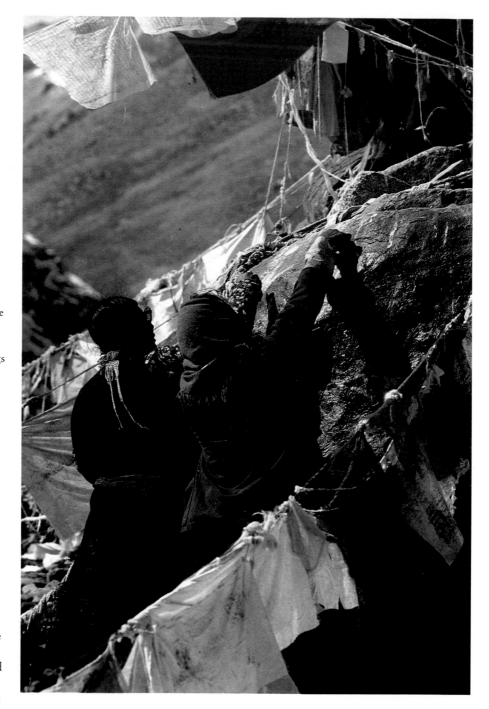

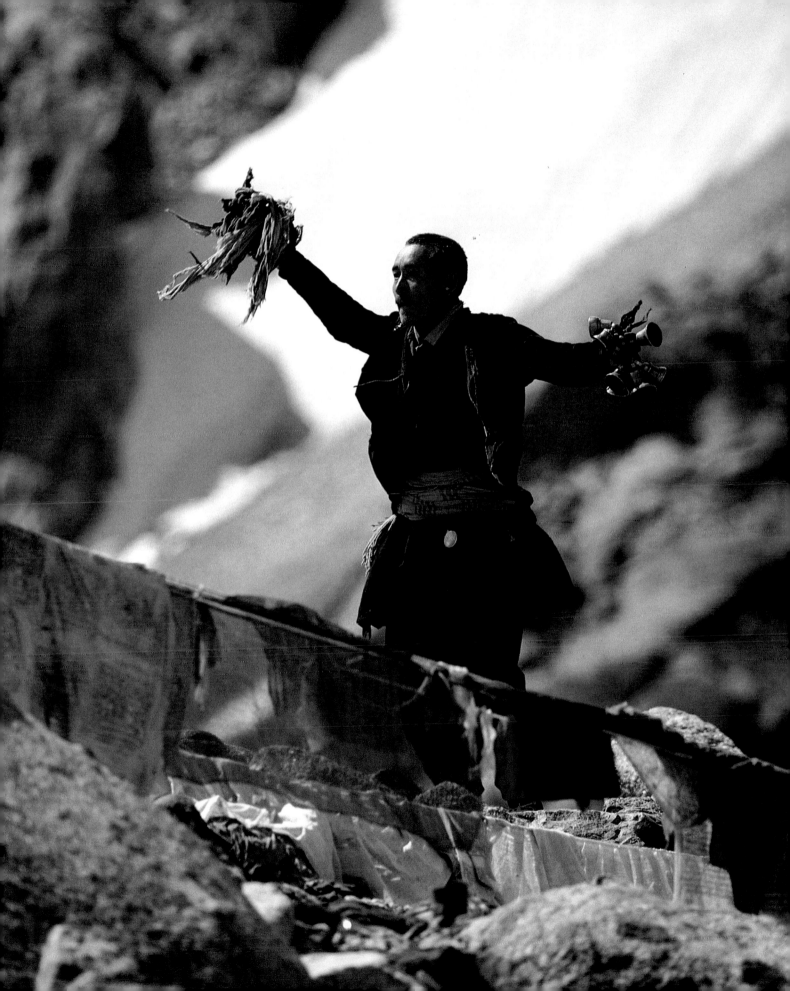

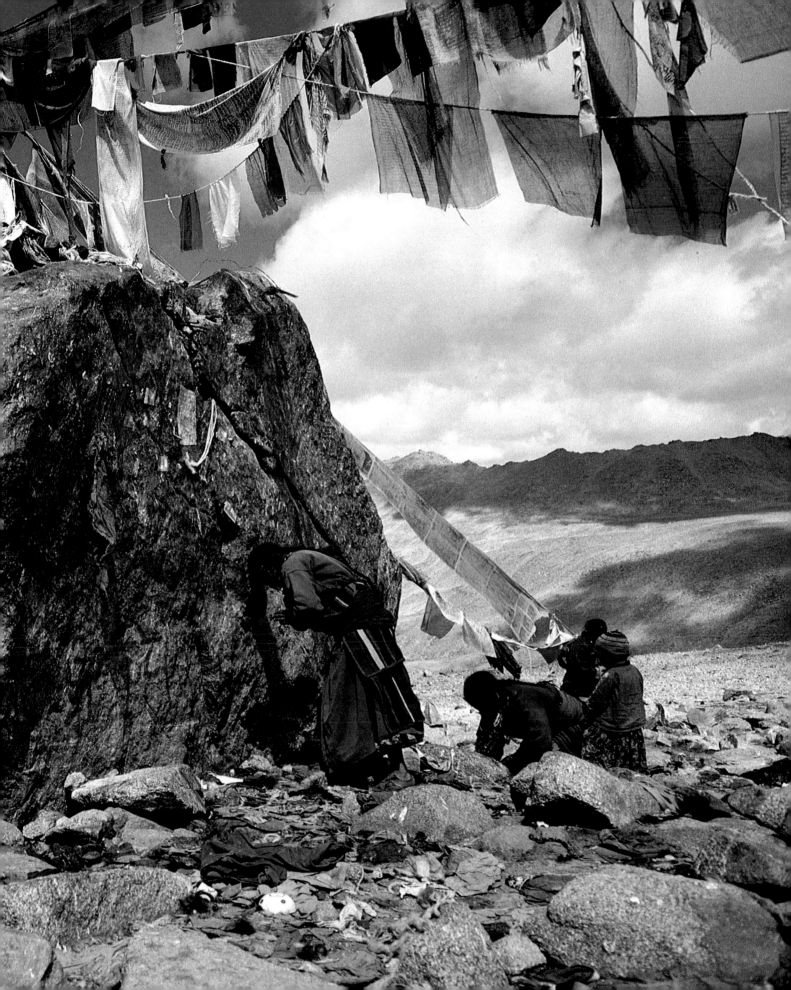

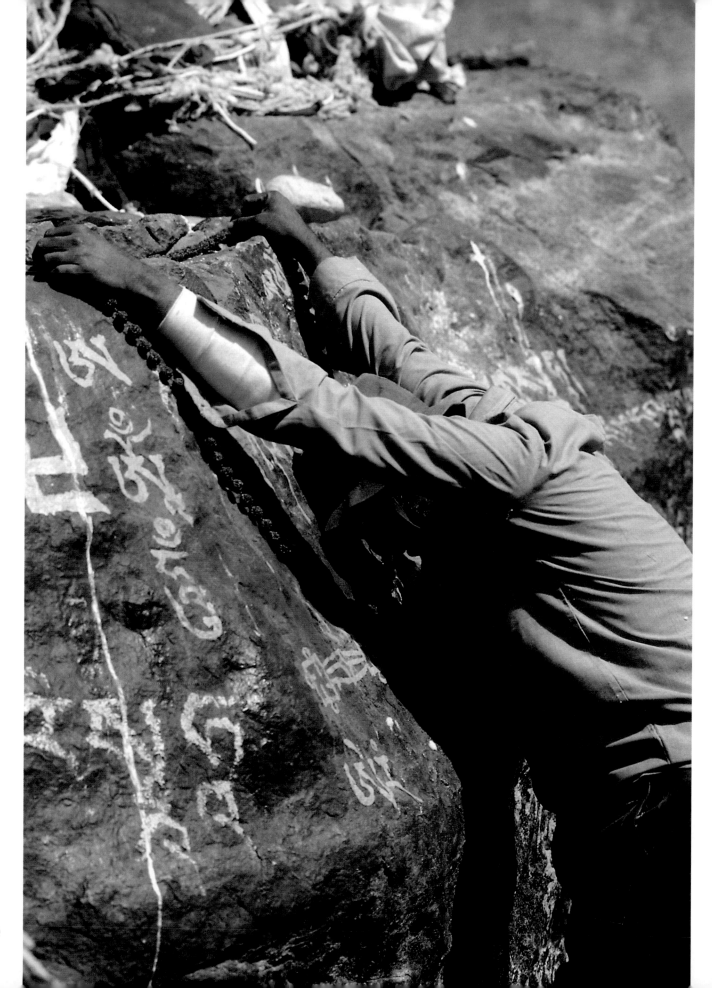

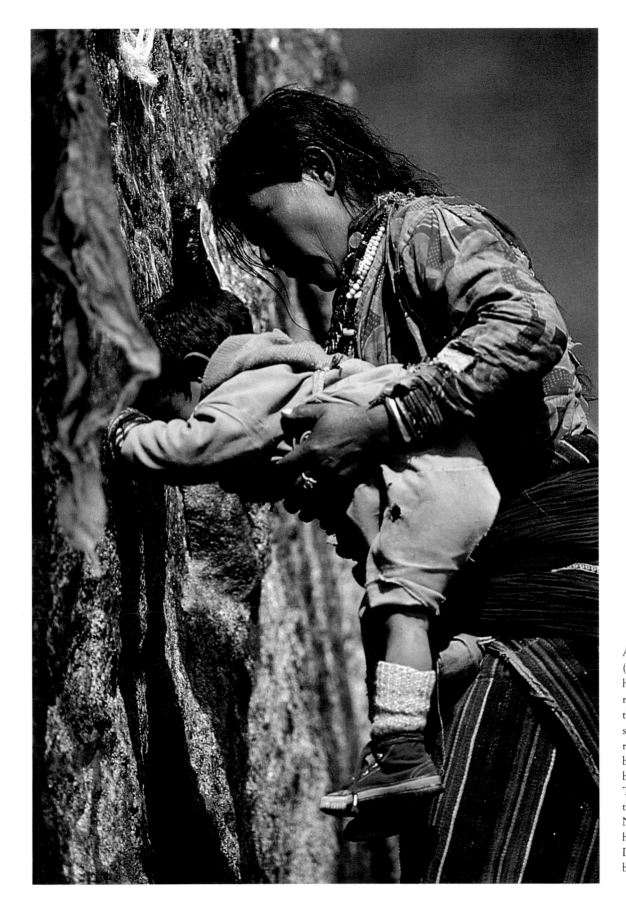

An Indian pilgrim (*opposite*) touches his forehead in reverence against the Dolma Stone, stretching out his rosary of prayer beads to receive a blessing. *Left*: Tradition through the generations – a Nepali mother lifts her son up to the Dolma Stone for a blessing.

Pilgrims on a one-day circuit must hurry down from the pass to complete the second half of the *kora* and reach Tarchen by nightfall. *Right*: Descending from the Dolma La, pilgrims file past the green waters of Tukje Chenpo Tso, the 'Lake of Mercy', which at 18,400 feet is among the highest lakes in the world. *Below*: In a freezing blessing, a fellow pilgrim baptizes a Nepali Buddhist with icy water from the lake, a ritual to follow the spiritual purification of the Dolma La.

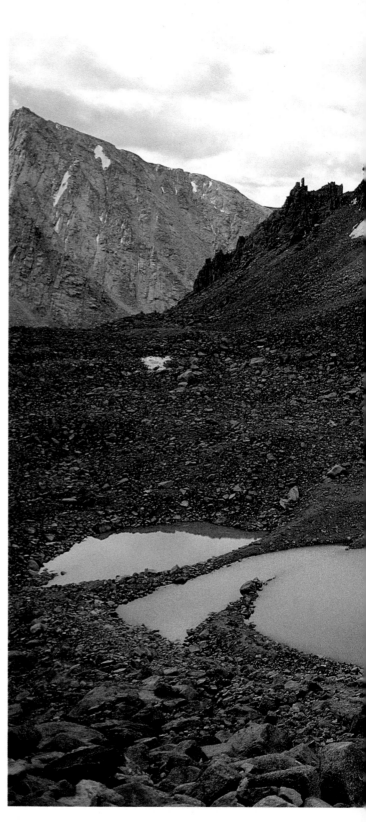

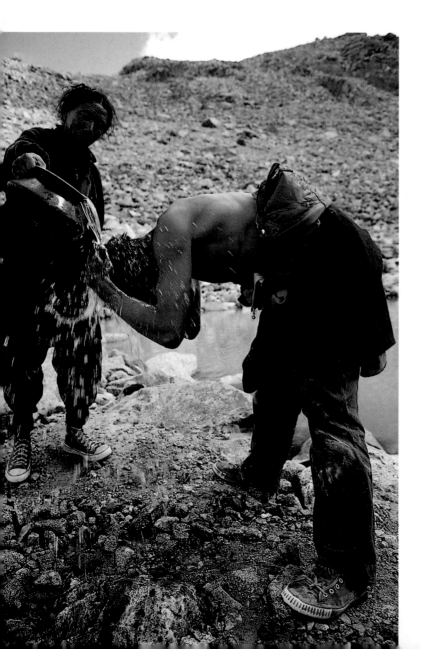

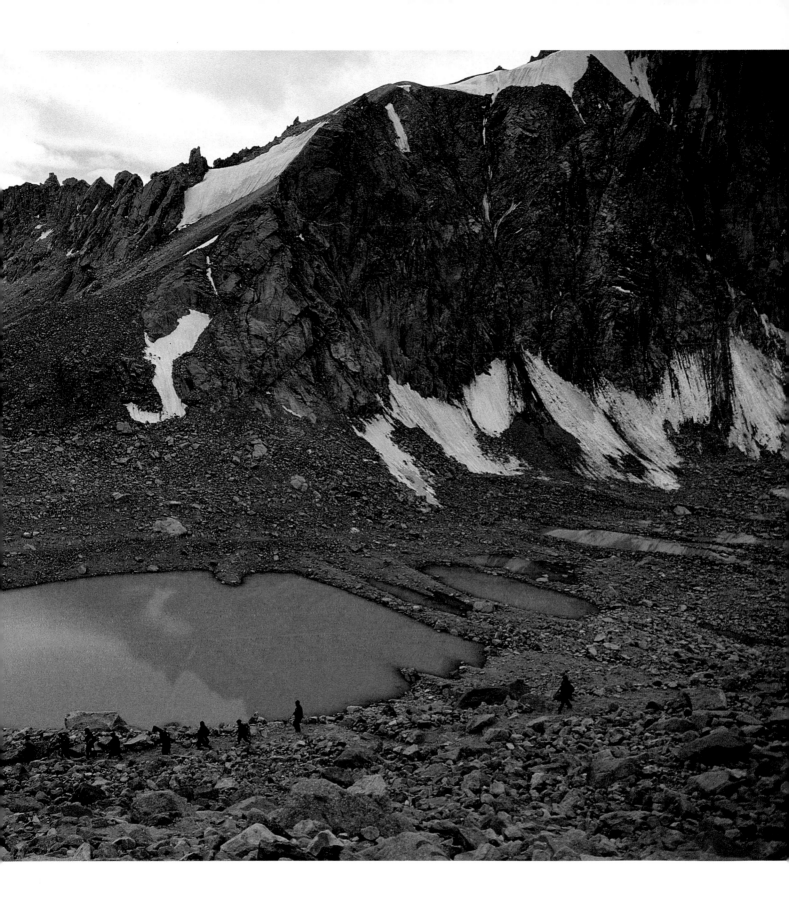

A family leads its ponies down the steep trail
from the pass into the eastern valley (*right*). A
Tibetan proverb says 'A horse which cannot
carry uphill is no horse; a man who will not walk
downhill is no man.' *Below*: A father snatches a
quick pause for butter tea and a cigarette by the
side of the trail during a rest stop.

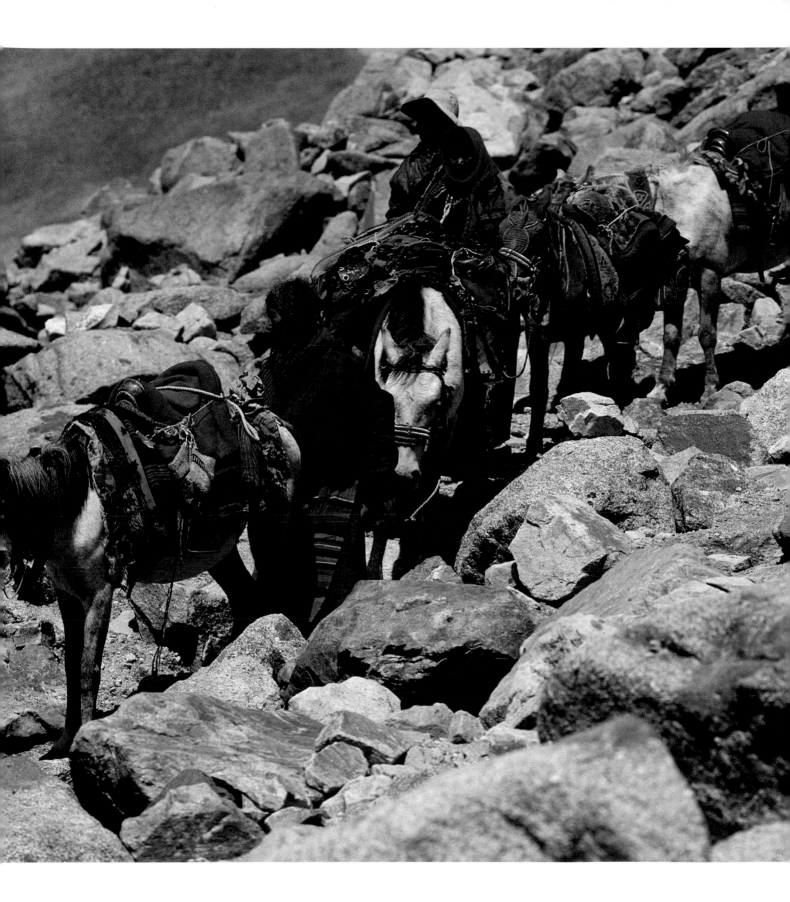

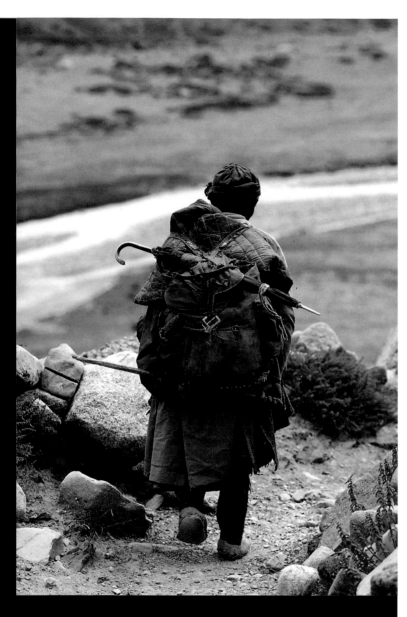

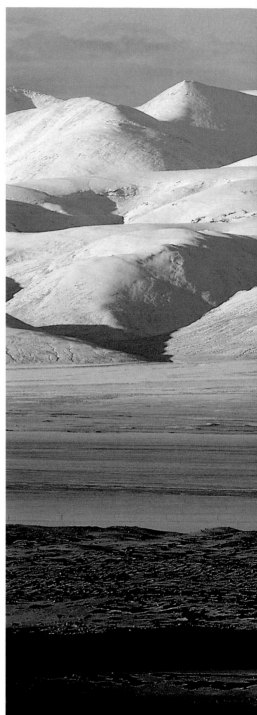

His journey almost completed, a lone pilgrim heads down the
trail back to Tarchen, the great circle of the *kora* nearly
closed. *Right*: Leaving the eastern valley the pilgrim enters the
vastness of the Barkha Plain. By late autumn, light snowfall
dusts the surrounding hills. The crystalline air clears still
more, and distances lose all normal perspective. The profile of
a rock cairn is visible on the right.

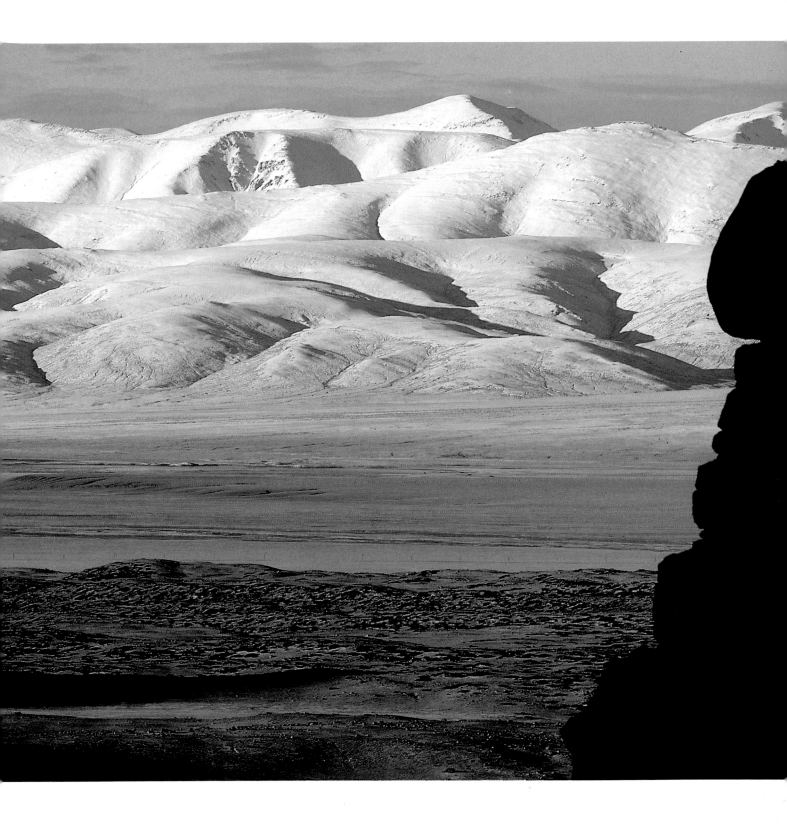

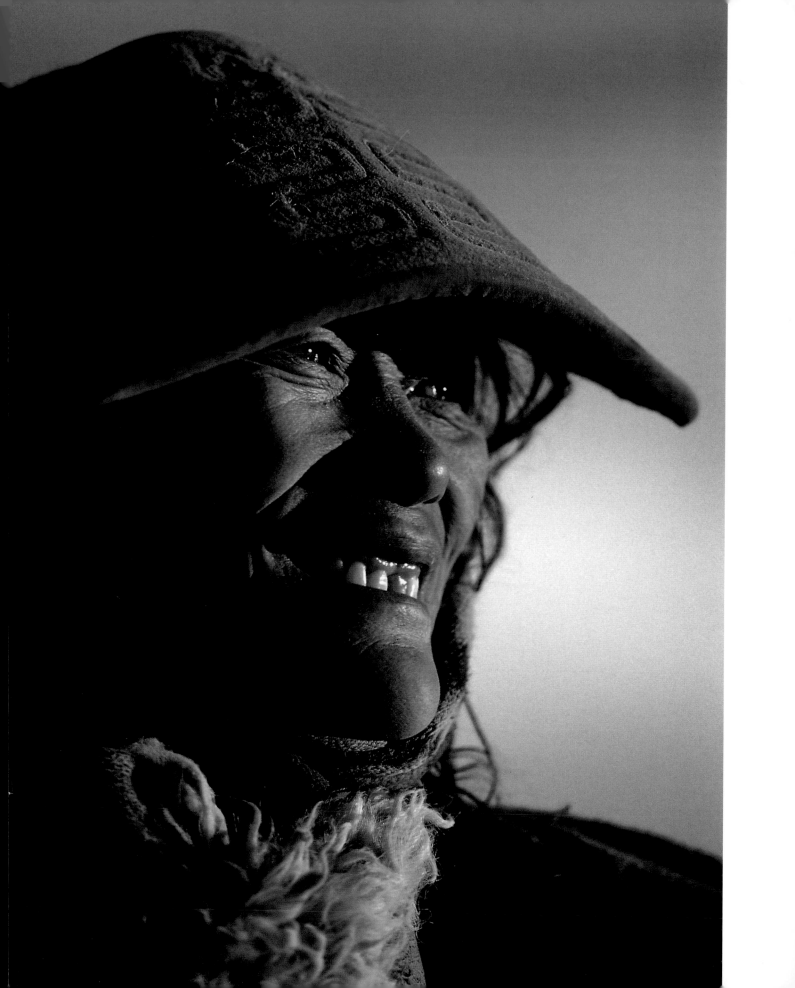

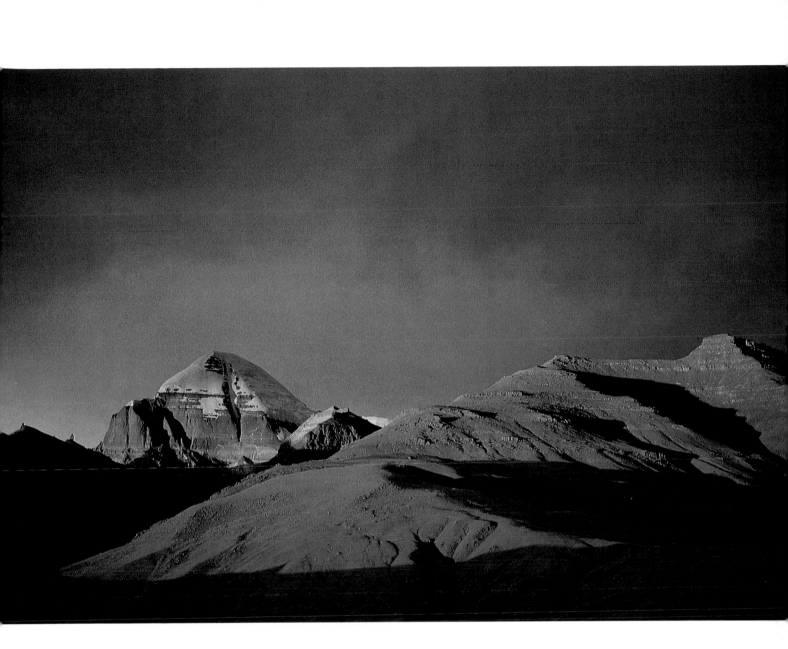

The faith of Tibetan pilgrims gives them perfect confidence in
the validity of their spiritual quest. Even the most casual
pilgrim possesses this belief, and there is no denying the light
shining in the eyes of some. A magic *chorten*, a natural temple:
Kailas fills the surrounding region with a power beyond
reason, a reality approached not by logic, but by faith.

Kailas glows in the cold moonlight,
impenetrable and eternal, a symbol of ultimate
perfection. To mistake the mountain for the
goal of pilgrimage is to miss the point: for the
faithful Kailas is simply a mirror, magnifying
and reflecting back the divinity projected onto
it. In itself it is no more than a heap of rock and
ice, but viewed through the right eyes, it gives a
glimpse of infinity.

6 The Inner Kora

'The prophecy of the Buddha says, most truly, that this snow mountain is the navel of the world, a place where the snow leopards dance. The mountain-top, the crystal-like pagoda is the white and glistening palace of Demchog. . . . This is the great place of accomplished yogis . . . There is no place more wonderful than this; there is no place more marvellous than here.' (*The Hundred Thousand Songs of Milarepa*)

I remained in the Kailas region three months, travelling to Purang and Lake Manasarovar then returning to the mountain for another long stay. Early one morning I wandered far to the north on the hills above Tarchen, pursuing a wary herd of mountain goat. Unexpectedly I found myself in Kailas' inner sanctum, on the *nangkor*, the 'inner *kora*' route I had traced on Swami Pranavananda's map so many times. Beginning at Tarchen, the trail leads north to encircle the pyramidal peak that rises directly below Kailas. Hindus call it Nandi, after the sacred bull that kneels before temples of Shiva. The path crosses a high pass beneath the south face of Kailas and doubles back southwards in a loop. On the eastern side of Nandi, the trail passes two tiny lakes. According to an old Tibetan pilgrims' guide, the water of the first is 'black like *chang*' (Tibetan beer); the other is 'white like milk' and contains the mystic 'key' to Kailas.

All this had intrigued me for several months, but to pass on this route tradition demands the pilgrim first perform thirteen outer *kora*, and at that point I had only done six or seven. Drawn by curiosity I followed the route several miles north. Then the trail entered a natural amphitheatre whose northern wall was Kailas itself, and I hesitated, feeling like an intruder. I was closer to the mountain than I had ever been, close enough to walk up and touch the weathered rock face, but something held me back.

I sat on a sun-warmed rock, part of the rubble of a glacial moraine, and studied the patterns ice had etched onto the cracked and curved stone of Kailas. Overhead a hawk soared in watchful circles. There was a certain peace there, but it was not that of tranquillity, for it was suffused with an intense power, and the air vibrated with a deep, barely audible hum. Perhaps it was the murmur of water rushing under ice – but there was no ice to be seen, and the stream flowed freely. The sound seemed to emanate straight from the mountain's heart. This was a place to stand in awe but not to linger. I turned back at the foot of the pass, leaving a final secret for the mountain to hold. It was a gesture of respect, a simple offering. What could I add to this perfect place, but to leave its sanctity intact?

Nowadays the traditional pilgrims to Kailas have been joined by a new sort: Western travellers in search of the unspoiled and exotic, a quest which tends to destroy the very qualities it hopes to find. They arrive in twos and threes on the back of trucks or in organized groups in Land Cruisers, drawn by vague rumours of a holy mountain or an urge to 'be the first'. There are genuine pilgrims among them; some Hindus or Buddhists, others without a specific faith but able to understand the process of pilgrimage. But many are immune to the spirit of the place. 'I'm not sure it was a good idea to come here', one man told me. 'I could have gone trekking in Nepal – I hear the mountains there are something else.' Or: 'You know, I'm sort of disappointed with Kailas. It's really not as mystical as I thought it would be.'

The Tibetan pilgrims, in contrast, had not the slightest doubt that the mere sight of Kailas was a great blessing. In a way I envied their wholehearted sincerity; they believed in the mountain, and it became divine for them. Faith is as simple as that – for us, as difficult as that. Of course for many Tibetans, the journey to Kailas was first an adventure or a trading trip; simply to make the journey was no guarantee it would be a religious experience.

Contrary to romanticized accounts, Tibet has no monopoly on spiritual realization. But despite years of suppression its people have managed to retain their faith, and a natural acceptance of the spiritual. Even the most casual pilgrimage was grounded on a bedrock of belief, and there was no denying the light shining in the eyes of some pilgrims I met. Casual or devout, they all belonged to a community of shared belief that gave its members an utter certainty in the value of their spiritual pursuits – a certainty by now lost to Western society.

The clash between the two traditions was difficult for some Western visitors to reconcile. 'How can these people still be so superstitious?' they marvelled. 'Why are you walking around the mountain so many times?' an American woman asked me with an air of suspicion. 'Are you Buddhist or something?' Because I had no words to answer her, I walked around the mountain some more. If Kailas' presence permeated me deeply enough, perhaps I would begin to understand its mystery – for although I could not yet explain it, I had no doubt that a mystery did exist; the power of it struck me every time I saw the mountain, each time I went around. What is your secret? I asked, confronted with that great form locked in frozen silence.

The answer came, not all at once, but slowly. Never completely, but fragmented into shards of words.

The reality of Kailas is of a sort approached not by logic, but by faith – and this is not blind belief, but simply a confidence in the validity of experiences beyond the realm of facts and the senses. This is the secret of all the rituals of pilgrimage, the prostrations and mantras and circumambulations, the piled stones and tattered prayer flags. Their importance is not in the acts themselves, but in the attitude they create: an openness to a higher state of being, a profound reverence for the natural perfection expressed by Kailas and Manasarovar, and a belief in the potential in every being to touch that perfection.

This, for lack of a better word, is faith, and those who come without, who come only to look, find only the barest realities of mountain and lake. Inevitably they are disappointed, for they are searching without what can only be found within. But those who come in true sincerity, whatever their beliefs, are the real pilgrims, and they find what they seek, not only within the lake and atop the mountain, but present all around, in the air and earth and light, the power of the sun and the restless touch of the wind. It is a power tangible to those who have the capacity to feel it but otherwise invisible and unprovable, a matter of 'superstition'.

The secret of the mountain? It has none. In itself it is no more than a heap of rock and ice. Various qualities – its appearance, its height, its isolation, and the feelings these evoke – have made Kailas a fitting throne for the symbols of the ultimate man has placed atop it, Shiva or Shenrab or Demchog; transcendent knowledge, Eternal Bliss. In the end, Kailas is no more sacred than any other place on this planet. It is *we* who make it what it is: a repository for the dimly-felt perfection we sense within ourselves. Because we fear, in a way, to actualize it, we place it atop a mountain and worship it as divine, for this potential is superhuman, and we are comfortable in our humanity, warm and safe. But even from this distance the transcendent acts upon us. Like a mirror, the mountain reflects back the divinity we have invested it with, incarnating it as a symbol to remind us and lead us on.

To mistake the mountain for the ultimate goal is to miss the point. Its meaning at once suffuses and transcends its appearance. In one sense Kailas is the divine centre at the heart of all creation, and from its worship comes a vision of the divinity of all things. In another sense, it captures for a fleeting moment the Absolute for which all symbols are only substitutes, translations of eternity and infinity into the realm of time and space.

Out on the open plains there was a sense of limitless freedom. I walked miles to a goal no more precise than a distant hill, walked hours for the pure joy of it, then threw myself flat on the ground to watch the clouds tumble in wind-tossed swirls of vapour. I loved these open spaces, their lucent colours and crystalline light and the ringing silence of the great blue bowl of sky curved over the earth. Power flowed on the wind through the entire clean unobstructed space, and the light blessed each blade of withered grass and every pebble with a self-contained completeness, a clarity approaching the intensity of a vision.

At certain moments time would stop, distance would dissolve in its own immensity – and suddenly eternity and infinity would be there within reach. This sense of boundlessness was an unexpected gift, for who would think to find the divine in the middle of nowhere?

Two Chinese truck drivers I met near the shore of Lake Manasarovar were one day bemoaning the desolation of the remote place. 'Too cold, too high, no food, ai-yah . . .' I translated their complaints to a Tibetan companion, and with a sudden intensity he said to me: 'Tell them that here life is *real*.'

He was right. Here life and land alike are reduced to their simplest components, and this stripping away, far from impoverishing them, creates the space for a certain essentiality to shine through, an element of meaning which vanishes when things, material or mental, begin to pile up. 'But there's nothing here', the Chinese objected. 'Only mountains, a lake, and it's so high.' Precisely, I thought. A mountain. A lake. So high.

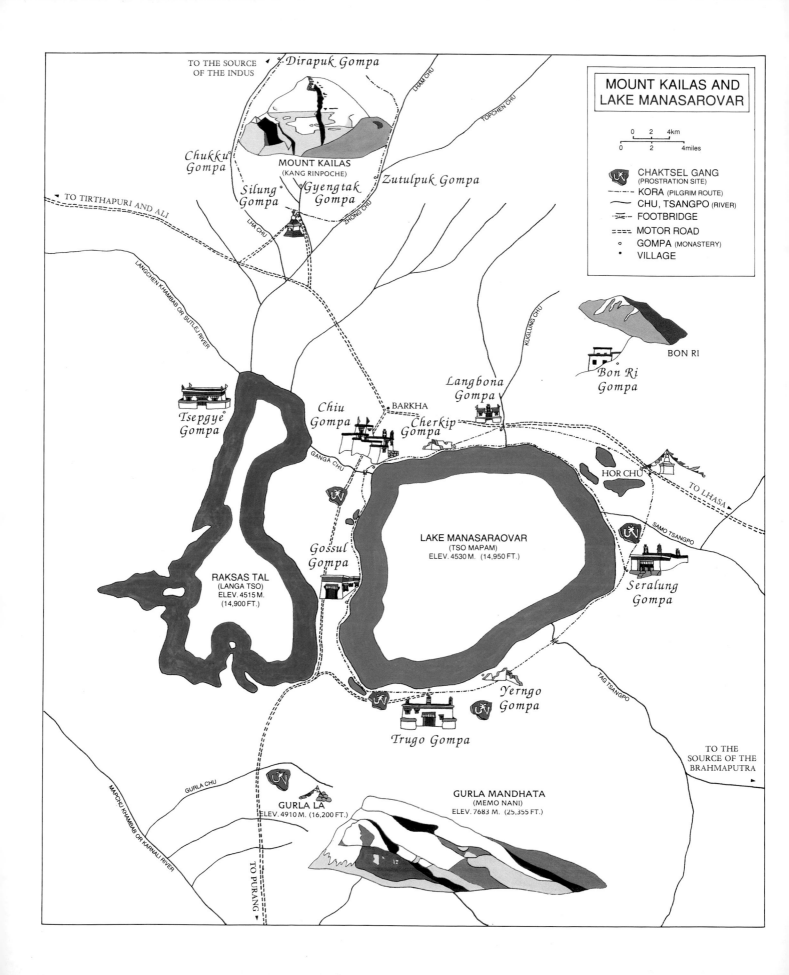

TO THE SOURCE
OF THE INDUS

Dirapuk Gompa

LHAM CHU

TOPCHEN CHU

MOUNT KAILAS AND
LAKE MANASAROVAR

0 2 4km
0 2 4miles

*Chukku
Gompa*

MOUNT KAILAS
(KANG RINPOCHE)

Zutulpuk Gompa

*Silung
Gompa*

*Gyengtak
Gompa*

CHAKTSEL GANG (PROSTRATION SITE)
KORA (PILGRIM ROUTE)
CHU, TSANGPO (RIVER)
FOOTBRIDGE
MOTOR ROAD
GOMPA (MONASTERY)
VILLAGE

TO TIRTHAPURI AND ALI

LHA CHU

ZHONG CHU

LANGCHEN KHAMBAB OR SUTLEJ RIVER

KUGLUNG CHU

BON RI

*Bon Ri
Gompa*

*Tsepgye
Gompa*

*Langbona
Gompa*

*Chiu
Gompa*

BARKHA

*Cherkip
Gompa*

HOR CHU

TO LHASA

GANGA CHU

SAMO TSANGPO

*Gossul
Gompa*

LAKE MANASARAOVAR
(TSO MAPAM)
ELEV. 4530 M. (14,950 FT.)

RAKSAS TAL
(LANGA TSO)
ELEV. 4515 M.
(14,900 FT.)

*Seralung
Gompa*

*Yerngo
Gompa*

TAG TSANGPO

Trugo Gompa

TO THE
SOURCE OF THE
BRAHMAPUTRA

GURLA CHU

GURLA LA
ELEV. 4910 M. (16,200 FT.)

GURLA MANDHATA
(MEMO NANI)
ELEV. 7683 M. (25,355 FT.)

MAPCHU KHAMBAB OR KARNALI RIVER

TO PURANG

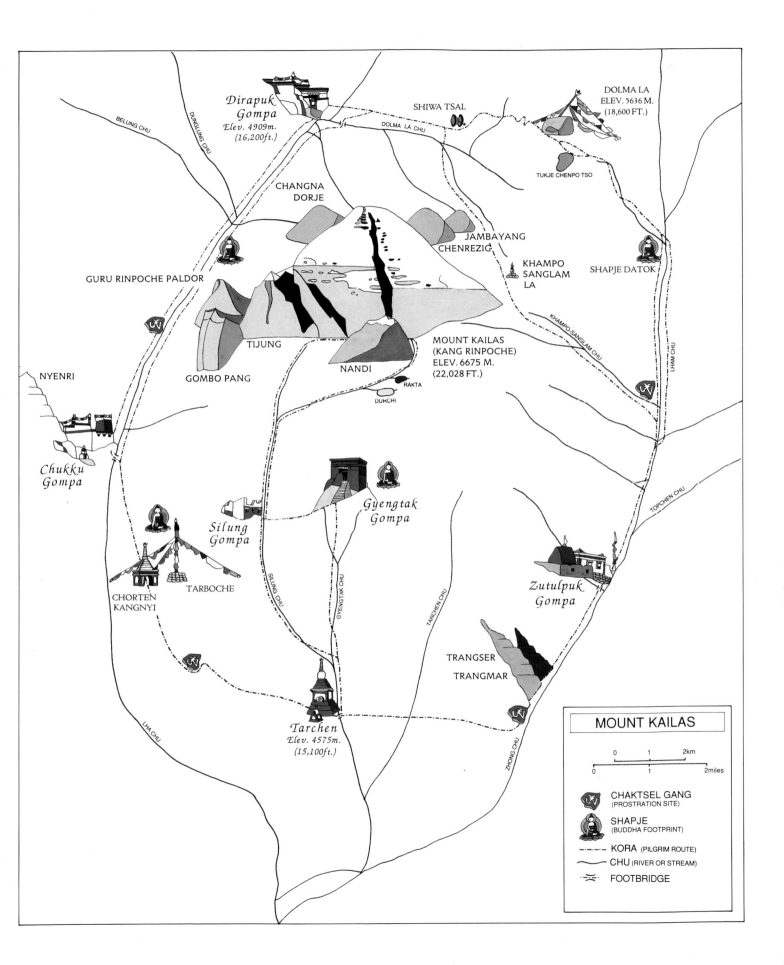

Dirapuk
Gompa
Elev. 4909m.
(16,200ft.)

BELUNG CHU

DUNGLUNG CHU

SHIWA TSAL

DOLMA LA CHU

DOLMA LA
ELEV. 5636 M.
(18,600 FT.)

TUKJE CHENPO TSO

CHANGNA
DORJE

JAMBAYANG
CHENREZIG

GURU RINPOCHE PALDOR

KHAMPO
SANGLAM
LA

SHAPJE DATOK

NYENRI

TIJUNG

GOMBO PANG

NANDI

MOUNT KAILAS
(KANG RINPOCHE)
ELEV. 6675 M.
(22,028 FT.)

RAKTA

DURCHI

KHAMPO-SANGLAM CHU

LHAM CHU

Chukku
Gompa

Silung
Gompa

Gyengtak
Gompa

TOPCHEN CHU

Zutulpuk
Gompa

CHORTEN
KANGNYI

TARBOCHE

SILUNG CHU

GYENGTAK CHU

TARCHEN CHU

TRANGSER

TRANGMAR

LHA CHU

Tarchen
Elev. 4575m.
(15,100ft.)

ZHONG CHU

MOUNT KAILAS

0 1 2km

0 1 2miles

CHAKTSEL GANG
(PROSTRATION SITE)

SHAPJE
(BUDDHA FOOTPRINT)

KORA (PILGRIM ROUTE)

CHU (RIVER OR STREAM)

FOOTBRIDGE

Glossary

Spoken Tibetan has evolved differently from the written language so that modern Tibetan orthography is far from phonetic (for example, the world pronounced 'chura' is spelled 'phyurba'). Tibetan words used in this book appear in simplified phonetic form. Vowels are pronounced as in 'Do Re Mi Fa'; 'u' is similar to 'oo'.

(S) denotes a Sanskrit word; all others are Tibetan.

chaktsel gang	prostration station
chorten	Buddhist monument, originally a reliquary mound; usually a square base topped by a dome
chuba	Tibetan garment, a loose-fitting robe belted at the waist
dakini (S)	female spirit
drogpa	Tibetan nomad
gompa	Buddhist monastery
Inchi	Englishman; a term extended by Tibetans to refer to all Westerners
Kang Rinpoche	'Precious Snow Mountain', a Tibetan name for Kailas
kora	religious circumambulation
lhakhang	shrine, temple
linga (S)	phallic symbol of Shiva's generative power
manas (S)	mind, intellect
mandala (S)	complete circular design symbolizing the phenomenal world of Tantrik Buddhism
mani wall	a low wall topped with flat stone slabs inscribed with mantra or sacred texts.
mantra (S)	'Instrument of thought', a formula of sacred syllables recited as prayer and meditation
momo	Tibetan dumplings
parikrama (S)	religious circumambulation
prasad (S)	an object infused with holy power, a blessing
shapje	footprint of a Buddha or other holy person
torma	a religious offering made of moulded dough
tsampa	roasted barley flour
vajra	the 'thunderbolt'; a ritual object symbolizing the indestructible nature of ultimate reality

Further Reading

For a general overview of Tibet, Giuseppe Tucci's *Tibet: Land of Snows* (London, 1967) and *Tibet* by Thupten Jigme Norbu and Colin Turnbull (London, 1969) are comprehensive, interesting surveys of traditional culture. *Tibetan Civilization* by R.A. Stein (London, 1972) covers Tibet's political and religious history in more detail. Robert Ekvall's *Religious Observances in Tibet* (Chicago, 1964) examines Tibetan Buddhism from an anthropological perspective. *The Hundred Thousand Songs of Milarepa*, a poetic summation of Buddhist precepts, appears in several English editions; Garma C.C. Chang's translation (New York, 1972) is among the best.

The adventures of Western explorers in the Kailas region are summarized in Charles Allen's *A Mountain in Tibet* (London, 1982), which describes the search for the sources of the four great rivers. Although *An Account of Tibet: The Travels of Ippolito Desideri of Pistoia, S.J., 1712–1727* (London, 1932) was not published until over two hundred years after the Jesuit's journey, it remains a fascinating, perceptive description. Volumes II and III of Sven Hedin's three-volume masterwork *Transhimalaya: Discoveries and Adventures in Tibet* (London, 1909–1913) contain a wealth of historical material on the mountain range as well as an account of Hedin's adventures in the Kailas region.

Among primary sources on Kailas, *The Sacred Mountain* by John Snelling (London, 1983) surveys Kailas' role in Asian religions and the accounts of pilgrims and travellers who have journeyed to it. *Kailasa-Manasarovar: Ascent to the Divine* by Rommel and Sadhana Varma (Switzerland, 1985) places Kailas, and the entire Himalaya, in their Hindu context as embodiments of divinity. Ekai Kawaguchi's *Three Years in Tibet* (Madras, 1909) includes a description

of the Japanese monk's journey to Kailas. The three chapters on Kailas in *The Way of the White Clouds* by Lama Anagarika Govinda (London, 1966) remain the classic description of a religious pilgrimage to the mountain. Finally, Swami Pranavananda's *Kailas-Manasarovar* (Delhi, 1949, 1983) is the complete pilgrim guidebook, a collection of anecdotes and advice which gives an entertaining glimpse into the world of traditional pilgrims.

The photographs in this book were shot in extreme conditions of cold, wind, dust and high elevation. I needed equipment that could stand up to the elements and perform on command over an extended period. I chose Canon and it did. My equipment consisted of Canon F-1 bodies with 17mm F4, 24mm F2, 35mm F2, 50mm Macro, 85mm F1.8, 135mm F2 and 300mm F4L lenses.

R.J.

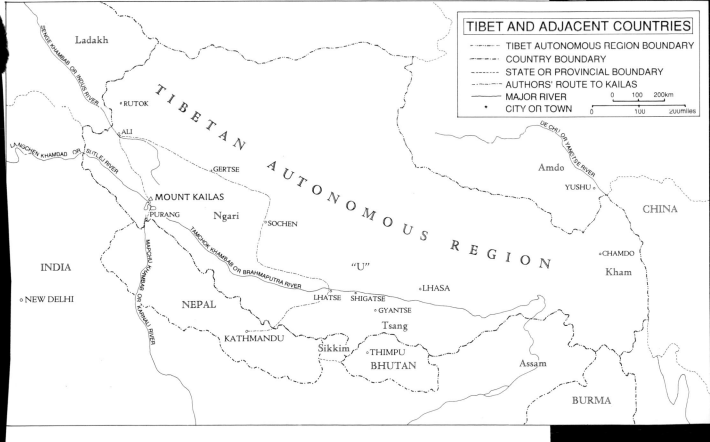

Two Tibetan boys proudly pose in front of a painted backdrop of Kailas
in a Chinese photo studio in Ali.